MICHAEL FREEMAN
CAPTURING THE MOMENT
THE ESSENCE OF PHOTOGRAPHY

D1296629

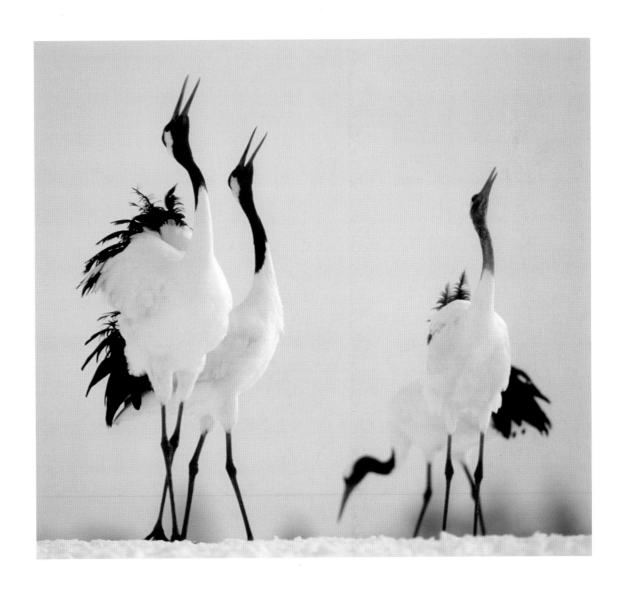

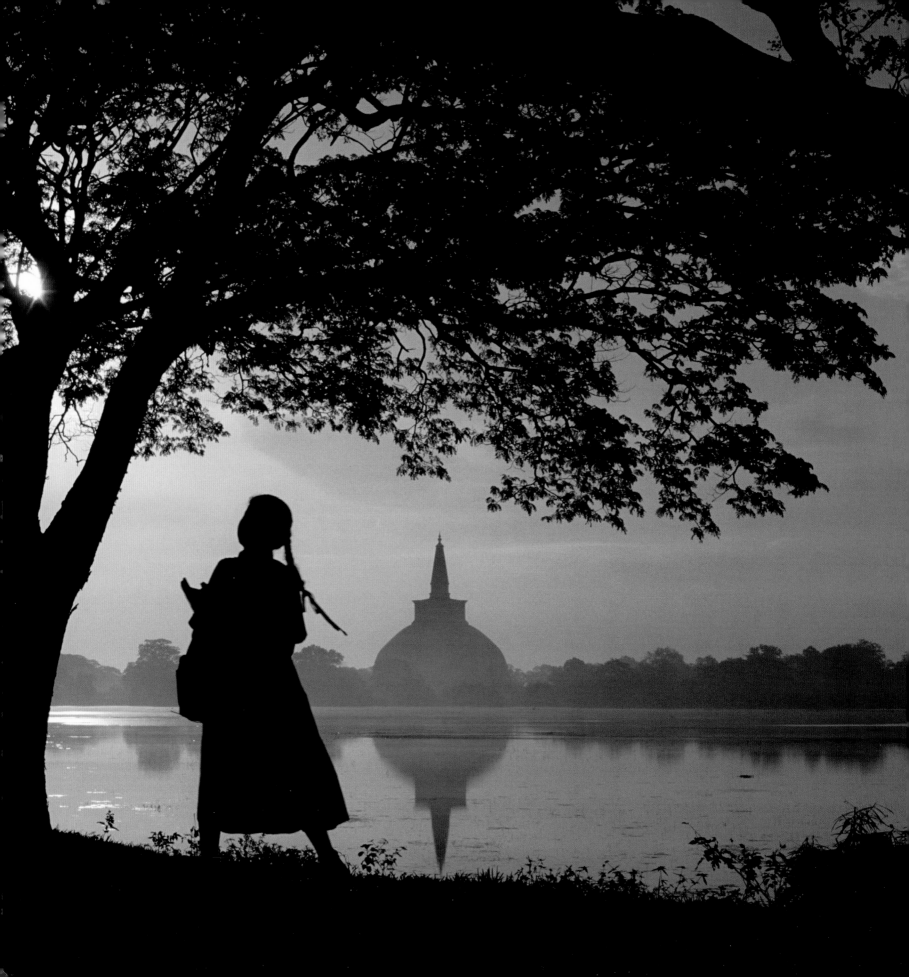

MICHAEL FREEMAN

CAPTURING THE MOMENT

THE ESSENCE OF PHOTOGRAPHY

ilex

First published in the UK in 2014 by:

ILEX
210 High Street
Lewes
East Sussex
BN7 2NS
www.ilex-press.com

Distributed worldwide (except North America)
by Thames & Hudson Ltd., 181A High Holborn,
London WC1V 7QX, United Kingdom

PUBLISHER: Alastair Campbell
EXECUTIVE PUBLISHER: Roly Allen
ASSOCIATE PUBLISHER: Adam Juniper
ART DIRECTOR: Julie Weir
EDITORIAL DIRECTOR: Nick Jones
SENIOR SPECIALIST EDITOR: Frank Gallaugher
SENIOR PROJECT EDITOR: Natalia Price-Cabrera
ASSISTANT EDITOR: Rachel Silverlight
DESIGNER: Kate Haynes
COLOUR ORIGINATION: Ivy Press Reprographics

British Library Cataloguing-in-Publication Data
A catalogue record for this book is available from the
British Library.

ISBN: 978-1-78157-976-3

Printed and bound in China

10 9 8 7 6 5 4 3 2 1

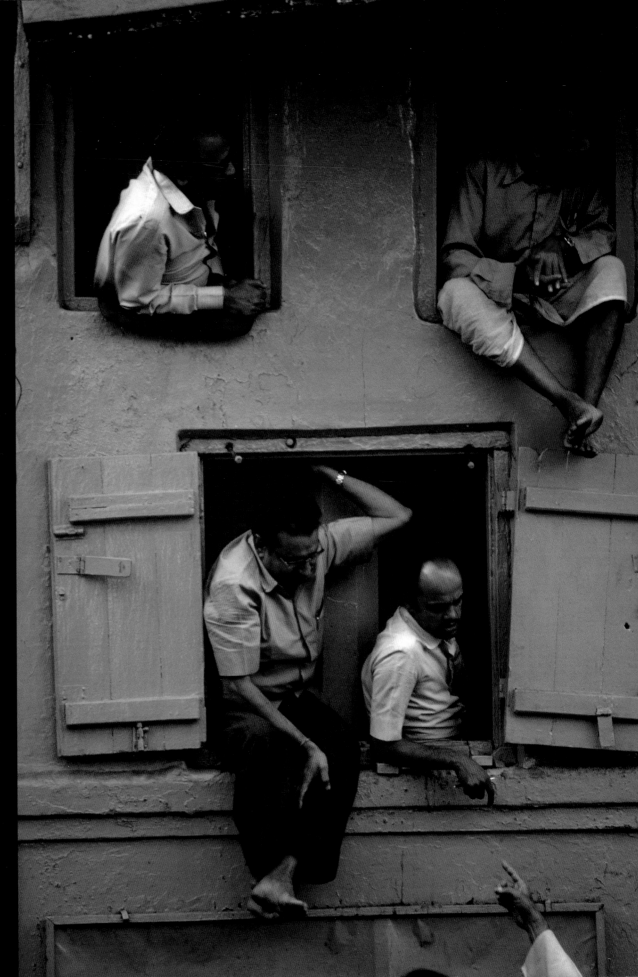

CONTENTS

1 CAMERAWORK

The fundamentals of shooting when time is of the essence, and when slices of time are embedded in the image, beginning with preparation, a view of what a unique moment can bring, shooting styles and techniques, and the key role of editing.

2 IN-CAMERA MOMENTS

Moments that are mainly dependent on point of view and framing—that exist for the camera only and not for other people.

3 FAST MOMENTS

Typically measured in fractions of a second, these are the events we tend to think of as momentary, demanding fast anticipation, recognition, and shooting by reflex.

4 SLOW MOMENTS

Moments that arrive and take place slowly by our normal standards of perception, but are nonetheless critical for imagery. These are events that unfold typically over many minutes or hours, such as the passage of the sun through the sky.

INTRODUCTION

"Life is all memory, except for the present moment that goes by you so quickly that you hardly catch it going."

TENNESSEE WILLIAMS

Just one thing sets photography apart from every other activity or art. It saves one single moment from a stream of real-life action and fixes it forever (or at least until you decide to throw it away). Some of us argue that capturing moments is what photography does best, and that this is the skill to hone and perfect. As a skill, it certainly responds to being worked on, for the evident reason that some moments are simply more arresting to look at than others. Really good moments make compelling, memorable photographs, and it's easy to see that well-liked and famous images are the way they are because the photographer caught something that in turn caught the public imagination. Marilyn Monroe's skirt flying up on the set of *The Seven Year Itch*, Robert Capa's falling soldier, Ansel Adams' *Moonrise, Hernandez*, and Alfred Eisenstaedt's *V-J Day in Times Square*, are all about moment.

It's all too easy to get philosophical about this, but I prefer to get practical. We all use cameras now (even though many of them accept incoming calls as well), so photography these days is less about quietly appreciating other people's images and more about shooting our own. We can start by demystifying the writings about moment, most of which feed off the endlessly quoted *Decisive Moment* of Henri Cartier-Bresson. He meant that when it all comes together in the viewfinder, you know it's the right time to shoot. He wrote, "Inside movement there is one moment at which the elements in motion are in balance. Photography must seize upon this moment and hold immobile the equilibrium of it." He did not mean that there is only one such moment per situation, because different people see things in different ways. But if you are aware as a photographer, there will likely be one moment that's right for you.

Put in the simplest way possible, moments are about choosing when to shoot, about realizing that the way things come together in the frame right now may be better, or worse, than in the next few seconds. Or minutes. The time frame varies hugely, from hours to a fraction of a second, but what remains constant is that one point will deliver you a more satisfying image than the others. But none of this means much unless it is useful in helping us all capture more interesting moments. And there are skills and techniques—many of them— that we can use to achieve this, which is why I'm going to limit the navel-gazing and concentrate on the practicalities of capture. This is all the more important now with the huge numbers of photographs being taken. One estimate for this year is around one trillion, though I hesitate to mention even this ludicrously large figure for fear of it quickly going out of date. The reason for this greater importance is simply that the more images accumulate, the less memorable and interesting they become. Standing on the shore of an ocean of imagery, you have to work harder to make one that stands out. It really isn't enough to just point and shoot. The camera can do that for itself. If we want to be able to claim a moment in time visually as our own, we need to develop the skills to find it and capture it.

First, we'll look at camerawork, and by that I don't mean how the camera works but how photographers work with the camera—any camera. There are, for example, different styles of capturing best moments. In particular, there are three main contrasting styles, as much to do with personality as anything else, which I call Fireman, Builder, and Marksman (read on for the explanation). Next comes the kind of moment that purely and only exists in-camera, and is to do with things coming together from one point of view and one photographer's point of view. Then we look at fast moments, which need qualities like anticipation and planning much more than an exact shutter speed (yes, I know that sounds strange, but it's true). Finally, there are slow moments, when the pace of change can be measured in minutes or hours, but when also the decisions need to be more carefully considered. ■

Photography's unique abilities

The ability to freeze a moment in time has long been heralded for its aesthetic and philosophical implications. But there are also captured moments that are even more powerful than a frozen frame of tense action, which also speak to photography's artistic strengths.

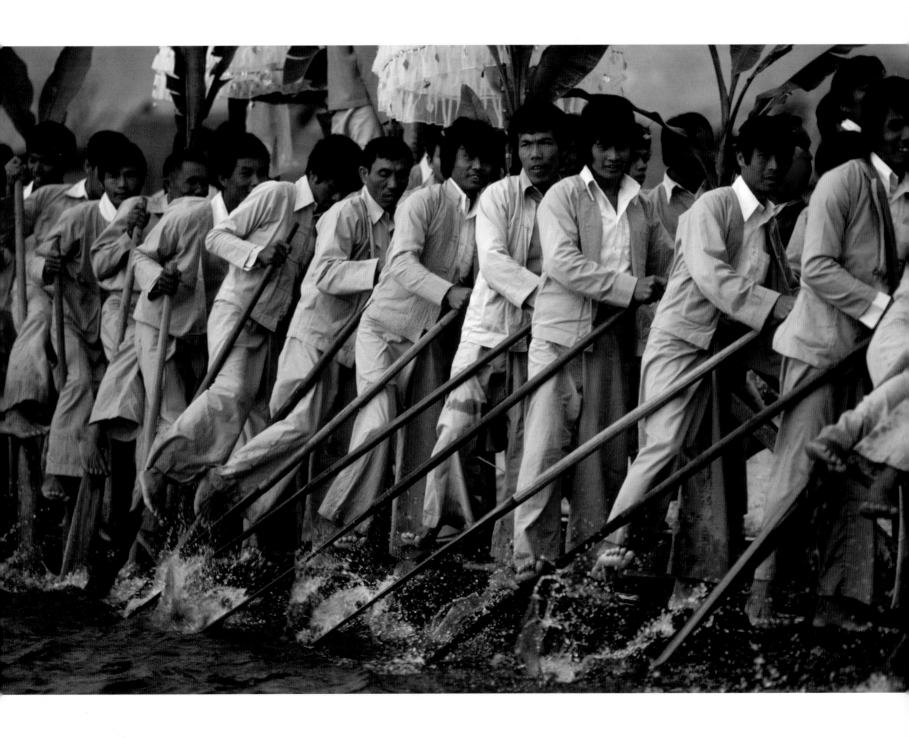

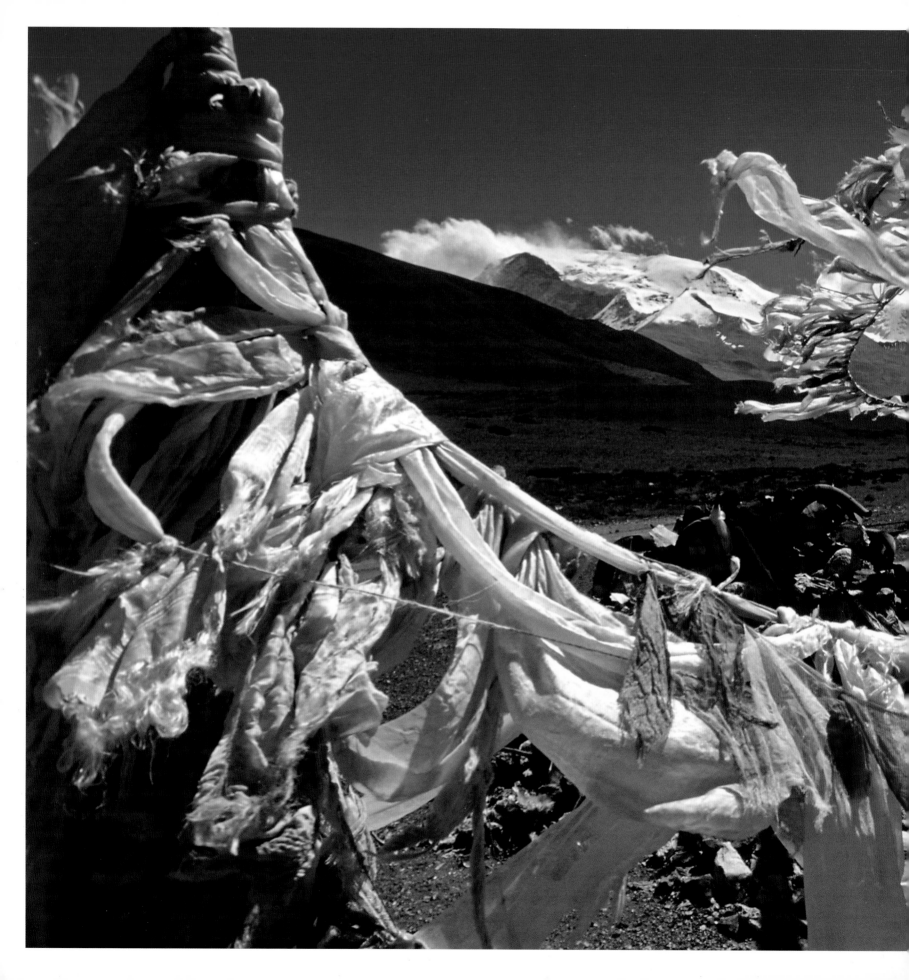

CAMERAWORK
1

Despite the technical-sounding title, this chapter is as much about ideas as about operating the camera. Rather more so, in fact, because well before the mechanical issues of shutter speed, the choice of single or continuous triggering, and other settings, there's the basic matter of what kind of moment will be the best one. The difference between the continuous flow of action that we see and experience in life, and a still slice taken out of it, is a major jump, and not a completely natural one, either. We probably take it for granted more than we should, that the camera is going to efficiently deliver a still version of what we're looking at. Some of the time, with a more-or-less static subject like a building, a still life, or a landscape, it indeed turns out like that—a still frame from a scene in which nothing much is happening and where movement plays no part.

Much more of the time, however, life and activity of some sort is going on in front of the camera, and the choice of when to shoot becomes the main one. Some actions follow a trajectory, such as a ball being thrown, a vehicle driving down a lane, a bird taking flight, and the good thing about trajectories is that you know what comes next, and can prepare for it. Other actions happen suddenly, with little or no warning, like a smile on a face in the street, or something hidden bursting into view. These need reaction rather than anticipation, and a different kind of preparedness. In either case, what difference, visually

and emotionally, is that action going to make to the scene? And is it, or should it be, small enough in the frame to be just one element, or would it work better closed in on with a tight framing? Which would be more interesting? Which would be more effective?

All of these decisions—and there are more—affect the way the camera needs to be used. Camerawork is wrapped up in all the reasons why you are shooting the moment, and so the techniques go much deeper than simply knowing what shutter speed is appropriate. One important range of technique that we explore in this chapter is between selective shooting and collecting a mass of images quickly. There is more to this than just a question of quantity, because it reflects both personality in the photographer and the needs and possibilities of the situation. I divide this into three main groups of technique, which I call Fireman, Builder, and Marksman, for reasons explained later on. We'll also look in more detail at the kinds of moment to expect from photography's most frequent subject—people. Posture, gesture, and expression all contribute in different ways to how we appear in front of the camera, and the range is huge. Finally, camerawork surely extends to the editing process, not only because this is where photographers re-live their decisions, but also because when you shoot it's wise to anticipate how you will treat the images later.

A HISTORY OF MOMENT

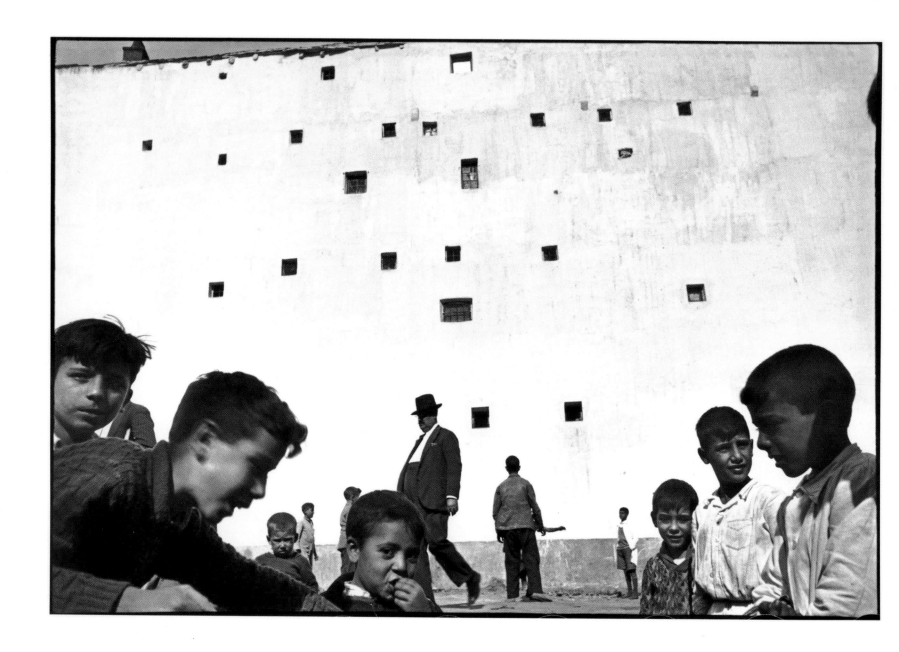

With the idea of moment so central to photography, it's little surprise that it has been the focus of so much opinion and theorizing. Every commentator and writer who wants to be taken seriously in the field has something to say about it. Henri Cartier-Bresson cornered the market in the idea of there being an independently special moment to be captured with his phrase "the decisive moment"— actually borrowed from the 17th-century Cardinal de Retz, very much a non-photographer, who wrote, "There is nothing in this world that does not have a decisive moment." Applied to photography, as Cartier-Bresson did in his 1952 book *Images à la Sauvette*, it seems entirely appropriate, a view bathed in commonsense. "The decisive moment" is hard to avoid and argue against, to the point where it is in danger of being considered a cliché (the fate of all good expressions).

This has not, of course, prevented many from trying, and the cheap journalistic tag "the indecisive moment" is almost as common as the original, and a lot more tiresome. In fact, the trail that the famous phrase initiated is the hunt for the specialness of a camera-captured moment, and not surprisingly, it's all to do with success and failure. A successful photograph (at least of the kind that depend on timing) is one in which the photographer has managed to catch an uncommon moment that pleases him or her, and which strikes a chord with enough other people to form an audience. The writer and critic John Berger put it like this in a 1972 essay titled *Understanding a Photograph*: "A photograph is a result of the photographer's decision that it is worth recording that this particular event or this particular object has been seen. If everything that existed were continually being photographed, every photograph would become meaningless. A photograph celebrates neither the event itself nor the faculty of sight in itself. A photograph is already a message about the event it records. The urgency of this message is not entirely dependent on the urgency of the event but neither can it be entirely independent from it. At its simplest the message, decoded, means: I have decided that seeing this is worth recording."

The other part of the equation that describes success is that an audience agrees, and finds that moment in the photograph worth looking at. In between you shooting the picture and it being displayed online, in a gallery, or in a publication, there is an important gap, during which other people are doing the looking and making their minds up. And with the booming wider interest in photography, the audiences are getting bigger—and more opinionated. The moment you chose needs approbation. "Hang on," you might think. "I go to all this trouble perfecting my skills and my observation so that I capture exquisite moments, and then it's up to some casual observer to say whether or not they really are significant?" Well, increasingly yes is the answer, and there always will be disagreement as to what makes the good moment.

The writings of photographers themselves are all concerned with defining their own ideas of moment, and understandably self-serving. For example, what Arnold Newman thought photographers should be looking for "is photographs, not the decisive moment. When they decide that the photograph is ready for them, that's a decisive moment. If it takes an hour, two hours, a week, or two seconds, or one-twentieth of a second—there's no such thing as only one right time. There are many moments. Sometimes, one person will take a photograph one moment; another person will take a photograph the other moment. One may not be better, they'll just be different." Garry Winogrand, championed by the 1970s New York art establishment as a kind of maverick street photographer, said, "No one moment is most important. Any moment can be something," which is no more enlightening than most of his comments. A certain "what the hell, why are you even asking these kinds of question?" attitude prevailed in that particular period, and a contemporary of Winogrand, William Eggleston (also on the Museum of Modern Art's A-list), came up with a response that sounded as if he'd never considered the matter before. Asked in a

Spain, Madrid, 1933, Henri Cartier-Bresson

Cartier-Bresson's most widely reproduced images, like this one—and many would say his best work—are in fact fully in the tradition of early photographic surrealism, despite Robert Capa's later advice to move away from this into more mainstream reportage. This is surrealism as a way of saying "see how interesting and strange the ordinary world can be when you look at it my way," and usually, with Cartier-Bresson, it involves a precise and strange moment of capture.

A HISTORY OF MOMENT (continued)

television interview what he looked for when out shooting, he replied, "What I'm photographing, it is a hard question to answer. And the best I've come up with is 'life today.' I don't know whether they believe me or not, or what that [referring to a particular print] means. I don't know what to say about that, but it is today." Eggleston, it should be noted, polarizes opinion more than most famous photographers, and has many ardent supporters who enjoy the way he has found beauty in the mundane. What's interesting for this book is that Eggleston's definition of moment is "today," and specifically the today of Memphis, Tennessee, a fairly dull city that he has chronicled exquisitely for decades. Eggleston's moments are slow moments, a crucial topic that I'll deal with here.

All of this is the photographers' view of moment, but the philosophical possibilities caught the attention of some writers (though surprisingly few). By the 1920s, film and lenses were sensitive enough for cameras to handle moments efficiently, and Walter Benjamin in 1931 expressed the fascination many felt at being able to see beyond normal human vision: "...we have no idea at all what happens during the fraction of a second when a person actually takes a step. Photography [...] reveals the secret. It is through photography that we first discover the existence of this optical unconscious."

Mining the philosophical depths later, Susan Sontag and Roland Barthes pondered the photograph's relationship to reality. Sontag wrote, "the camera makes reality atomic, manageable, and opaque. It is a view of the world which denies interconnectedness, continuity, but which confers

on each moment the character of a mystery." Her thought that a photograph "is both a pseudo-presence and a token of absence" echoes French art critic Roland Barthes' description, which he called "That-has-been." This is philosophically deeper than most of us will ever want to go, but he wrote, "there is a superimposition here: of reality and of the past. And since this constraint exists only for Photography, we must consider it, by reduction, as the very essence, the *noeme* of Photography" because no other medium or art does this. Simply because "this object has indeed existed and that it has been there where I see it," there is, according to Barthes, some madness at work. "The Photograph then becomes a bizarre medium, a new form of hallucination: false on the level of perception, true on the level of time."

Sontag's "mystery" and Barthes' "madness" are entertainingly explored in the last original good writing on the subject, by writer Geoff Dyer in his quirky *The Ongoing Moment*. Like Barthes, his qualifications lie in his interest in photographs, not his practice (he doesn't own a camera). He views decades of (mainly American) photography in terms of odd, idiosyncratic themes like hats, steps, park benches, and roads heading toward the horizon. Funnily enough, thinking about this way of classifying images and looking at the selection in my own book here, I seem to have photographed a lot of trees without thinking about it deliberately. Over the years, different photographers return uncannily and usually unknowingly to similar graphic moments. In this eccentric-but-illuminating stroll through

photography, Dyer acknowledges a contemporary approach to moment—the viewer's choice. Who says that a moment is good and special? Who applies the benediction? The audience does. ∎

Morocco, Meknes, Moulay Ismael Mausoleum (Muslim shrine), 1985, Bruno Barbey

Eggleston's greatly extended moment, defined as "life today," is by no means unique in the history of photography, and shares its roots with the archetypal form of the photo essay, or picture story—that mainstay of magazine photojournalism and the photographic book. In order to extend the moment, the photographer also has to extend the coverage over many images. Individually, they may have their own life and particular appeal, but assembled together they become something else—an editorialized view. When the photographer is in control, as Bruno Barbey is here, this edited construction can become a meditation on place extending through a very long moment indeed. Barbey, a long-standing member of Magnum, grew up for twelve years in Morocco, and keeps returning. For him, it is his homeland, and he is drawn to it because there, he says, "I find the smells and colors of my youth." His 2003 book *My Morocco* is a collection of imagery spread across many years that explores, graphically and often obliquely, the complexity of this country.

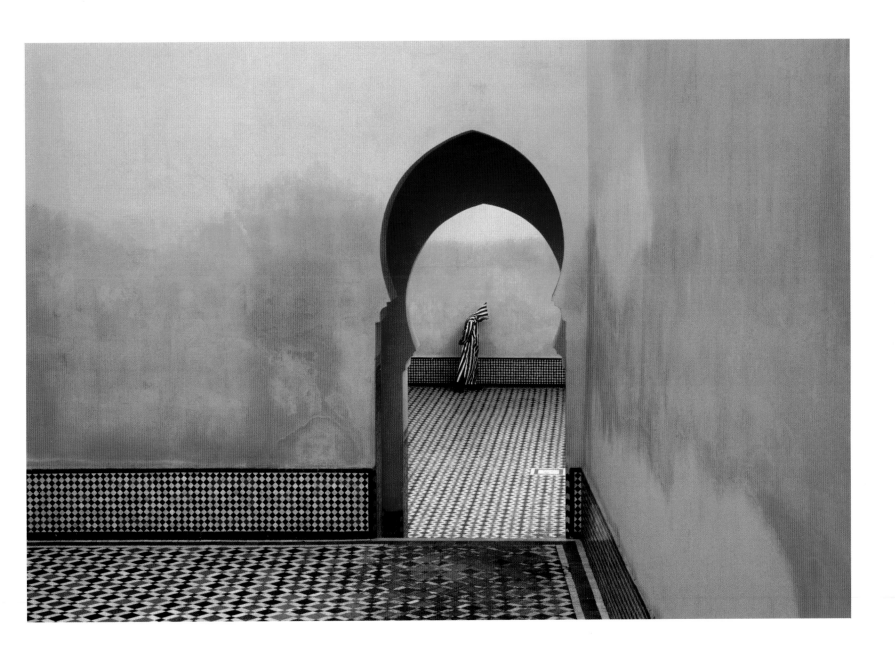

PRIORITIZING MOMENT

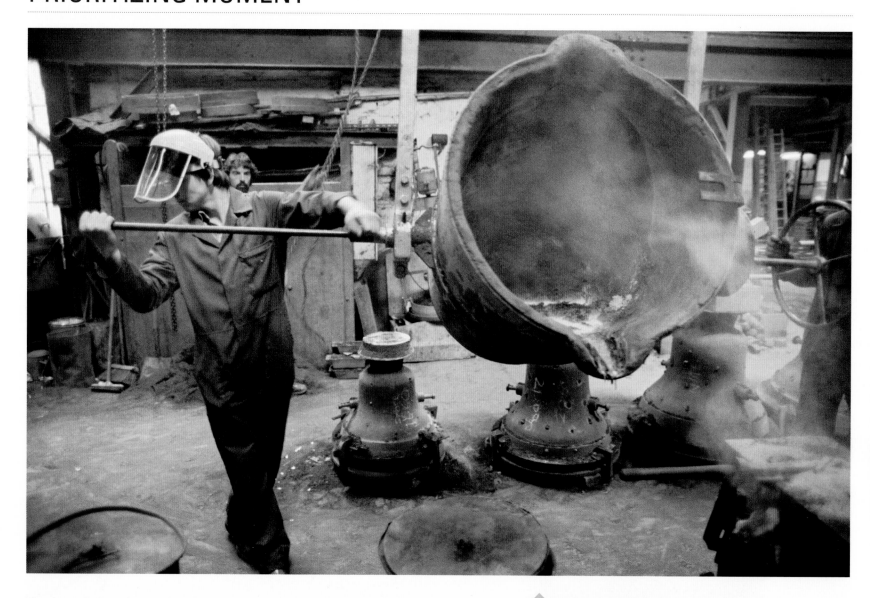

There's very little in photography that doesn't call for a decision about when to shoot. It might not always seem to matter that much, and there may be other pressing concerns, like the framing or lighting, but a photograph is always of one moment, whether we care or not. Photographers who work mainly with things that happen quickly, such as in reportage, wildlife, or sports, are particularly inclined to think about moment, but it applies to most subjects. If you haven't made a

habit of putting timing at the top of your list when you're shooting, now may be a good time to start.

In fact, I could argue that it's now more important than ever before. First, still photographs now compete more directly with video than they ever did before, as both can come from the same camera with little more to do than choose between two release buttons. Yet, the two kinds of imagery, even though made with the same equipment, could hardly be more different. Video records the full

Whitechapel Bell Foundry

More than one thing often happens in any moment you care to put a label to. At the London foundry that cast both Big Ben and Philadelphia's Liberty Bell, the moment of pouring the molten metal is clearly key, but of course also predictable. Less obvious, but more important for the appeal of the image, is the almost balletic posture of the foundryman, turning his face away from the intense heat.

Key Points
Being decisive
Need for better
Always a choice

Coachman, Lord Mayor's Show, London

Moments can also be inactive. In most shots that concentrate on a face, photographers generally look for expression, meaning a show of feeling or thought. Here, a coachman attending the Lord Mayor of London's carriage, waiting for the procession to begin, has a reflective moment.

flow of events, and if you want to isolate a moment, you need to edit it. A still image records your on-the-spot decision of what the moment was, and there's no going back on that choice. This tends to point up the difference quite sharply.

Second, with the numbers of photographs and photographers increasing exponentially, what makes the good pictures stand out? With maybe a trillion images being shot this year, this is a timely question. There are many ingredients that can potentially go into making a good photograph, but the moment is nearly always unique. Very few scenes in life are ever repeated exactly, and for people and their behavior, never. Finding the "good" moment is what this book is all about, and it takes thought, practice, and your own judgment. There is no robotic formula for timing a shot that you, and others, can then look at and feel that you caught something special, something that will never be repeated exactly. It takes skill and imagination, and at the end of it, there will still be disagreement. All of the examples in this book involve choosing between one and the next moment, and I show them. Sometimes the choice seems obvious, at others uncertain. The idea that I'm encouraging here is to hone your judgment on the matter of timing, to make it a priority when you shoot. The more you do this, the more easily the decisions on moment will come. ∎

Pemon boy, Canaima, Venezuela

Playing in the shallows of a lake in the Guiana Highlands of Venezuela, a young boy kicks out exuberantly. This is classic moment-of-action, capturing both the peak of the kick and the backlit spurt of water.

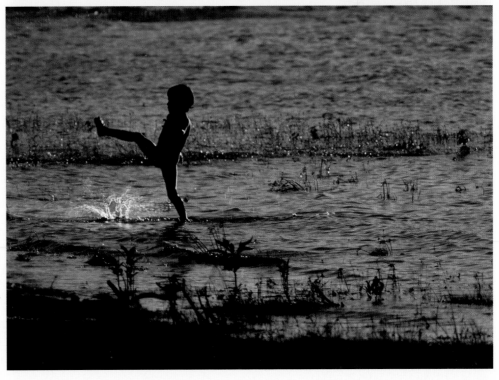

THE VIDEO-CLIP APPROACH

There's a phrase that's been doing the rounds recently, unattributed (as far as I can tell), that goes: "At some point photographers will just shoot video and pull the best frames out." It's the kind of thought that thrills equipment-focused photographers with the promise of better resolution, more choice, and more stuff in general. It's certainly true that at the higher end of the digital-video industry, with 4K and 5K cameras (a resolution of 4,000 and 5,000 lines along the horizontal axis), the output quality now matches top DSLRs. This currently plays more to the filmmaker than to the still photographer, because it's a way of saying that wonderfully high definition—i.e., still-photography definition—is available and affordable (just about) to independents. And the way technology and cost in the imaging industry goes, performance will improve and its cost will reduce. This capability is coming to a camera near you very soon.

But does anyone take the idea seriously that you could do away with taking single images, shoot a video clip instead, and just scrub through it until you found the moment you like? Apparently, yes. In one published video, prominent American studio-portrait photographer Peter Hurley compared shooting a model using his customary Hasselblad with a Red Epic—a 5K video camera. The experiment was tilted toward image quality (result: no discernible difference), but it also introduced a necessarily very different way of working. Published on fstoppers.com, it's a well-chosen shooting situation, because not all action has to be at the velocity of Olympic sports. Expression and pose in a portrait session also operate in fractions of a second. The implication of shooting and then pulling frames is that you could treat an active shooting situation not as an occasion for concentrating and thinking about exact moments and the fine difference between

one millisecond and another, but rather for framing and recording a continuous sequence which you later examine to retrieve the shot. Now that is quite a big shift, from making decisions in real time to decisions in the less-urgent surroundings of an editing suite—or in front of your laptop.

It's interesting to see in this video that the photographer's working method does not actually change much, due to the studio setting and his style of working, which is very much engaged with drawing out performance and expression from his subjects. What happens, though, is that instead of a hundred or so frames all intentionally shot with a still camera, he is faced with 7,000 possibilities, and the large majority of them are non-starters—just getting the model into a position and an expression. It's a huge number to go through with any attempt at concentration, and simply impractical.

This, however, will not stop a number of photographers, perhaps even a large number, from doing this when it becomes feasible, and the reason is that it just seems easier—in theory. The problem with editing of any kind, however, is precisely that it can be done at length and at leisure (unless you're a professional picture editor or video editor with an insane deadline). This means that, as it's accessible to anyone, it can be done well or badly, conscientiously or lazily. All the urgent on-the-spot decisions are behind you. Of course, editing is supremely important, but loading it with all the responsibility of choosing the moment is a little like not bothering with the exposure settings and saying "we'll fix it in Photoshop or Lightroom."

Fascinating though the idea may be, I mean it as an introduction to a way of capturing the moment that is already with us. It's an older and deep-seated idea in photography that potential images sit within sequences of action that you can

think of as set pieces. Think, if you will, of a situation in front of the camera as a block of activity with a finite beginning and end. It could be something you have organized, like a portrait session, or something as uncontrollable as a little piece of street theatre—say, two people talking or a musician playing on a street corner, or anything. You as the photographer define this block of action simply by your decision that from this viewpoint and with this framing there is something going on in front of you that makes sense as a photograph—or rather will do if it all happens right.

It's a way of thinking that you can apply pretty much across the board. Yes, there are photographs that are plainly not much driven by time, such as some still-life images, but I suspect that these are very much in the minority. Even a landscape has a timeline, as changing light brings a sense of moment to even the most static scene. And if you are paying full attention to even the slowest-moving subject with the least things happening, what small changes do occur actually become magnified in importance. Many photographs have their success topped off by attention to detail.

The value of this approach is to consciously see shooting opportunities as blocks of time containing possible images, of which one will be the best for you. I wonder if it's too fanciful to compare this thought with the famous idea of Michelangelo that blocks of stone contain sculptures that need only to be released: "In every block of marble I see a statue as plain as though it stood before me, shaped and perfect in attitude and action. I have only to hew away the rough walls that imprison the lovely apparition to reveal it to the other eyes as mine see it." Well, maybe it's grandiose to put it in the same terms, but the idea holds true. The modern equivalent of the block of stone is the imaginary video clip of the action in front of you. ∎

Key Points
Still vs. video
A block of time
Slicing the block

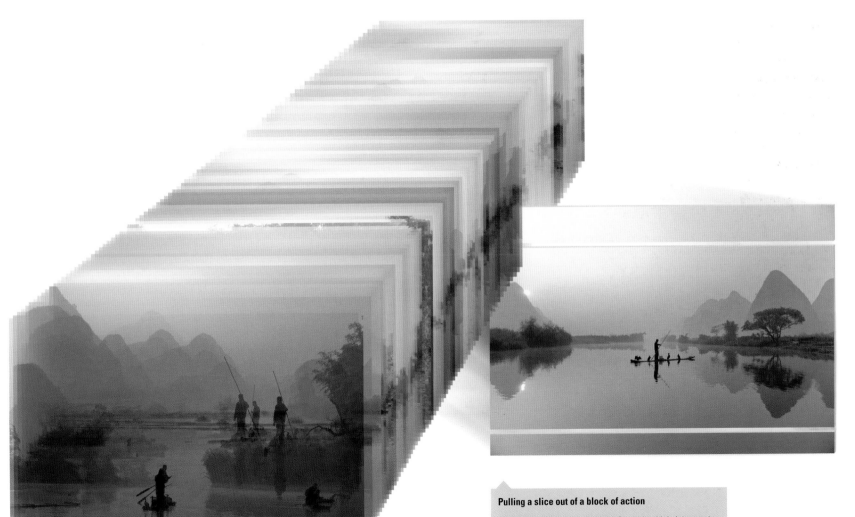

Pulling a slice out of a block of action

A shot that graced the cover of *Capturing Light* (changed for some foreign editions), this was essentially a chosen moment from a self-contained hour and a quarter of drifting down a river photographing this cormorant fisherman, resulting in more than 80 frames. From the start, it was likely that only one image—maybe two at best—would ever be used, but concentrating on a single, slowly changing opportunity like this encourages a lot of shooting. In concept, the take represented a continuous flow of action containing many still images, of which just one would finally be chosen as the best.

URGENCY, PRECISION, SPEED

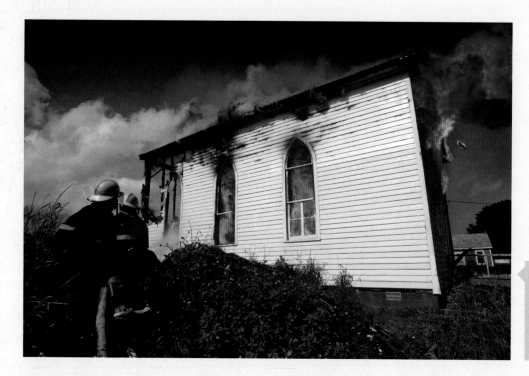

If we start to dig into the qualities of moment, at least in terms of capturing it, it seems to me these qualities exist as a triad, and their relative importance varies from picture to picture. They may not be immediately obvious unless you consciously think about them each time, but knowing them can make a difference to your camerawork. The danger is that consciously thinking about them as you shoot can slow you down more than it can help, so it's not a bad idea to practice in situations that give you plenty of time until they become second nature. This applies most of all to the first—urgency. Between seeing a possible shot and taking it, how much time do you have? Put another way: Is it about to disappear, or do you have at least a few seconds to collect your thoughts and make sure all the camera settings are right? It's something that ought to cross every photographer's mind, even if it crosses very

rapidly, because you need to use that reaction time wisely. Urgent situations tend to separate professionals, or at least the experienced, from beginners, and missing a shot entirely because you didn't react quickly enough is a bad experience. As Cartier-Bresson put it, "When it's too late, then you know with a terrible clarity exactly where you failed; and at this point you often recall the telltale feeling you had while you were actually making the pictures," and also, " We photographers deal in things that are continually vanishing, and when they have vanished, there is no contrivance on earth that can make them come back again."

Street photography, for one, is usually full of urgency, and a day out hunting for shots is demanding, even if exhilarating. Other situations, like landscape, seem to be, if not exactly devoid of urgency, then at least slower paced. Nevertheless, just because you've been waiting an hour or more

for the sun to get into the right position, it's a mistake to think that you have all the time in the world. This kind of slow moment, which I'll explore toward the end of the book, can lull you into a relaxed pace—and then suddenly you find you have only a few minutes in which to organize and shoot. Dusk shots like those on pages 186–187 are notorious for this: the infamous 10-minute window that my previous book *Capturing Light* goes into in even more detail.

Next comes precision, and this can be in either space or time. It means: How important is it for the success of the shot that you are absolutely accurate? For example, do you need to fit a passing figure exactly in one narrow space in the setting, or is there some leeway? Or, does a real action shot have to be caught at the nanosecond peak, or will a fraction earlier or later be just as good? For example, if you're looking to get the subject more

Key Points

3 qualities of moment
Relative importance
Priorities in practice

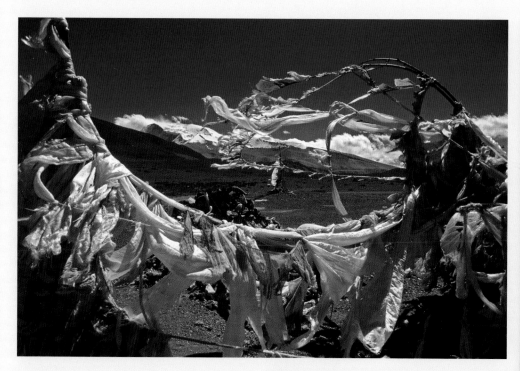

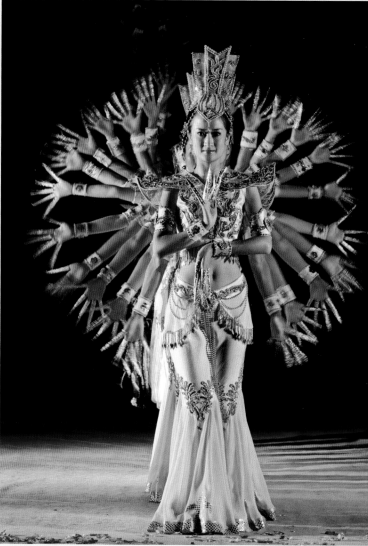

or less filling the frame, perceptually there is quite a bit of room, as in the photograph of the elephant on page 64, so precision is lower than when trying to shoehorn one shape into another that's only slightly bigger, as in the photograph of the falconers on page 90.

Finally, speed. Is whatever is happening in the frame so fast that it either puts pressure on your finger reaction, or needs a higher-than-usual shutter speed? The rapid hand movements of the tea factory worker on page 158 needed a shutter speed of 1/400 second to guarantee sharpness. In the London Bridge shot on page 80, both the cyclist and bus are moving steadily enough to be caught at 1/125 second, but they moved into the frame very fast, with no warning, for the reasons explained about using a very long telephoto. In other words, the importance of speed isn't confined to a fast shutter setting. By contrast, with an

end-of-day sequence lasting almost an hour, speed was the last concern in the shots of Mount Popa on pages 184–187.

Although I've never seen it done like this, the idea of rating shots on these three qualities seems useful to me, because if you can think quickly and clearly about what the shot needs, you won't waste time on what's less important. There are some surprises in the examples that follow. ■

Speed

High on the Tibetan plateau, prayer flags flap wildly in the wind, their image moving rapidly across the frame. Speed is clearly the key quality here, not just to freeze the moving shreds of cloth, but also to have the whole line of them in a specific position.

Precision

This is the famous 1000-hand dance from China, in which a line of performers stand facing the audience and coordinate their hand and arm movements (the origin is Buddhist, representing the multi-armed bodhisattva). Here, the moment depends entirely on precision of timing, in order to capture the arms in a particular combination.

THREE STYLES OF CAMERAWORK

In the kind of photography that works on timelines, there are basically three different strategies for catching the moment. These are divided as much by personality as by task. I call them Fireman, Builder, and Marksman. Why personality and task? Because these three working methods each definitely appeal to different personalities, but at the same time the circumstances on the ground also intervene.

The Fireman approach is to shoot as many frames as possible in the space of time available, and the name comes from the expression "hosing," which describes it perfectly. The C for Continuous Drive mode on a camera is made just for this: hosing down the subject, taking no chances on missing anything, and waiting until later to edit the take and choose the best moment from many. The Builder approach also results in a number of images all trying to be The One, but it's incremental, step-by-step. Typically, this is when you think you may have a good moment, but because the situation is still available, you wait for another moment that betters it, and continue like this, hopefully improving one frame at a time— building, in other words, on what you've already shot. The Marksman approach stands well apart from either of these, and involves resisting the temptation to shoot before the moment is right, putting all your energy into making one single shot that nails it precisely. As we'll see over the next few pages, there are justifiable times for using each of these three, but regardless of practicality, one or the other will still suit different photographers' styles.

Fireman

The Fireman approach means hosing down the scene at however rapid a rate the camera will manage. The argument is that a high-performance camera can shoot at, say ten frames per second, so why not leave the timing to it entirely. You'll end up with maybe a few dozen very closely spaced images—plenty to choose from. It guarantees a result and so, the argument goes, it is actually a more responsible and professional way of shooting. We're a step away here from shooting full-frame video and simply cherry picking the best frames later, so it's worth thinking about the implications. I realize that all this carries some criticism of hosing, but essentially it's about deferment— deferring first to the camera for releasing the shutter, and second to the editing process, leaving your decision on the best moment until later. In terms of personality, the Fireman takes a kind of pride (perverse, some might say) in overkill, and by no means is it the child of digital photography. In the days of film, shooting a hundred rolls was not insignificant, but it happened quite frequently on assignments. I often came across the attitude that the client could afford it and, by association, the photographer was therefore worth it. It was a way of boasting, and maybe still is.

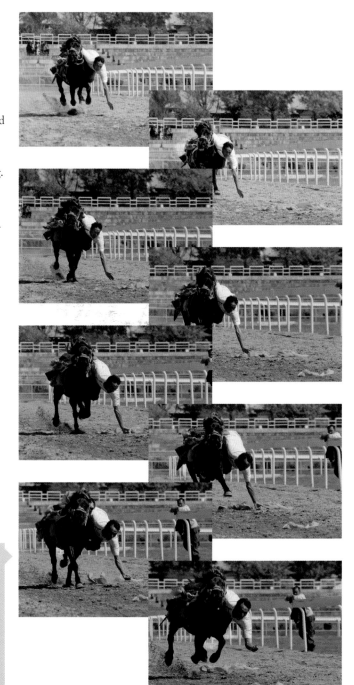

Fast-approaching horses

A basic Fireman operation—camera on Continuous Drive, capturing as many images as possible in the time span. Here, two bursts, with the zoom control on a 70–200mm lens being racked slightly to keep the approaching horses in frame. Technicals: AF-C (the continuous autofocus setting), ISO 200, 1/1000 second at ƒ/8. Strong midday lighting did no favors for the image, but at least allowed a safely high shutter speed, reasonable depth of field for one horse, and low noise from a low ISO setting.

Key Points
Safety in numbers
Personality affects
Shifts decision later

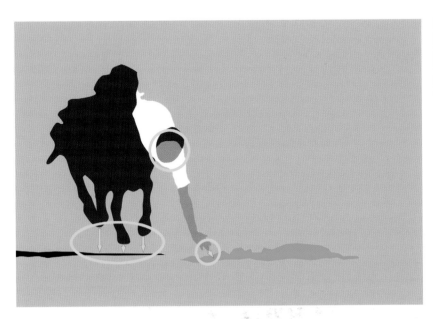

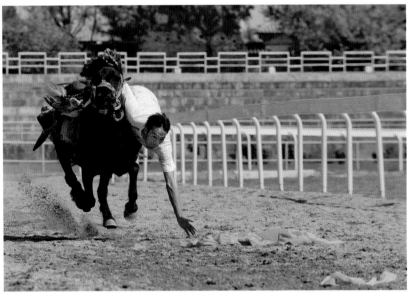

Anatomy of movement

The rapid sequence at ten frames per second dissects the horse's gallop in a way reminiscent of the very first use of a camera to analyze movement, by Eadweard Muybridge in 1878.

Best moment from a sequence

The most special moment, certainly hoped for from this continuous sequence, was when all four legs were off the ground, with the man just reaching for the green cloth.

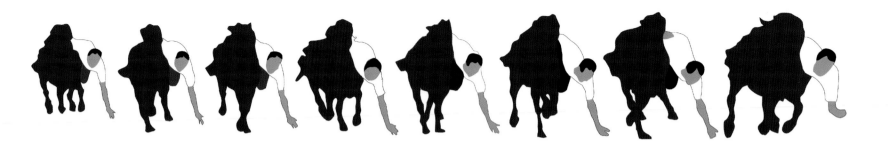

THREE STYLES OF CAMERAWORK (continued)

The arguments against Fireman are: first, it's inelegant; second, it fails to concentrate on anticipation, decision, and fast reactions; third, it's suspiciously indecisive; fourth, it runs very practical risk of actually losing the crucial moment because the firing rate is automatic. This last needs a little explanation. Let's say that the shutter is firing at ten frames per second, and the movement is standard, such as a person walking normally, so you have the shutter speed set at 1/100 second. That means that the camera fires only 10% of the time, and you have no control over when. What would you lose? That depends partly on how finicky you are about the exact position of the figure and its limbs.

As you can tell, I'm not a great enthusiast for this approach, but that's my personality. And yet, I sometimes do this myself, so what—personality apart—are the practical arguments for being a Fireman? The prime situation is a burst of very fast action, as in many athletic events or a key wildlife moment (such as a predator leaping). With someone walking, as above, you ought to be able to time the shot more precisely yourself than the camera's continuous burst can, but with action this fast, it's a lot less likely. It may be faster than you can see with any certainty, so a burst of continuous may even be revelatory. Nevertheless, consider that if you've upped the shutter speed to, say, 1/500 second because you're tracking a galloping horse, that ten frames per second means that the shutter will fire only 2% of the time. If you were looking for a shot with all four legs off the ground, it's not guaranteed. It's also important to know the capacity of the camera's frame buffer—how many frames you can shoot on a single burst. If the sequence of action lasts longer than the frame buffer can hold, you'll lose the end of the sequence.

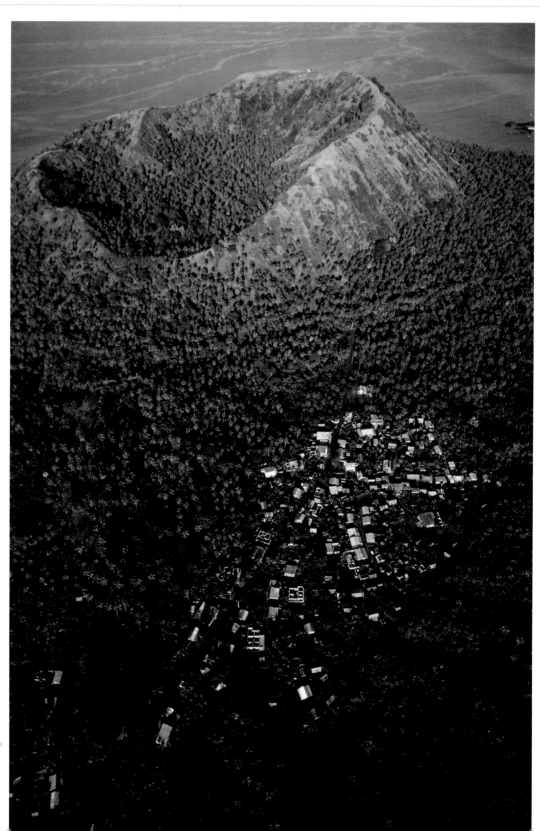

Old volcano, Mouandzaza Ambouani, Comoros Islands

Key Points
Super-fast action
Insurance
Many good moments

Comoros aerials

Aerial photography is one genre that encourages heavy shooting, prompted by the cost and organizational effort needed to get in the air at the right time and in the right place. Helicopters are best, but always expensive. Once in the air over a good target, there are no good reasons not to keep shooting as the aircraft moves around the subject. This is an old volcanic cone in the Comoros Islands in the Indian Ocean, and I had for one hour a Gendarmerie Nationale helicopter on loan. Shown here are nine out of several dozen frames shot with a wide-angle lens (20mm) covering a roughly 90-degree arc of a full circle. The helicopter made three similar circuits, and this is typical when you have an obvious large feature. The pilot circles counterclockwise at a distance that gives the framing you want (in a small helicopter, the shooting position is usually the left-front seat, with the window open), but only some of the 360-degree circuit is normally useful.

A second argument in favor is insurance against error, either yours or the equipment's. The possibility of focus error alone makes this worth considering, and a top-level camera has, by default, the capacity to follow focus as the subject onto which it has locked approaches. In a situation like the horse race shown on the previous page, it can actually be safer to leave the focus to the camera in Continuous mode than to run the risk of the focus system searching for a subject when the shutter is half-pressed. With a long lens, this can be disastrous and waste a few seconds—there is a lot of glass for the servomotors to move around. Insuring against loss of focus was exactly the reason for leaving everything to Continuous in that case.

And yet another argument in favor is that many shots in a sequence may be equally good, but subtly different, and all worth having. This is the reasoning behind the sequence shown here. It was a case of having no reason not to, prompted by the rare opportunity of having a helicopter in the first place.

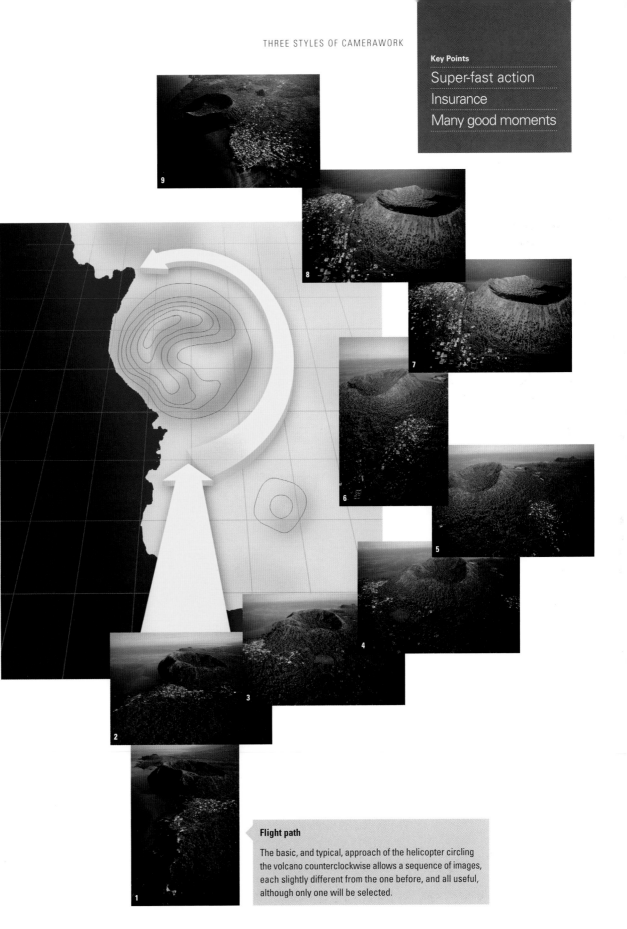

Flight path

The basic, and typical, approach of the helicopter circling the volcano counterclockwise allows a sequence of images, each slightly different from the one before, and all useful, although only one will be selected.

THREE STYLES OF CAMERAWORK (continued)

Builder

Second in our competing styles of camerawork is the Builder approach, which at first glance of a typical shoot seems suspiciously similar to the Fireman hosing-down approach. There are indeed some similarities, but here the shooting speed is slower and more care is usually being taken with concern for the timing for each frame. In fact, there is much more to say about a "building" sequence than about either of the other two styles, because the photographer is making a constant stream of micro-decisions.

The reason for this, and the ethos of this kind of shooting, is to try and improve on a competent shot, incrementally. It's particularly suited to slow- and medium-paced action, or at least to situations which afford some time within them to keep on shooting—such as two people in conversation, for example. Or perhaps following a tea picker in Assam and learning the rhythm of her actions so as to find the shot that contains the peak, which is the moment of the leaves being thrown in to the basket on her back. The Builder idea is to stay with the situation for as long as you think there is a chance of an even better moment. This could be a gesture, a stance, and expression, and even if the improvement is small, there's a case for staying with it and paying attention. Another way of thinking about this is as an improvement curve. It is very likely to obey the law of diminishing returns, and at some point you'll need to review and assess what you have already, and whether you'd be spending your time better moving on to something else.

In the example here, on a cattle ranch in Bolívar, Colombia, I was accompanying two vets preparing to artificially inseminate cattle, and the first step was an examination. Simply because of the viewpoints available, this was the main shot. The light was good, there was plenty going on. It called for a wide-angle

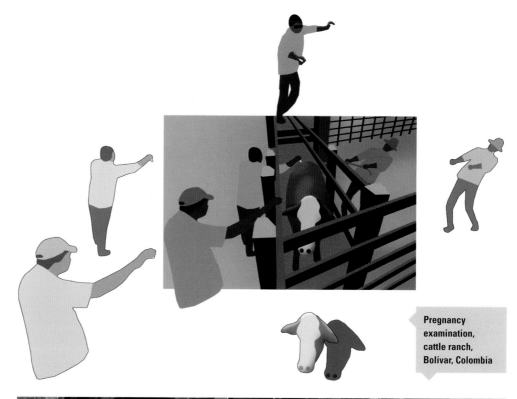

Pregnancy
examination,
cattle ranch,
Bolívar, Colombia

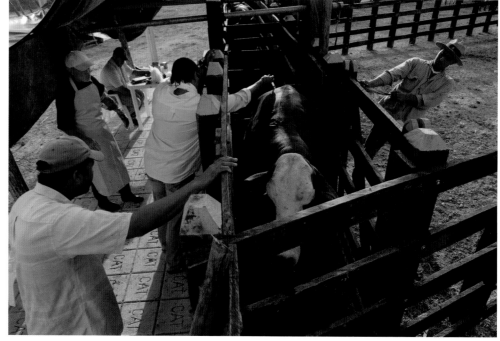

1

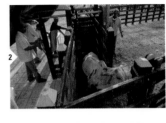
2

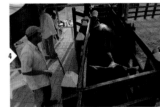
3

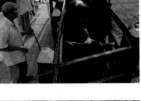
4

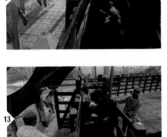
5

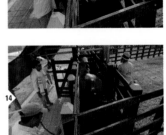
6

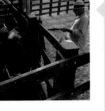
7

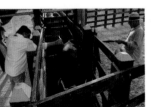
8

9

10

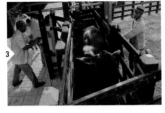
11

12

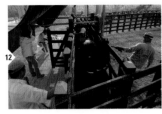

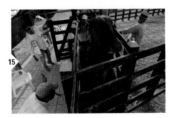
7

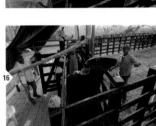

13

14

15

16

A day with a cattle vet

Here's a situation where the framing of the shot quickly worked itself out. Over a hundred cattle were being examined by a vet for pregnancy. The first shot was adequate, but I needed to stay with the situation to refine it. Details of action, multiple actions, posture, and readability all offered possibilities of improvement. Building sequences usually end at the best shot or shortly after, but here, for the reasons mentioned, I stayed with the situation longer than I normally would.

view, and somewhere around 24mm seemed right. Given that, it was the variations from moment to moment that counted, and with 127 cattle passing through one at a time, each occasion promised a slight improvement on the previous. This first batch of 38 cattle took an hour and a half to process. Other factors can also play a part. In this case, there was absolutely nothing else to do for the morning, and no other potential picture competing for attention, so there was no reason not to stay in case of any slight improvement. In the end, quality of the sunlight brought the shooting slowly to an end, but by then I had shot 109 frames, more than usual for a single final image.

In terms of personality, most Builders tend to be conscientious and dedicated to the idea of improvement. In other words, there's a picture situation in front of the camera, and they're doggedly determined to get the best out of it. There may, however, be another personality trait involved—indecision. That may sound unfair, but situations that allow you to keep on shooting can also lessen the urgency to make your mind up, shoot, and move on. There's a tendency to think "well, it's all still in front of me, so just one more." There's nothing necessarily wrong with this, but there's a surprisingly fine line between taking small critical decisions at full concentration, and lazily continuing to shoot. Looking at it from the point of view of the task at hand, instead of personality, building is usually a good idea if you have the time, provided that you use it in a focused way. Quite often, the main decision is balancing the improvement you may be making to the shot in front of you, and the possibility of other, different pictures still waiting. It boils down to prioritizing. The next photo opportunity may be a short walk away, and the field may be greener. There is usually a nagging feeling that maybe you should give up and move on.

THREE STYLES OF CAMERAWORK (continued)

There was only one practical viewpoint that showed everything—perched on a fence and looking down the line of cattle wedged tightly in the pen. Given the positions that people took up around the nearest holding pen, the framing settled in naturally to this horizontal view, at between 24mm and 28mm. It soon became clear that I was looking for the best combination of the following four separate moments: head of the cow being examined up and recognizable; either the vet and his arm clearly visible, or the moment of the injection with the syringe sunlit; cowhand at right pulling on the tail to hold the animal in position; if anyone at left, they should be reasonably clear. A fresh cow entered the pen every two or three minutes, so there were plenty of variables. When the positions of people allowed it, I also framed a few shots vertically.

All of the shots were acceptable, and in the final edit, twelve were identified as being better than average, of which seven were considerably better, judged on the combination of best separate moments. Then there was a different set of moments, not showing the typical process, but striking because a few of the cows tried to jump the fence. There were six selected from these, judged on the position of the animal and on sharpness (the first few of these had motion blur because I had not expected this much faster movement and was using a slower shutter speed of around 1/125 second to allow more depth of field from a smaller aperture).

Marksman

The Marksman approach is the one that, on the whole, carries the most cachet among photographers. Partly this is because it's tied up with the intensely physical, sports-like ideal of the perfect shot—the ability to get something that's difficult and challenging just right. This is universally admired across the board concerning all kinds of action. Partly it's also because of the legacy of perfectly caught moments by the pantheon of great photographers, including Jacques-Henri Lartigue, Henri Cartier-Bresson, Martin Munkácsi (whose excellently timed shot of young African boys running into the surf was the confessed inspiration for Cartier-Bresson taking up photography), and Robert Capa, among others. It's hard to argue with this kind of single-shot excellence, as it's built into our culture. It is also inescapably difficult, demanding not only experience in how life in front of the camera is likely to shape up, but a talent that may, rather unfortunately, be partly innate. It's not unreasonable to think of photography as a competitive sport, and seen like this neither is it surprising that native talent plays an important part, however much we would all like to think that we have what it takes. Cartier-Bresson, incidentally, made a direct analogy between his style of street photography and hunting, in which he also indulged early in his life. He wrote that after he returned to Paris from Africa, where he had hunted, and where he discovered photography, "I prowled the streets all day...ready to pounce and to 'trap' life."

We should also not underestimate the part that shooting film used to play in this. Film was a finite commodity. It cost money, processing cost more money, and even if someone else were paying (more on this shortly), you still had to pack it, carry it, load it, and look after it. Film had the potential to be squandered, and so most photographers didn't let it. That no longer matters with digital shooting, but the cultural legacy lingers on. In terms of personality, the Marksman approach is purist, craftsman-like, and driven not a little by pride. As a way of completing the task, it is undoubtedly elegant and worth striving for, though some (the Firemen and Builders) would argue that it doesn't take advantage of newer technology, such as continuous-shutter operation, large frame buffers, and costless recording. Guaranteeing the result is quintessentially professional, of course, but the whatever-it-takes argument ignores the effect of training yourself to become better at recognizing and capturing the single moment. Nailing it in one shot ought to be everyone's ideal.

In this shot, taken in a traditional broom factory in north-central Thailand, I was fruitlessly trying to get something interesting out of a pile of these distinctive brooms. Out of the corner of my eye, I caught the movement of a girl carrying an armful from a shed to my right. I sensed also that she was shy about being photographed, which was why she moved quietly behind me. I had no time even to frame, just to swing round and hope for the best. As I'd been shooting a static scene, the shutter speed was not particularly fast—about 1/60 second—but this actually helped the panned shot by introducing some motion blur, which separates the girl nicely from the background. Basically, a lot of luck. ■

Girl with Thai brooms, Lap Lae, Thailand

Marksman—single shot, no build-up, no working around the subject. The opportunity presents itself, and you shoot.

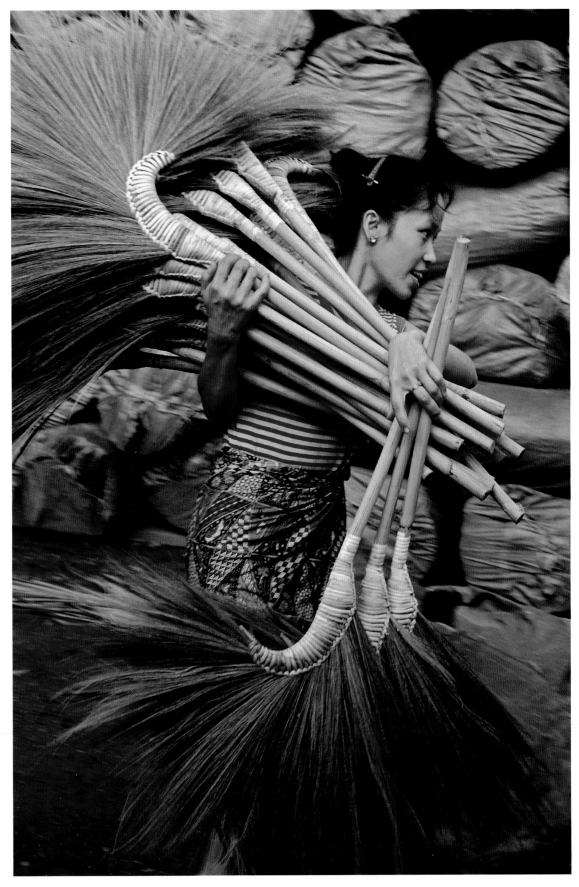

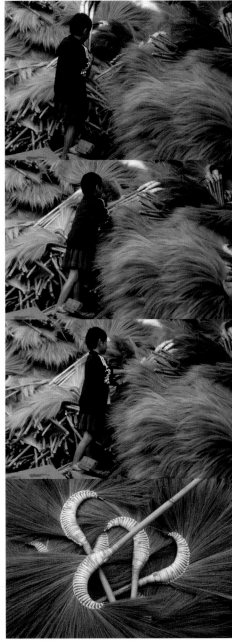

The unlucky shots

The contact sheet for this kind of snatched image is always disappointingly empty of information. There's no build up, just a disjointed image inserted among others.

POSTURE

It shouldn't come as much of a surprise that, as most of the subjects in this book are things that move, there are a lot of pictures of people. And people move in particular ways, so it's worth taking a considered look at how, and in particular how these movements look to the camera. In any case, people are the most photographed of all subjects, and the choice of when to shoot is not only enormous, but it matters. Few photographers remain cold or detached when they're capturing a person, because we all have emotional ideas about how we want that person to look. Attractive, if they're a friend or family. The same if you're being paid to make them look as they wish to appear. Or perhaps energetic, if they're involved in some physical activity that's part of the purpose of shooting. Or even silly and awkward, if you're a news photographer with a mission to criticize a public figure. The list is endless, and underlines the fact that it's almost impossible to be detached from emotional judgment when looking at people intently. And as photographers, we look at our subjects more intently than do most.

Human movement, inasmuch as it matters for the camera, breaks down into three scales—the entire body, the arms and shoulders, and the face. Here, I'm calling them posture (for the body), then gesture, and expression. Sometimes, though not always, they combine, as in the grimace of effort of a weight lifter, but still, generally, one of the three takes precedence for a shot. First, then, the whole body, whether standing, crouching, sitting, walking, running, or even launching into the air. There isn't a perfect word for this that takes in all of these, and posture carries some suggestion of being still and deliberate ("you there at the back of the class, Freeman, sit up straight!"), which it shouldn't. Still, the common idea of "correct" posture gives us some insight into the innate importance we attach to the stance, attitude, and bearing, whatever you want to

call it. Most people have some opinion about the way people hold themselves, and this opinion generally spreads out on the lines of being either right, correct, elegant, or else careless, ungainly, clumsy, even dispirited.

I'm stressing this social view of posture for a particular reason. If you are photographing a whole body, and it moves (few people hold perfectly still except a well-discipline soldier on parade, or one of those street performers who specialize in looking like statues), then like everything else there will be one position that looks better to you than the others. The decision, if you have a free hand with no other factors getting in the way, is likely to be for one of two reasons—occasionally both together. One is how well the posture conveys the action or situation, convincingly or otherwise. The other is how elegant or awkward it looks. Most of the time, most of us go for convincing and elegant, but quirky and clumsy can also get attention in the right sort of image. ■

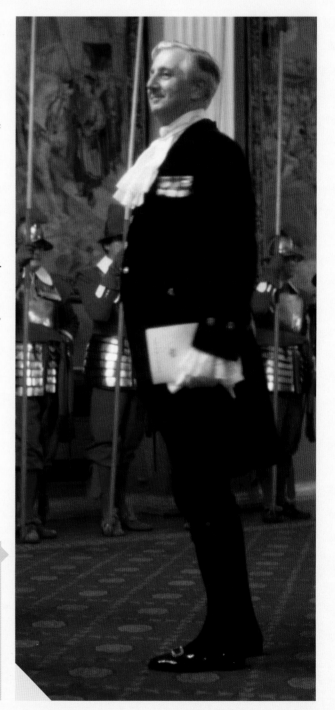

A range of posture

Body positions cover a huge range, sometimes with built-in gesture. All the ones here have some special quality of moment that qualified them to be worth shooting. The color coding of small corner triangles identifies the main reason for choosing this moment:

Green: typical, descriptive, explanatory

Pink: elegant, poised

Orange: unusual, characterful

Key Points
People as subject
Whole-body view
Social view

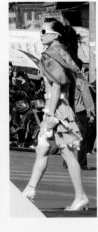

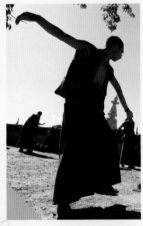
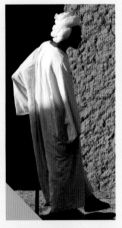
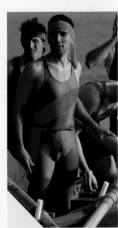

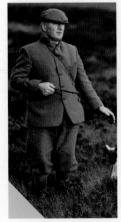

GESTURE

I'm not completely sure how meaningful it is to separate posture from gesture, because they are often combined—think of someone turning to point at something in the distance, and even more so, think of a ballet dancer using both posture and gesture deliberately to maximum effect. They do, however, have one important difference between them. Gesture is always intended to convey some meaning, while stance as we just saw is usually simply a part of some action, and usually not given much thought.

Gesture can be deliberate, as in pointing, or it can be involuntary, as a shrug often is, but because we're attuned to it, we always search for meaning. There is yet another distinction, between the practical and the personal. In manual labor, for example, the movements involved in lifting, turning, opening, manipulating, or whatever, are all gestures from the photographer's point of view, but they are essentially practical. They may involve exertion, and that itself communicates well in an image, but they don't normally have anything to do with personality. Other gestures, however, such as reaching out to take someone's hand, or shaking a fist, are meant to reveal emotion and intention. They are a physical clue to what's going on inside someone's head, and that, of course, makes them perfect and fascinating material for a photograph.

As with posture and expression, in any one situation you're likely to find a particular moment of a gesture more interesting or visually attractive than another. It can be because of elegance, in the same way as posture. It can be because it gives a clearer view of what is going on and helps to explain, or it even can be the opposite, surprising and puzzling an onlooker who isn't quite sure what the context is. But what all moments of gesture have in common, and what makes them generally desirable in a photograph, is that they bring life

and avoid the static. This doesn't mean to say that good photographs always avoid the static, because expressionless, deadpan imagery celebrates a very different style of looking, as in typologies (what I call inventory photographs). By definition, however, this kind of photography isn't much concerned with moment. ∎

A range of gesture

Gestures tend to be either practical, as part of some activity like work, or personal, as a way of communicating some intention or feeling. As with posture earlier, the color coding of small corner triangles identifies the main reason for choosing this moment:

Blue: practical

Pink: expressing an emotion

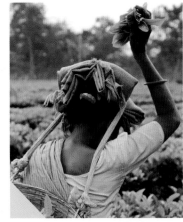

EXPRESSION

The smallest scale of movement and moment in people photography happens in the face (minor body parts are more in the category of still life, and kind of abstracted from the person who owns them). It's interesting that we place a great deal of meaning in facial expression, especially in what we believe other people are thinking and feeling. I say "what we think" intentionally, because most people take an unreasonable amount of pride in their ability to judge people from their expression, and photography buys into this. How often have you heard the expression that the eyes are "the mirror of the soul?" Sounds clever and thoughtful, but really? This basic idea, of capturing the inner self through some rare opening of the eyes into the soul, divides photographers who do this kind of thing. Can you, or can't you? Personally, I'm skeptical, because if it were true, the police, criminologists, and security services would be out of a job. Many people are incredibly good at concealing their interior lives behind their expression. Photographers' egos get in the way, due to pride in what you could call "perfect capture."

Nevertheless, a constant passage of expressions crosses the face, like a weatherscape, and some are going to be more resonant than others. But resonant to whom? Certainly always to you, the photographer. Frankly, what counts in photographing a face is what you think you see through the camera. The choices are made on appearance, and whatever is going on in your subject's mind, no viewer is ever going to know. They will see a moment that you chose, and be influenced by that choice. If there's no caption to contradict the obvious, then the audience will believe the obvious. So, a smile communicates pleasure. Of course, a smile can conceal all kinds of sentiment, but photography deals in, if you'll excuse the obvious expression, face values. ■

A range of expression

Expression is concentrated entirely in the face, and so calls for tighter framing than posture or gesture. In rare case, lighting, composition, or sheer force of the expression can make it work in a longer shot, with the face taking up only a small part of the frame. These examples, however, have all been cropped in close for this spread of images.

Key Points
Revealing thought
Resonance
Face value

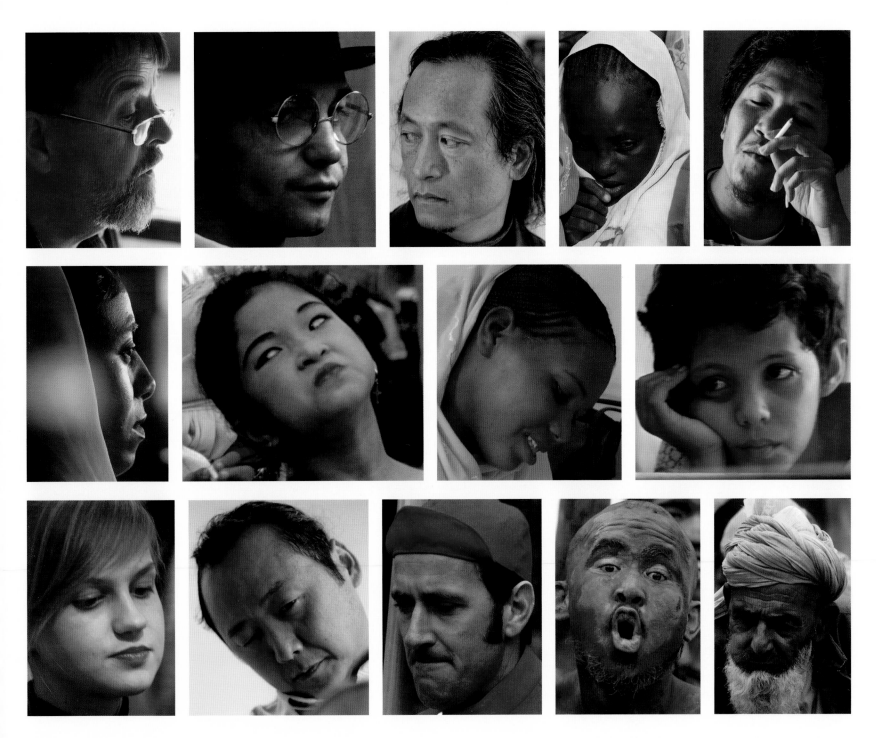

EDITING

With the kind of moment-led images that we're talking about here, it's rare for every single decision taken on the ground, in the middle of shooting, to go through the process, unchanged, until finally being displayed or published. Yes, if you're on top of things, you'll often know which frame is going to be a final select as you take it, but photography is surprisingly full of after-thought, even among photographers who pride themselves in being supremely confident. Contact sheets and outtakes, when made available for others to see, amply support this, even if we're talking about historical masters like Robert Capa, Henri Cartier-Bresson, and W. Eugene Smith, all of whom were known for shooting precisely and with incredible determination.

Decisions

Editing, which I do not mean in the sense of digital processing, is the later, quieter review of a take, and a time to decide without pressure. This doesn't mean that it's necessarily a better time to decide, but it does add another layer of thought before you finally release an image out into the world. In today's oceanic volume of imagery sloshing about on the internet, there's even more need for an image to be fit for purpose. Editing for the best moment is a separate operation that often sits within the overall process of selecting the best. From the point of view of moment, each group of similar images is a self-contained unit, and when this is part of a larger take, it helps to think of the group as a single image. That was, after all, the intention when shooting.

Editing is a part of photography, and I go into it at some length in *The Photographer's Story*. It is, or should be, more than just a practical sorting of pictures, and to do it well means treating it as the final part of an organic process that begins with imagining the picture in the run-up to shooting. Depending on how the shoot goes, it can involve more, or less, time and thought, but it is always directly connected. In *The Photographer's Story*, I feature a blow-by-blow edit of a take from a wet market that is quite heavily concerned with finding a moment. I won't repeat that analysis here, but if you have the book, it would be useful to read through that part again.

What I will repeat, however, is that to get the most out of editing, I suggest treating it as a two-handed process. On the one hand, it's good to re-live the shoot, going back over the reasons why you chose to shoot at each of those particular moments, remembering why you thought each new capture was better, if only slightly. Make a new assessment—do those shooting decisions still hold up? This obviously works better if you do the edit reasonably soon after the shoot, when the exposure and focus choice you made are still fresh in your mind (EXIF data can tell only so much; context is also important to remembering why certain decisions were made, and also determining if they were appropriate or not). On the other hand, in parallel to this, step back and be as objective as possible, as if you were a picture editor. This second way is an aid to being more critical of yourself, which is always a good thing. In each way, what you're looking for is the detailed reasons for shooting at each moment, and the little variables.

Workflow

As in shooting, editing can be highly personal, and there is not one workflow that fits all. What I'm showing here is a kind of template designed to be useful, but also designed to be changed according to preference. I've written about this in other books, particularly in *The Photographer's Story* and *The Digital SLR Handbook*, but it bears repeating, and here I'm looking at the workflow more from the point of choosing moment rather than any other quality. The starting point is the raw take as shot. Within the entire take for one subject or situation, there can be a number of groups, each of which has similar or near-identical images, where the photographer has been trying for a single best moment. At some point early in the editing process, these have to be reviewed individually with the aim of selecting the best moment. It's this particular unit of the editing process that we're interested in here. Depending on the style of shooting—Fireman, Builder, Marksman—there can be anything from a very few frames to a hundred or more.

STEP ONE

Upload the
Raw images
from the
camera's
memory
card to the
computer
hard drive.

STEP TWO

Make a technical check of the images, possibly
deleting outright mistakes (gross over- or under-exposure,
soft focus, camera shake, object obscuring view).
Exercise caution in deleting, as some mistakes can be
salvaged with software if the image is important enough
(e.g. deconvolution software to restore soft
focus up to 20 pixels in diameter).

STEP THREE

Order, number, name and caption the Raw images.

STEP FOUR

Group images that were shot to
achieve a single best moment.

EDITING (continued)

The detailed selection that we went through on the previous pages has to fit into the general editing workflow, which begins with downloading the entire take and going through the general housekeeping. This is the practical, mechanical, and non-creative part that includes filenaming, captioning, and making, if necessary, a strictly technical edit to delete major errors. Once that is out of the way, the take is ready for a more thoughtful review on creative grounds.

STEP SIX

From this first round of basic selects, make a final selection of the best moment in each group.

STEP SEVEN

Add these best moments to the remaining images, and review all together to make a first round of selects.

STEP EIGHT

Refine the selection further.

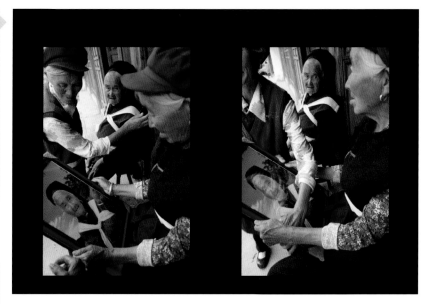

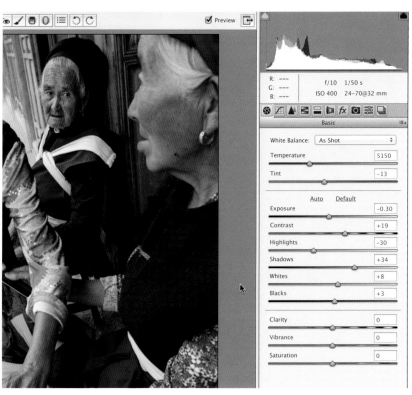

STEP FIVE

In each group, make an initial selection of acceptable images.

STEP NINE

Process the final selects.

STEP TEN

Archive and backup.

The idea of the edit is to select the useable images that will be displayed or published. You can do this in any order you like, but I recommend first grouping the images that were shot in order to arrive at a single best moment. These are mini-edits within the larger edit, and their selects can then go forward to the round of an overall selection (I'm assuming here that the overall take covers a wider range of subjects and viewpoints). This separates the two kinds of editing. Even if you spent time and dozens of images working toward one best moment, that alone does not mean it has a better chance of surviving the final edit than a single shot. ■

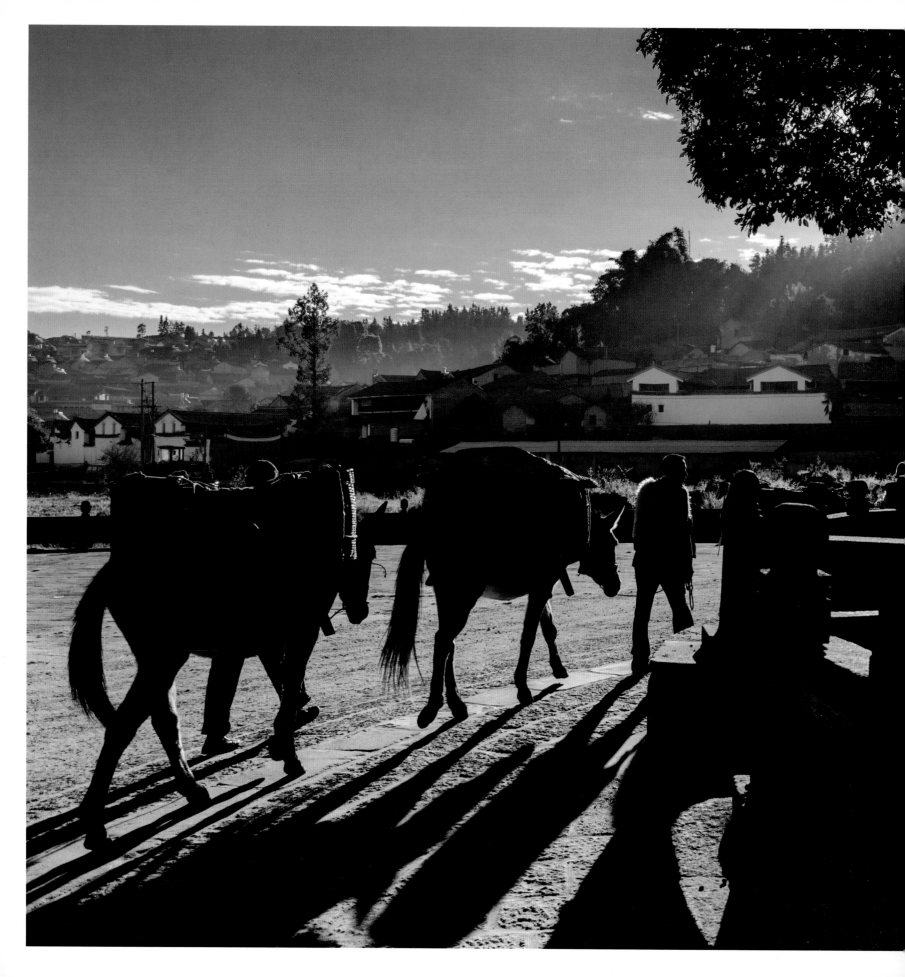

IN-CAMERA 2 MOMENTS

This may not be the expected way of dividing kinds of moment, but it is the practical one. In making three sections—In-camera, Fast, and Slow Moments—I'm simply continuing what I did in my last book, *Capturing Light*. Which is to say, organizing it according to the way I, at least, actually shoot. First comes the kind of moment that exists in the viewfinder or screen, and not necessarily in the un-reconstructed world—in fact, often not in the real world at all. Give me a moment to explain. There's the thing that happens, and then there's what we see happening, and it's the second that makes a photograph. Here's an example of a bad moment. You're on one side of a street photographing something—let's say a couple about to kiss—on the opposite side. As you shoot, a passerby inconveniently walks in front of you, and you end up with a blurred shape hiding the very moment you intended to capture. Tough luck, but that bad moment happened only to you and your camera, not for anyone else. The couple still kissed, and then walked on, oblivious. But you missed it.

Or, you're driving along a winding country road, and as you round one bend, you see ahead the most glorious tree in bloom, full of startlingly red flowers at their peak. In fact, three trees all together, nicely spaced. There's a landscape shot here, at least. But then you also see a woman in front, walking away from you, about to pass these trees and their flower-heavy branches dripping to the ground. This is obviously more than just a landscape; it's a moment, if you get it right and catch the figure of the woman in one of the empty spaces between the masses of flowers. But only from where you are looking. From anywhere else the moment doesn't exist. It happened only in the camera, not in the wider world. You can see it on the next page.

Am I laboring the point? Possibly, but if so, it's for a deliberate reason, because when moments exist only in-camera, there are different practical things you can do to manage them than if they were simply there for everyone to see. This has a lot to do with your exact viewpoint, with framing, the lens, and above all with the graphics of the shot. In the photograph of the African hunting dogs on pages 44–47, what makes the one image work better than the others is the alignment of the camera and the several dogs. The snout of our open-mouthed hero dog is crucially not quite touching the others. Of course, it's not touching them at all, but graphically we feel that it may.

SLOTTING IN PLACE Flame Tree

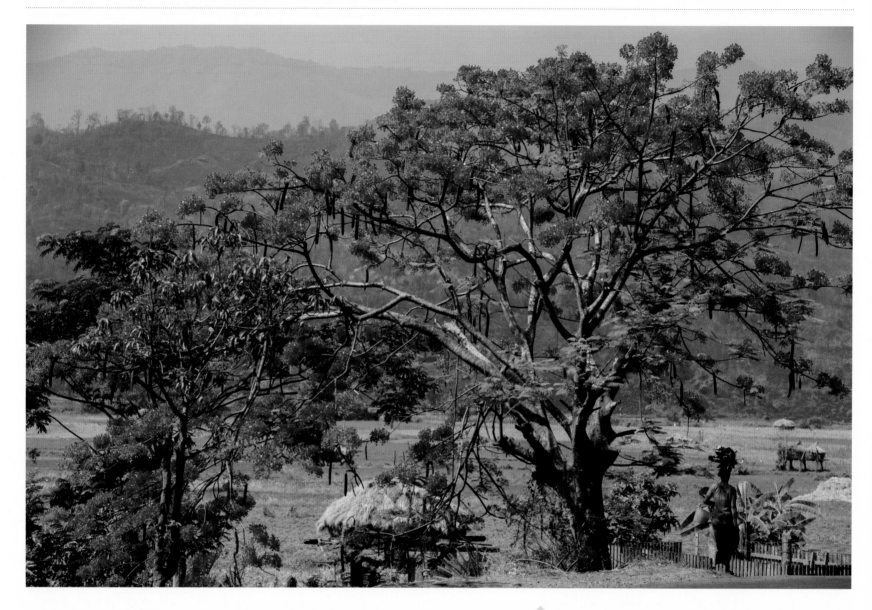

I tried to find a typical moment-of-capture to begin with. An image that would set the scene for the many variations to come, and would introduce the usual decisions and techniques in getting just that exact instant when things work in the frame. Not surprisingly, the more I looked into the details of each case, the more specific each was. I have to step back slightly to find situations that have parallels with others and which show a type of

moment. This, in Myanmar, is one such moment, broadly typical of many, and yet entirely its own particular set of circumstances. One of the valuable lessons I hope the many examples in this book will give is that each case is unique, and the moment you hope to extract from it is unique also.

This one fits into the category that I call, just for my own use, slotting in place. It boils down in the final seconds to having a setting that I like and a

Flame tree, Magwe Division, Myanmar

smallish subject that I want to fit into it, like completing a jigsaw. This is all entirely in my mind and in the camera's viewfinder. It doesn't exist outside that very limited frame of reference, and that means that if I get it right, it becomes purely my image. That's the general ambition, anyway.

Key Points
Probable sequence
Following subject
Switching format

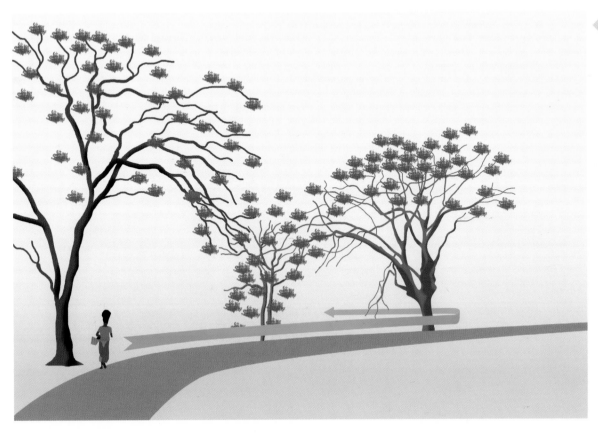

The trajectory

The situation at the start, with the woman's likely route—which turned out as expected.

This was Myanmar in the hot season. Stunningly hot and energy-sapping, but as my 4WD rounded a bend in the generally unvisited Magwe Division, we saw one of the few good things about the summer: a flame tree in full bloom. In fact, three flame trees all together and overlapping. And no, the color has not been digitally tweaked in processing. In itself this was a passably interesting landscape, but a woman was walking down the road in front of us, and this made it a different and much more worthwhile proposition. The sun was fairly high and part of me would have preferred richer lighting, but I have what I have, and anyway, it looks hotter like this (and it is!). Having jumped out of the vehicle and walked quickly forward, I could guess the woman's route, just hoping that she would not turn off early onto some sidetrack that I didn't know about. So, it was very likely that she would continue walking across the

frame to the right, keeping to the left side of the road as it curved around, and it was possible that she would turn off at the lane and so, from my point of view, double back to move left.

But really, the main subject is the flame trees. The woman will bring them to life in the final image. I want maximum red blooms in the frame, with a space for her, so as I'm walking forward I'm putting my options into order, from first and most likely to the just-hopefuls. First is always more likely, because she could turn off or even do something else, like turn round and ask me not to photograph her. I need to guarantee the first available shot, and I have in view four gaps, shown on the next page in increasing uncertainty. I'm pinning my hopes on the third, a horizontal, and then hoping that number four may just come off. That would be a vertical full of red if she walks down the lane from right to left.

The first is not going to be the best, but I go for it anyway, as I need to make sure I have at least some kind of useful shot. Maximizing the amount of red flowers means shooting for a vertical. It falls down on the fact that the arrangement of shadow and sunlight makes her less conspicuous. She moves on and I follow to get cleaner gaps on either side of the tree trunk for the shot I'm betting on— the horizontal. My second option, also a vertical, works out much better, with a nice curving cascade of flowers and the woman outlined well in the gap against the green fields beyond. I next line up for the horizontal, which I've already planned. The hut to the left of the tree trunk confuses the woman's outline, and I don't shoot, but as she moves to the right of the trunk, it all falls into place, even better at the moment when she starts to turn off the road. I then wait, about twelve seconds, until she reappears on the lane for a final vertical, but it doesn't have the good organization I'd expected.

In the postmortem of editing, the horizontal holds up as the strongest in my mind, and indeed this is the one that gets a double-page spread in the book *7 Days in Myanmar* that it was shot for. But then an interesting thing happens for the gallery exhibition that accompanies the book launch. Another of my shots for the book, shown on pages 98–101, features a snaking line of red-robed monks shot as a vertical. The exhibition designer sees the connection, and it's the vertical of the flame tree that gets hung—the two shots paired have that coincidence that designers like, what *Life* picture editor Wilson Hicks called "the third effect." The extra lesson here is that you can't always guess the usage, so it usually pays to do a bit more than the obvious. In this case, that meant working out and shooting four alternatives instead of relying on just one. ■

SLOTTING IN PLACE Flame Tree (continued)

The hoped-for framings

From the start, these four framings were the ones I was going to go for. The arrows show where the figure of the woman might fit in each.

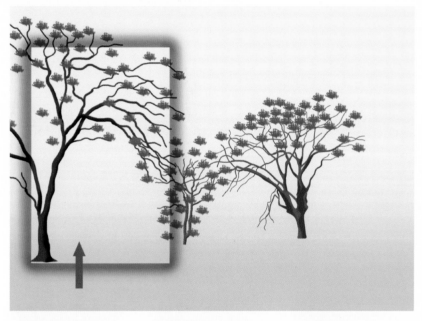

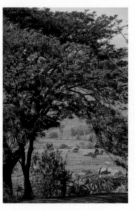

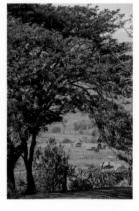

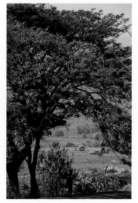

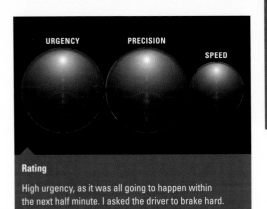

Rating

High urgency, as it was all going to happen within the next half minute. I asked the driver to brake hard. Precision was critical, and my main concern. Speed moderate: the woman was walking quite sedately, because of what she was carrying on her head.

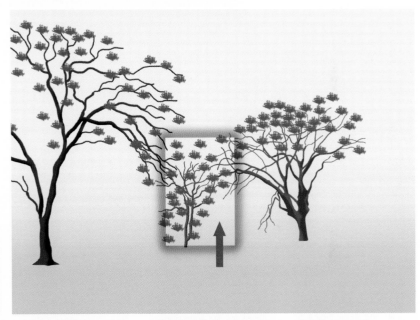

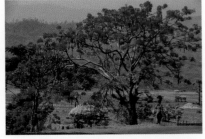

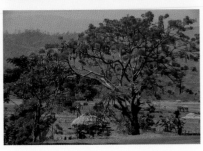

NEAT-FIT MOMENT Wild Dogs

Things fitting into place remains the theme of this chapter, and in many situations where there are the makings of a good shot, it quickly becomes a preoccupation. This was true here, on safari in Tanzania, where I had a good viewpoint of a group of African wild dogs (*Lycaon pictus*), but wanted to improve the shot from being simply efficient. With wildlife photography, you're usually looking for behavior to add this, but it needs patience and luck, so anything that you can bring to it graphically and visually helps.

This was in Mikumi National Park, Tanzania's fourth largest, though not heavily visited. West of the coastal city of Dar-es-Salaam, it offers a good chance of seeing African wild dogs, aka African hunting dogs, which are now an endangered species due to loss of habitat, and not all that easy to find close enough to photograph. This was the view from the vehicle with a 600mm lens—perfect position for a horizontal to include a few dogs at a time. Wild dogs are very social animals and hunt in large packs, and indeed their social behavior is quite specialized—basically, a lot of social interaction designed to avoid conflict and keep a large group operating in harmony.

As far as moment is concerned, I probably have several minutes, and I'm looking for some clear social interaction. Standing with jaws agape is one standard action for these wild dogs, and is thought to initiate a hunt. This is the most activity that seems to be going on, so I look to make the most of it. I have absolutely no room to move—the lens is resting on the window ledge—so I can rely only on timing and some very slight swings of the lens to follow the dogs. "Slight" meaning just a very few meters to the left or right of the group. I'm stressing this lack of choice to show that some moments cannot be influenced by camerawork. You just have to sit tight and hope for the best— and be ready for it if and when it happens.

Animals just sitting or standing around don't make satisfying images, unless they're rare and you're seeing them for the first time, and so the only times that I shot in this sequence, which lasted about a quarter of an hour until the pack moved off, were when there was some action, however slight. Scratching behind an ear, a head perking up, some sniffing, and of course, the jaws agape—which happened a few times. From this position, with the dogs outlined clearly against an out-of-focus pale background, the jaws agape worked best in profile, least well when the head was turned away. The clincher for the finally selected shot was the position of the lead dog's jaws against the head on the left. The two heads are actually some distance apart, but the foreshortening of this long lens brings them together graphically. ■

Rating

Urgency low, after the initial rush to stop the vehicle, switch off the engine, and get the heavy lens into position. Precision absolutely key, although I couldn't move. Speed average—these are normal movements, similar to people in conversation.

Focus of attention

In the selected shot, the moment does two things for the composition. It connects the heads of the two dogs visually, and the two arcs of their postures further concentrates attention on this point in the upper left of the frame.

Key Points
Points of behavior
Patience
Just-touching

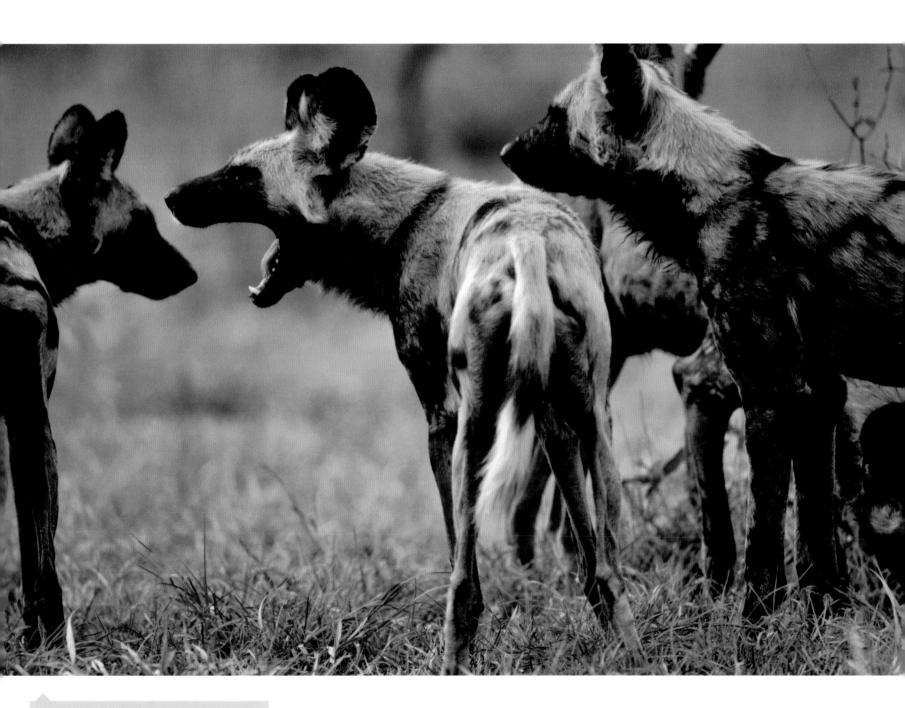

Pack of hunting dogs, Mikumi, Tanzania

45

NEAT-FIT MOMENT Wild Dogs (continued)

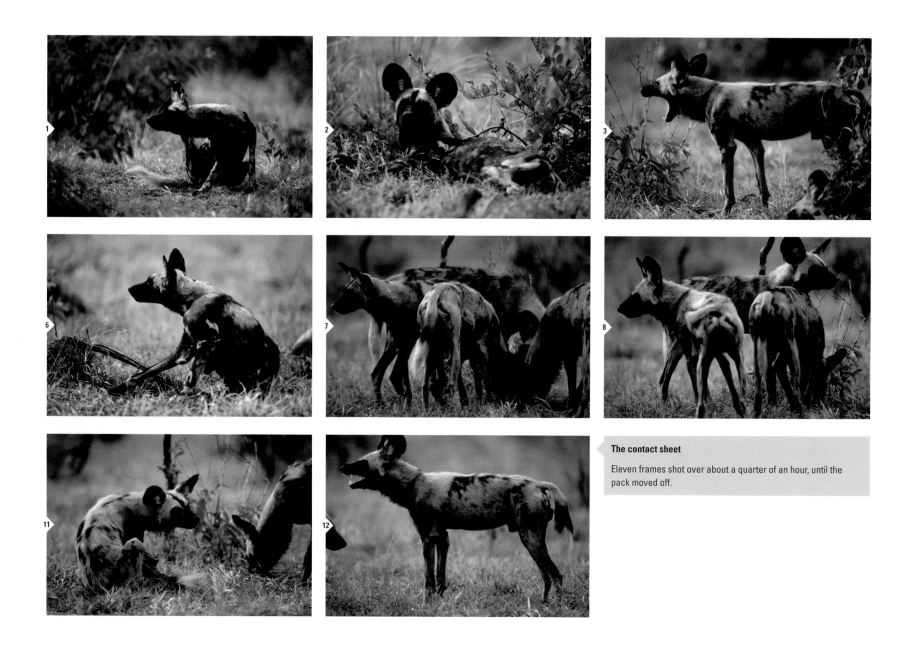

The contact sheet

Eleven frames shot over about a quarter of an hour, until the pack moved off.

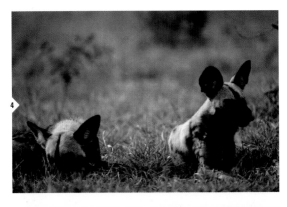

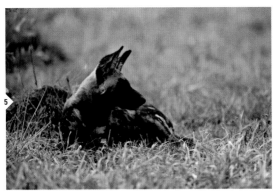

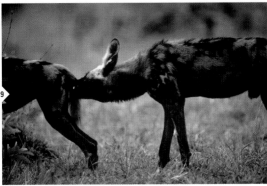

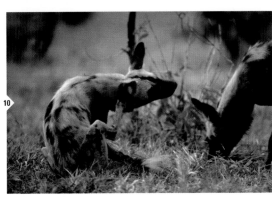

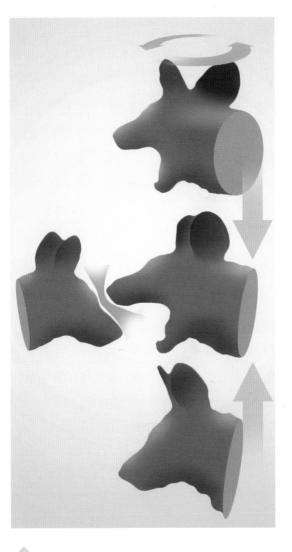

The ideal head position

Jaws agape was the behavioral gesture that counted here, and many of the shots concentrated on that. The ideal combined two things: jaws wide open and the head in profile. Ultimately, the almost-touching gesture fit with a second dog's head to make this frame the select.

ANTICIPATED MOMENT Wall Art In Bogotá

Carrera 80 Calle 30, Bogotá

Bogotá, capital of Colombia, has a new reputation for street art, and this mural near an expressway begged for a live human. Large-scale city street art can be striking, but shot statically usually seems to be missing something—and the something is quite often a lack of effort on the part of the photographer. So, while fully aware that figure-in-front-of-mural runs the risk of cliché, I knew I had to wait for a passerby to inject some life—and

moment—into the shot. The weather, incidentally, was no disadvantage at all, as flat light gives overall saturated colors—easier by far than fierce contrast from bright sun and shadow that could have concealed part of the art.

I first needed to choose a good viewpoint, which included imagining what difference, even if only slight, the hoped-for figure would make. Flat-on was an obvious possibility—artwork is usually

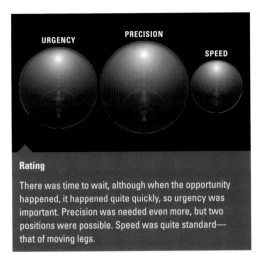

Rating

There was time to wait, although when the opportunity happened, it happened quite quickly, so urgency was important. Precision was needed even more, but two positions were possible. Speed was quite standard—that of moving legs.

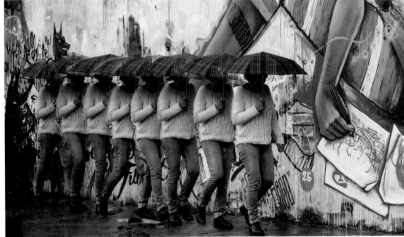

The shoot

There was time for eight shots of the walking figure, individually triggered, and I took the opportunity to shoot them all, even though there were just two likely "open" places for positioning the figure.

meant to be seen this way—but also an uninteresting one for a photograph, lacking depth and therefore the all-important context of the street setting. Next was where a figure would pass, and at what point would look best. This involves little things like how close someone would be walking to the wall, and how tall they were. Ideally, I'd want the figure not to cut across main areas of contrast in the mural, because then it would be less easy to read. There was also the simple professional satisfaction of getting the position dead right. Practically, this is quite a busy piece of art, so I identified two positions (marked here with the two yellow arches). Alternatives, much less good but making use of the eggshell-blue color of the other wall, are shown here by question marks.

Rainy weather keeps people indoors, so it promised to be a long wait. One person passed, but not close to the wall, so that moment failed. Eventually, I had the sequence, and shot several times—not on continuous, which removes all choice of timing, but singly and rapidly. Finally, as often, there was the wild card of posture. When people walk, there are good and less-good moments, regardless of where they are in the frame. You have no control over this when shooting, but it comes into play very much when you edit the take. ∎

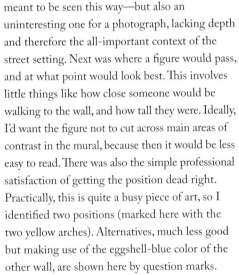

Rating the stance

The circles below each position rate the stance—the better looking ones have higher green values (my choice of good).

Urban context

The setting was a street corner in Bogotá, and this corner viewpoint gives the mural context—with construction behind and a bright powder-blue wall adjacent.

ANTICIPATED MOMENT Horse Caravan

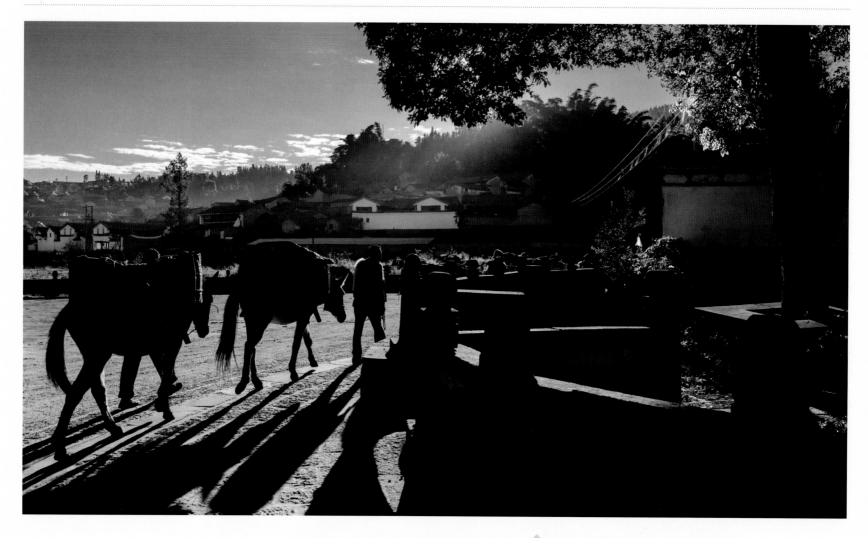

I knew well in advance exactly what was going to happen here. This was part of a workshop I was leading in southwest China, and we were at one end of the small town by an old clan ancestral hall, waiting for a horse caravan that was walking down the road. After it had walked past, the caravan would return, which meant we all had two goes at the same situation. Or did we? Many photographs turn on the detail, and despite doing your best to anticipate everything when time allows, some details slip through the net. The one that slipped through here was that the image of the horses walking past and toward us didn't actually work,

for the smallest, yet key, reason of legibility. They didn't read well. But on the return, they did.

The road curves around the ancestral hall, and there seemed to be two basic ways of shooting. One, naturally tempting, was from the other side of the road, so that horses and ancestral hall would be in the same shot. But this was not very satisfying as an arrangement—a rather flat and thin composition. A more atmospheric option was to shoot into the sun on this sparklingly clear morning, and go for silhouettes and edge-lighting from right next to the old building. The pity was that there was no way, short of a wide and

Horse caravan, Heshun, Yunnan, China

distorted panorama, of getting meaningful detail of the building in shot. Nevertheless, there were one or two interesting things going on, including the old curved wall, the overhanging tree, and the hazily lit old town in the distance.

If it worked at all, the shot would have to depend on the silhouettes of horses passing, and their long shadows. Because of the way the road curved, there was no way to get the entire caravan of a dozen horses in frame. Two or three would have to do.

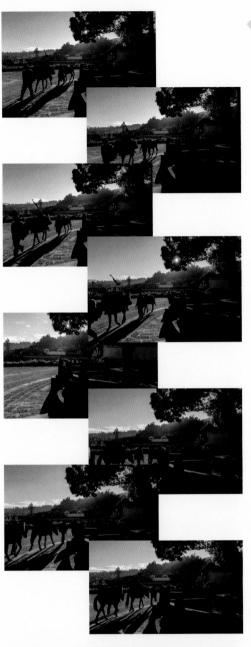

Forward & backward

The surprise was that, in silhouette, the horses and men approaching were visually less clear than when walking back and away from the camera. Separation and readable outlines were key.

The context

The view from across the street shows the situation, and though it was briefly considered for shooting, lacks visual interest.

Separation & readability

As the horses and men are being treated as silhouettes, it was important to keep the units separated visually. So, the key moment had two horses clearly outlined, with one man also visible. By contrast, as shown above in gray, men approaching the camera leading a horse invariably obscured the horse's head.

More than that was not practical without aiming more to the left, but that would mess up the composition by exposing too much empty space in the sky and road. Two-thirds dark building and tree against one-third road and sky was about the right proportion, and as I was shooting for black and white to keep attention fully on the horse silhouettes, I was definitely going to process the blue sky to be darker. In color, it was distractingly bright and empty.

But why didn't the advancing caravan work? It's all about clean lines. I couldn't get high enough to place the horses cleanly against the bright road. As it happened, each horseman led two animals, and the problem with that was that, from the camera position, each man obscured a horse's head, and he also broke the line of the road. On top of all this, a horse or man breaking the frame at left would be messy, and I wanted an entire animal on the left. You can see how few there were of these: three on the approach and just one on the return. And on the return—again, a camera position thing—the men were separated from the horses, which in the final shot simply read more clearly. ◼

Rating

Low-ish urgency because we knew they were coming, but some pressure as they passed, which took just a minute. Precision high, as the shot hinged on clean silhouettes. Speed moderately important.

URGENCY PRECISION SPEED

ORDERED MOMENT Wooden Footbridge

This striking wooden footbridge in the far west of Thailand clearly merited a good photograph. It also prompted some of the same thoughts as another example in this book: London Bridge on pages 80–83. Should I go for a descriptive shot, showing it at its most bridge-like? Should I be on the bridge or at a distance? This is the tropics in sunny weather, so did I want harsh light from a high sun or the more conventionally attractive shortly after sunrise or before sunset? And did I want it at its busiest? There was plenty of time to work this out, as I was there for a couple of days, and if it were not for the viewpoint I chose, this shot could have gone into the slow moments of Chapter 4.

As anywhere else in the world, people are most on the move going to work or the market in the early morning, and returning home in the late afternoon, and I certainly didn't want the bridge empty, so that automatically took care of broad timing. There were other locations and shots to do, so I concentrated on late afternoon. There was time to try different approaches. From slightly to one side, the view showed the dense mass of the pillars. This was the most descriptive view, but as a photograph, not so interesting. On the bridge itself and using a telephoto for compression gave the busiest looking shot, and that was fine, but I was more intrigued by the graphic possibilities of a high end-on viewpoint that was possible from a hill at one end. Here again I used a telephoto— a 300mm prime—for compression. Foreshortening gives a more overhead view and fills the frame with more bridge surface.

In going for this more strictly organized treatment, I was looking for a clean and formally

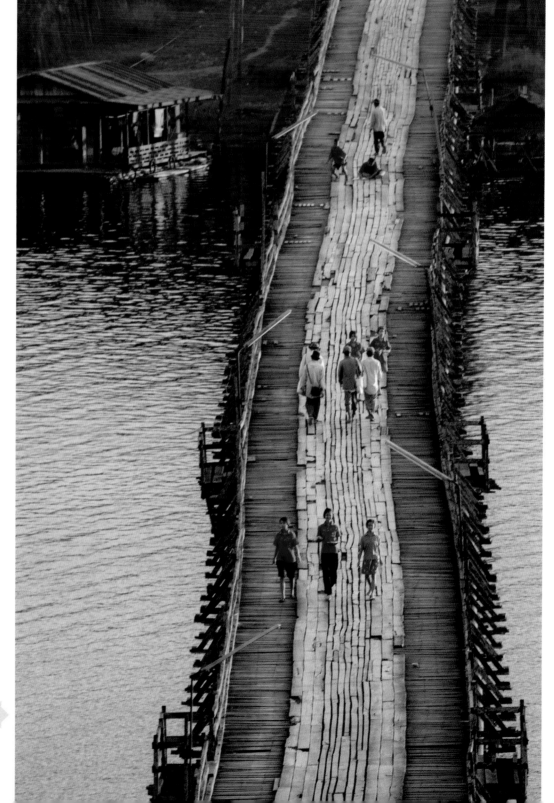

Wooden footbridge, Sangkhlaburi, western Thailand

Alignment & spacing

As the idea of the shot settled into being about clean graphic lines, alignment and regular spacing became important. The red colors also played a part, as did the last moments of sunlight on the far building.

A bridge-like view

Another alternative was a descriptive shot of the bridge's unique structure, and the clearest position for this was partly side-on from a distance, again using a long focal length.

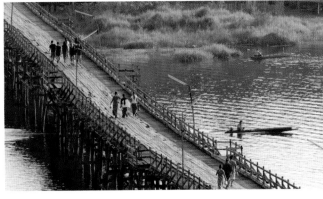

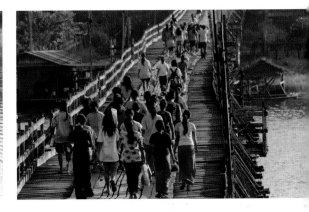

Timing the shot for the arrangement of small groups

Given the end-on viewpoint, the variable was the position of people walking, who, toward the end of the day, were mainly in small, separated groups.

On the bridge

One alternative was to show busy foot traffic from a pedestrian's viewpoint, also with a long focal length for compression.

shaped image, and that favored an ordered line-up of people on the bridge, rather than any straggling. So, from having originally been looking for a mass of pedestrians, I was now after fewer and neater. Moreover, as the numbers gradually thinned out, the light toward the moment of sunset was particularly good, picking out detail with cross-lighting. Each of the eight vertically framed shots that I took over the last five minutes of sunlight is serviceable, but the one I chose has, as the illustration shows, the most order. ∎

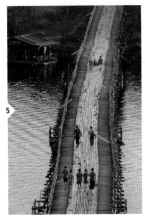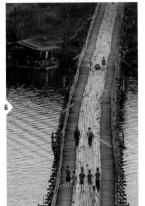
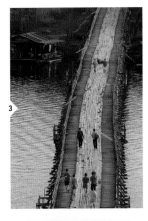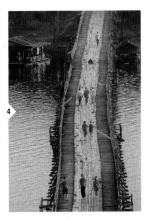

Rating

Very little urgency, moderately high precision, and modest speed because the slow movement made this a relaxed shoot.

PASSING FIGURE Water Tree

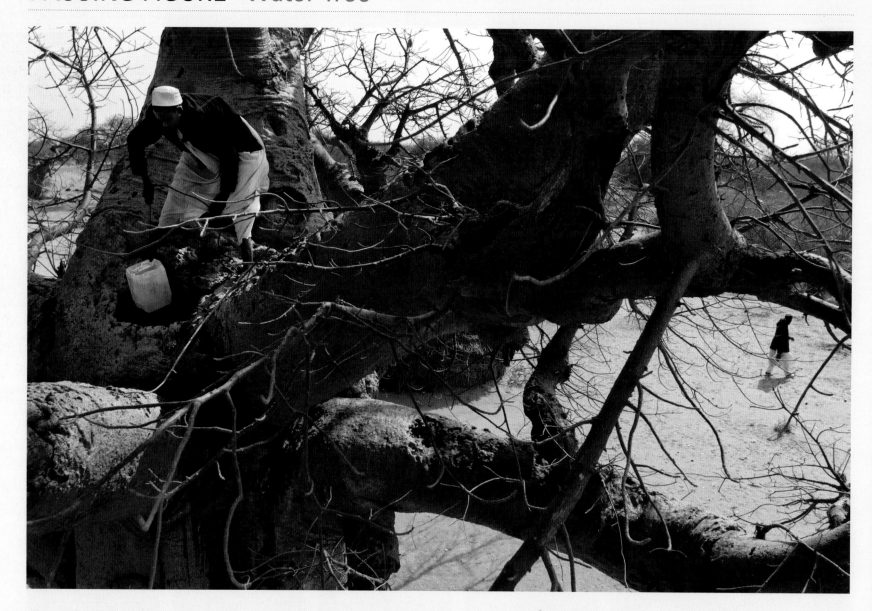

Baobab used for water storage, Kordofan, Sudan

There is an entire class of photograph that hinges on passersby. It's a compositional thing, and involves having a scene with a gap that will be brought more to life, or at least made more interesting and photographic, if a figure steps into it. Naturally, this happens only from the camera position, and apart from simply waiting for someone to do what you're hoping for, moving your viewpoint is one way of helping this along.

This was not one of those situations, given that I was perched right at the back of a tall, fully loaded truck, and had nowhere to move.

There was some element of preparation in this shot, though that did not include the passerby. One of the most unusual uses of trees anywhere is in the western desert area of Sudan, on the edge of the Sahel. There are baobab trees here, and with local ingenuity, villagers hollow out some of the soft

interior so that, in the meager rainy season, they can fill it with collected water. A tree like this can hold enough water for a small village through the dry season, and it takes the place of a well.

My viewpoint problem was height. As the main picture shows clearly enough, access to the water

Added interest
High viewpoint
Brief opportunity

Rating

Quite urgent as there didn't seem to be anyone else likely to pass by any time soon. High precision with only one gap in the branches as a window. Moderate speed.

Moments of drawing water

Quite apart from the moment of the passing figure in the distance, there was a sequence of action going on in the tree, as the man lowered the plastic container to fill with water, and then raised it. Any coordination between this and the passing figure was purely down to luck, and as luck had it, the moment was the most legible.

is up in the lower branches, and the ideal position is at least as high, and close. But the baobab stood on its own. Fortunately, there was a long-distance truck loading up for a several-day journey across the country, and we persuaded the driver to back up close to the tree. I had my viewpoint, and all was well. Nevertheless, always greedy for more, I wondered if I would get some activity below and beyond as well. I was lucky. After about six minutes I caught a glimpse of movement on the left, though I couldn't quite make it out. On the chance that whatever it was (probably a person) was moving right, I framed so that the right gap in the branches was ready for it. All this took several seconds, and I had less than four seconds with the man (as it turned out to be) in the gap and clear of its edges. The moment was not as "blind" as that with the telephone boxes on pages 94–97, but it still forced me to wait until I could see what I had in the frame. It's at times like these when you appreciate the extra warning that you normally have when you can actually see a figure approaching on the outside of the frame.

Given that the opportunity for shooting was so short, there's an argument of sorts for using fast continuous. If I had done that, I could have had many frames to choose from with the man in place. Instead, I preferred, as I usually do, to shoot singly for precision. It feels more in control than letting the camera take over, which is what happens with an automatic burst. But that's a matter of preference. ∎

Uncertain warning

From the camera position, there was only a hint of someone about to pass on the left of the frame behind the large branch, and without losing the framing, there was only a small gap on the right in which the figure would entirely fit.

The sequence

The shot was working perfectly well with just the man in the tree, as the subject was inherently interesting and unusual, but the final moment of the passerby lifted it a notch, photographically.

PASSING FIGURE Drinks Cart

Passing figures are, dare I say it, a regular fixture in street photography. Typically, there's a partial scene with maybe one interesting or useful element, and it needs a passerby to complete it. To a large extent, street photographers have this sense of needing someone of the right type to walk by because people *do* tend to walk by. That's what happens in city streets, and it's reasonable to expect that you might have that choice. In contrast to the previous photograph, where it was far from likely that anyone would just walk by in the desert, in city streets like this one in Cartagena, Colombia, there's a fairly constant flow, from left to right, right to left, and down the line of sight.

Street scene, Cartagena, Colombia

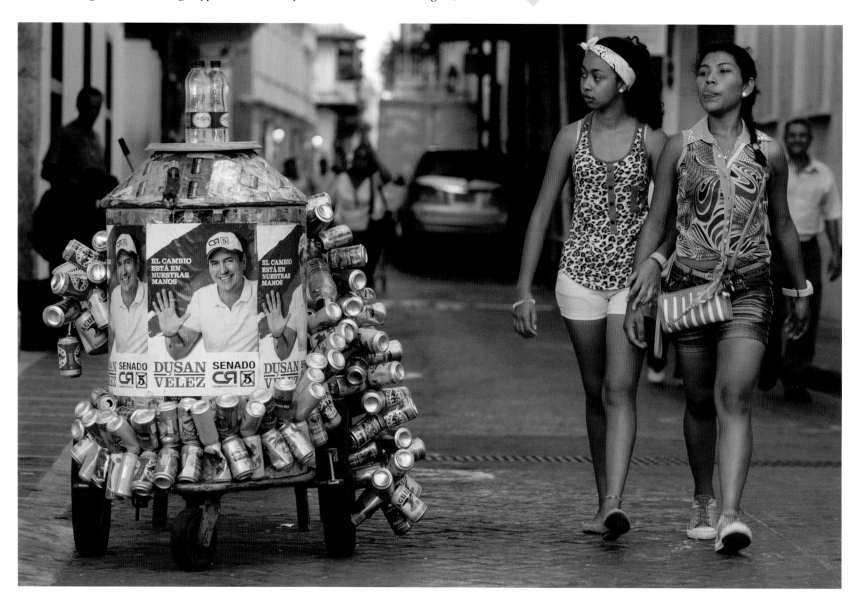

To begin with, I was waiting for another passing cart, but filled the time by shooting any passerby.

The two girls were an obviously good addition to the scene from the moment they first appeared.

After the girls had gone, I resumed waiting for a cart, though in the end it didn't fulfill expectations.

The sequence

Over the five minutes of shooting, there were several useful passersby, and time for a few frames of each. The anticipated passing cart was less strong than the two girls.

PASSING FIGURE Drinks Cart (continued)

The element of interest was a hand-pushed drinks cart, common in tropical cities, but this one was idiosyncratic, adorned with many empty beer cans. Not quite enough interest to make a frame-filling shot on its own, but with someone passing by, certainly. The vendor, incidentally, rarely tended the cart, and left it standing most days in the same place on this corner. That meant he was unlikely to step in to make a moment happen. The solution, then, was to find a viewpoint for waiting and which would allow a framing with space on the right for people or things passing. My first preference was for another cart being pushed—it's one of the features of this city—and indeed, I ended the sequence of shots once I had this. Meanwhile, however, there were people crossing, walking down the street away from the camera, and walking up toward the camera. Not all the time, but one or two a minute, which meant I could have them distinct and separated from others. One thing, though, was that the stationary cart was set back a bit from the corner, and I was using a medium telephoto to compress the scene and isolate the cart and passersby from the setting. People crossing left to right and right to left would be slightly out of focus. So, the best situation would be walking toward the camera, for the two or three meters they were alongside the cart.

As usual in street photography, you can plan and anticipate all you like, but you never really know what you're going to be presented with. The passing handcart that I had wanted only partly lived up to expectations, particularly because the man's face was never completely clear of the chair legs on top of his cart. Unexpected and much better were the two girls in shorts, walking arm in arm and in step, with interesting faces that draw the eye. I had about half a minute's warning as they approached, and shot for the brief period when they would be in the same focus as the beercan-

laden cart. That meant four shots, so that within the choice I made of which passersby, there was another choice to be made as to which was the best moment for the girls. Going back to the basics of people moments (see Chapter 1), this came down to posture and expression. I had caught them at very specific moments of step—two at full stride, which is the most active moment, and two at the still moment of one leg almost standing and the other bent at the knee, as the illustration on the opposite page shows. I definitely preferred full stride for it looking more purposeful, and the choice between which of the two frames was settled by expression—that of the girl on the left neatly outlined against black behind, and the other girl's tongue slightly out. ∎

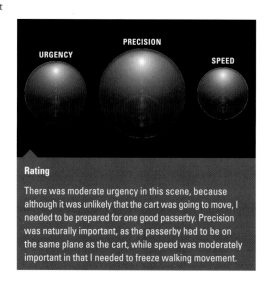

The less-interesting moment I was originally looking for.

URGENCY **PRECISION** **SPEED**

Rating

There was moderate urgency in this scene, because although it was unlikely that the cart was going to move, I needed to be prepared for one good passerby. Precision was naturally important, as the passerby had to be on the same plane as the cart, while speed was moderately important in that I needed to freeze walking movement.

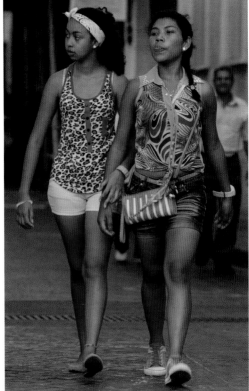
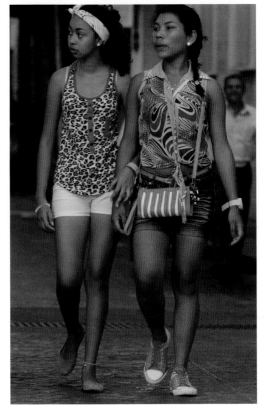
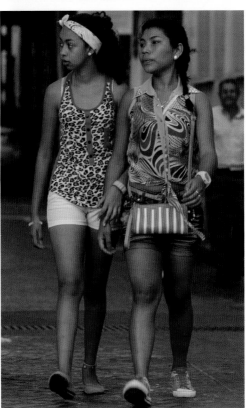

Walking moments

The markedly different energy levels in step are clear in these profile views of the girls' legs. The full stride appears to have more movement than the mid-step, which looks almost stationary.

Choice of posture and expression

Even within the six seconds of this burst of four frames, there are noticeable differences in expression on the girls' faces, and the most interesting frame is the second, with one tongue protruding.

FRAMING MOMENT An Exquisite Silhouette

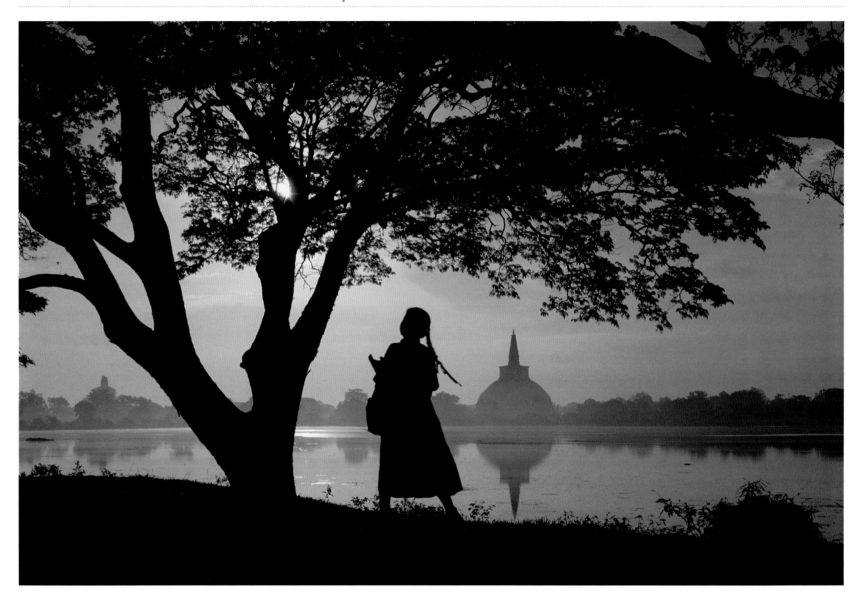

It's a classic in-camera moment when the composition needs an additional, lively element—one that you know is possible and worth waiting for. As with so many images that you first build up in your mind's eye, it begins with a few attractive elements that trigger the possibility of a good photo. In this case, early morning on the artificial lake known as a tank, in the ancient Sri Lankan city of Anuradhapura, produced this lovely golden light looking east, with the distant outline of the bell-shaped dagoba of Ruvanvelisaya on the far side. Added to this was a nicely spaced row of gnarled, characterful trees in stark silhouette in the foreground, their twisted trunks and branches framing gaps that looked out toward the distant monument. Villagers use the path running just in front of the trees, and this was the busy early morning, with children on their way to school.

Anuradhapura, Sri Lanka

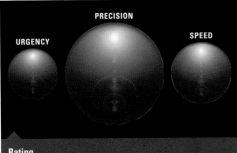

Rating

Precision (of placement) dominates this moment. There was some time to get into position, so urgency was not particularly high, and speed was normal—just the pace of a walking person.

The setting

There is a choice of two trees; each from a slightly different viewpoint, and each tree creates two possible frames on either side of the trunk. A view of the distant dagoba fits between either pair.

FRAMING MOMENT An Exquisite Silhouette (continued)

Fitting one of the villagers into a branch-outlined frame would be perfect, as long as the dagoba remained in clear view. This composition was all about separating elements and making them fit together. I found two viewpoints some meters apart, each with a pair of frames defined by trunk and branches, and I hopped uncertainly between the two. Either would work. In a situation like this, the idea is to fit a passing figure as neatly as possible into one of the spaces. Maybe even two figures at the same time on either side of the tree, although that would be asking a lot. Remembering that the dagoba is already in one of the frames, it would be easier to capture a figure in the other one, but it would be more challenging, and therefore more rewarding, to have it in the same frame—and this was one of the reasons for choosing the final image from the take of twenty.

Then there was the unpredictability of the figure itself. Some were more interesting than others, and some positions of each figure were more appealing. Chance clearly plays a large part in this. The result is a number of shots that I like, and none are completely hopeless. In the end, I chose the girl with the pigtail flying, neatly caught next to the dagoba, but it could as well have been one of the others. ▪

The full take

Even though the final select was shot early on, it was worth continuing to shoot to see who else would come along.

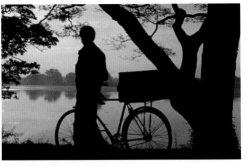
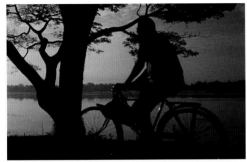
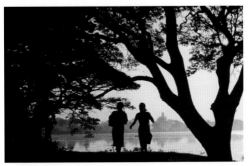
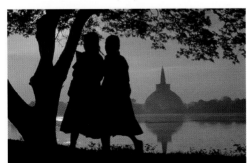
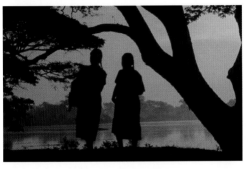
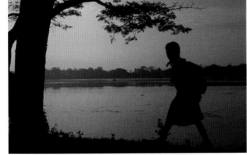
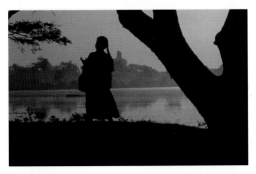
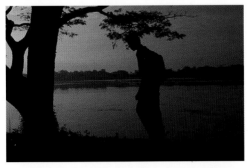
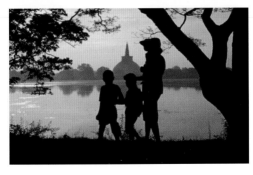
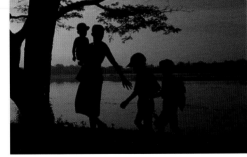

Mise-en-scène

Within the camera frame, the scene was further framed by the branches of the tree, which is where the important changes took place from shot to shot throughout the sequence shown here.

ADVANCING MOMENT Elephant on the Road

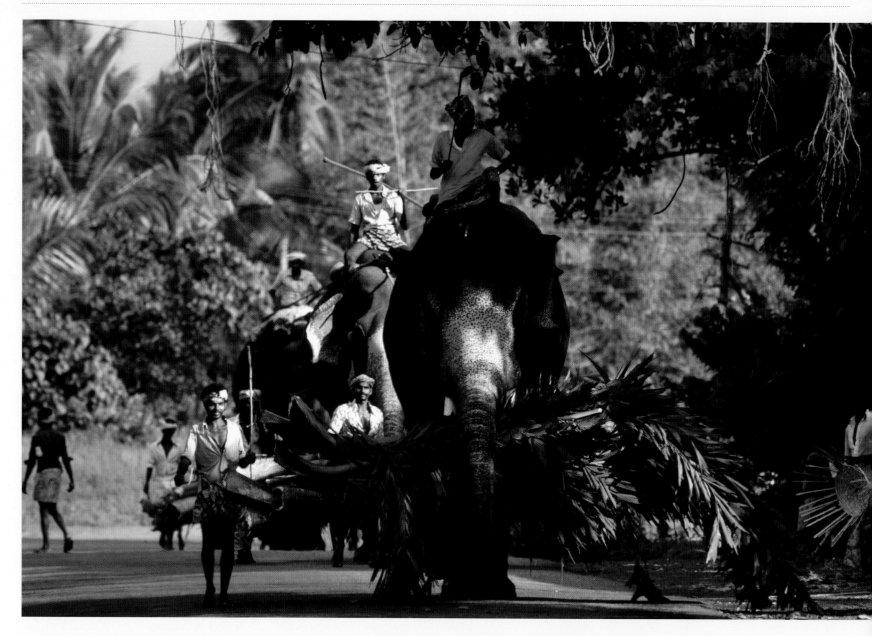

There's an entire class of moment that deals with an approaching subject. Generally, anyone looking at a single picture like this, of an Indian elephant with its mahout walking sedately along a coastal road in Kerala, sees a fairly straightforward image, but the decisions and activity that go into getting it right are very specific. They also benefit from practice. When you've done a few of these, you get used to the procedure and start ticking off the checklist. This case was typical. Between seeing the elephant far down the road and shooting there was a little time, about a minute, enough to prepare but not to delay. The idea is that very soon your subject will be properly placed and a good size in

Lighting determines the final shot

From the few final moments as the lead elephant passes under the tree, the selected image was chosen for the way the sunlight and shadow fell across it—specifically, the patches of light on the elephant's forehead and on the sheaf of fronds that it is carrying in its trunk.

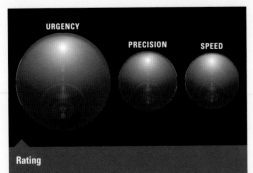

Rating

Urgency takes precedence in this picture, as in almost all advancing-subject shots, because there is nearly always less time than you think, as it gets larger in the frame. Precision is moderate, mainly a matter of keeping the elephant in focus, while speed is average.

the frame, and you will have a clean shot. This is all likely but by no means guaranteed. There are things that can go wrong that are out of your control, such as something getting in the way, or your advancing subject turns off unexpectedly to the side. There are also things that can go wrong that should have been under your control, of which the main one is usually focus, but another common one is leaving it just too late so that the target breaks the frame.

This is the checklist as it applied here. First, get a good position with decent background, and quickly. In this case it meant stopping the car and running to the side of the road. In an emergency,

it's often possible to move back, but that itself takes up valuable time. Second, decide the focal length, knowing that the longer the lens (from farther back, of course) the more slowly the advancing subject will change in the frame, so you have more shooting opportunities. In this case, I used a 400mm prime lens, but a zoom would let you pull back for a while to keep the target in frame. Third, all settings correct, meaning aperture, shutter speed, and ISO, depending on what you need. Here the light was good, so I shot at a low ISO, kept the shutter speed at the slowest necessary for the gentle action, 1/125 second, and that gave me a reasonable depth of field from $f/8$.

65

ADVANCING MOMENT Elephant on the Road (continued)

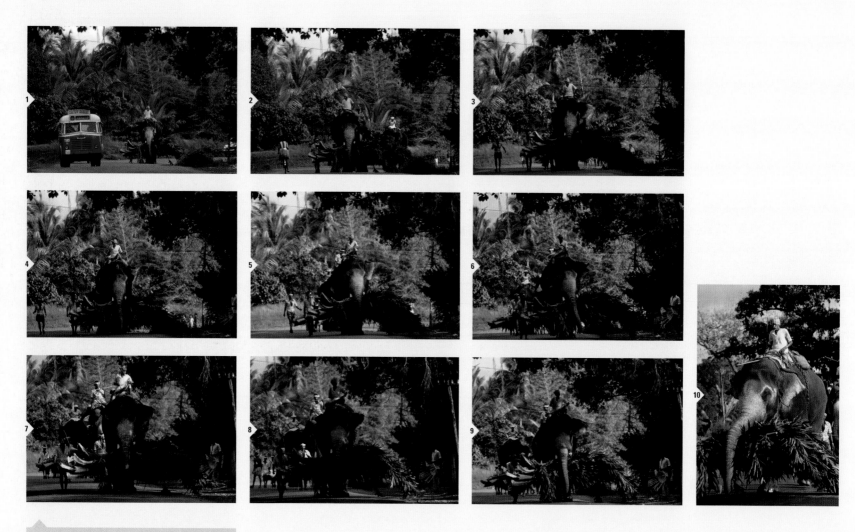

The sequence

After the first two frames, in which the elephants are small in the frame, the remaining horizontals are all good, but the best moments depend on movement of the elephant's trunk and the pattern of dappled light falling on it as it passes under the large tree.

Key Points
Larger in frame
Low position
Details of trunk

Working out what the subject needs in terms of the exposure triangle is one operation that should be smooth, if you think calmly, and you certainly don't want to waste valuable time. Fourth, a small point, shots of people or things moving along a road usually look better if you crouch closer to the ground. That way you don't take up space in the frame with useless foreground.

Note that the way I've positioned the elephants in the frame had to take into account their position on the road and how they increasingly fill it up as they get closer. In the first shot, they are too far away, and in the second, still not quite large enough in the frame for what I wanted. In the remainder, all of them are acceptable. I'm using the shadowed arch of tree and branches on the right to hold the right

side of the frame, and trying to show as little of the road at the bottom as possible. The different moments vary mainly because of the way the group is passing through dappled light and shade. The sixth and ninth frames are the best for me—the sixth because of the swing of the lead elephant's trunk, and the ninth, which I finally chose, because the light shows up the fronds that it is carrying. ▪

ADVANCING MOMENT Walking Home The Cattle

Here are more animals walking toward the camera, this time cattle being brought home from pasture into a small Yunnan village. Late afternoons in most agricultural communities are relatively busy times as people return from the fields, often carrying something. They make good extended moments—or slow moments in the terminology of chapter 4. That was why we were here in the village of Baixa at five o'clock. The actual shooting moments, however, tend to be fast and relatively unannounced. This seemed like a useful small street:

good cross-lighting, traditional rooflines, and no vehicular traffic. The original idea was to shoot a vertical that framed the old houses and part of a willow, but it was not working very well, as you can see from the photograph taken ten minutes earlier, the least unsuccessful of a series waiting for someone to pass by.

Then the cattle appeared farther up the road. I'd moved by this time, so had to get back quickly. Standard procedure for this kind of image is, as we saw with the elephant, to use a relatively long lens

and get quickly to a viewpoint where you can frame the shot before the subject moves into it. I had two or three seconds, and as I had pre-framed the background, there was no point zooming back. There was nothing particularly special about the result so far. Just a pleasant scene. I decided to ditch the framing and the old rooflines and try

Walking home cattle, Baixa village, Yunnan, China

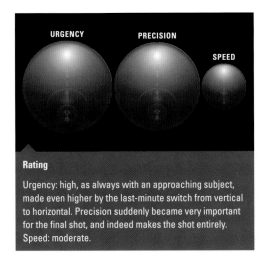

Rating

Urgency: high, as always with an approaching subject, made even higher by the last-minute switch from vertical to horizontal. Precision suddenly became very important for the final shot, and indeed makes the shot entirely. Speed: moderate.

A shift of emphasis

A combination of the graphic intensity of the silhouetted man, which outweighs the cattle in shadow, and the particular moment of his stride, shift the attention and therefore the whole point of the shot.

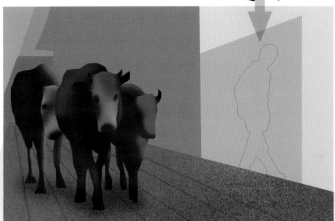

a horizontal, so after this short sequence I ran a short distance back and re-framed. Now the idea was to stay in position, kneeling and pulling the zoom as the cattle moved past, just to see if anything would happen. There were four seconds of opportunity, and by good luck, on the first frame the man leading his cattle strode out to one side. This was what I meant earlier, in Chapter 1, by posture. Just the way he steps, hands behind, facing down as if thoughtful and not camera-aware, makes the shot what it is. More to the point, he was neatly framed almost as a silhouette against the bright wall, and so takes full attention in the frame. The next four frames were without merit, which was not surprising because the shot had changed from being about cattle to being about the young man. ■

A sequence in two parts

The sequence begins predictably with the pre-chosen vertical framing, but moves to a horizontal framing once the cattle are nearer and in shadow.

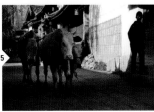
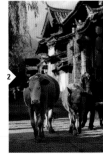

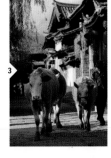

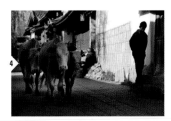

RECEDING MOMENT Rochdale Canal

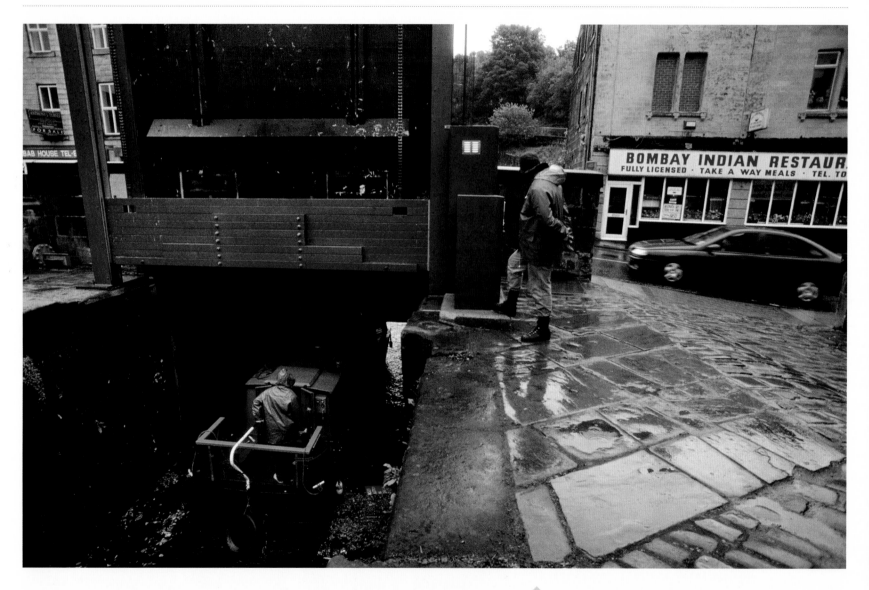

Things moving away from the camera work differently than toward, although the best moment is similarly (and often surprisingly) urgent. The first difference is that far fewer subjects actually work well from the back. It's rare to be in a situation where you're dealing with an approaching subject that makes a worthwhile shot, and then can continue by swinging around to photograph it going away. Sometimes it's a matter of making an informed guess about something approaching

as to whether it will turn into a photograph from behind. More often, receding shots happen because you come across them, usually with a sense of being a little too late and needing to catch up. This was the second case here, in the Lancashire town of Todmorden, while shooting a story on Britain's canal system. Following the Rochdale Canal through the streets of this old mill town, I turned a corner to see this unusual old lock gate rising, and a narrowboat about to go through.

Guillotine Lock, Rochdale Canal, Todmorden, Lancashire

There was obviously no time to lose. Most of the time, nothing at all happens along the canals, particularly in towns, so any little bit of action is a target. And a guillotine lock gate, as it's known, really needs to be photographed doing what it does.

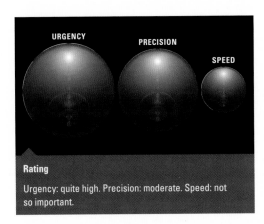

Rating

Urgency: quite high. Precision: moderate. Speed: not so important.

It was another beautifully wet and cold northern day (this is my part of the world, and days like these are thoroughly ingrained). In a way, this typical weather is good for shooting a story like Canals, but the disadvantage is the sky, which is so much brighter than the land and buildings that it flares and blows out. The solution to this is to frame it out, which meant getting closer quickly with the fixed 20mm focal length (no chance to zoom in). I also needed to get closer before the narrowboat disappeared underneath. Nevertheless, narrowboats, steered from the back, are one class of subject that work well from behind, and the matching green of both the boat and the man's rain cape were a bonus. What next? A car pulled up at the traffic lights hidden from view behind the gate. Slight swing right to include it and the full name of the Indian restaurant behind (looking distinctly far from Bombay). The boat passed under and that was that. ■

An arrangement of elements

The key moment is necessarily just before the rear of the boat, with the boatman at the tiller, disappears into shadow, but the arrangement of distinct elements—boat, lock gate, standing man, and car—is important to give a sense of a moment caught in time. The framing also takes into account the coincidence of greens.

A short sequence

With the narrowboat about to pass under the lock gate, there was time only for four frames.

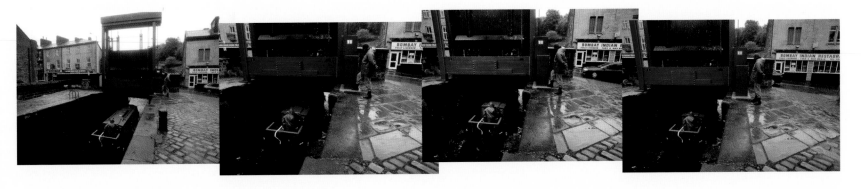

RECEDING MOMENT Walking on the Beach

Following a receding subject extends the time available, and sometimes brings in different possibilities that didn't at first seem obvious. As already mentioned, most things do not work well from behind, and that usually includes people. The audience is often left wishing it could see the faces, with the suspicion that the photographer ought to have been in front to begin with. But not always, and this was one case where the receding view worked better, partly for the lighting, but more for the reason that some subjects look more iconic, more representative, and less specific from behind.

So it was with these two nuns, taking a stroll along the beach.

Nuns are not the most frequent visitors to beaches, as they tend to have other things to do, and bathing costumes are not an option. I was on the lookout for beach life anyway, and quite liked this possibility, which I spotted from a hundred yards or so behind. The late-afternoon lighting from this angle was good, as long as I could manage to outline them against an uninhabited patch of darker sand. I sprinted a little, then walked behind. I'd set this aside as a cellphone-shooting afternoon, and one

Beach of the Malecon, Cartagena, Colombia

Beach of the Malecon, Cartagena, Colombia

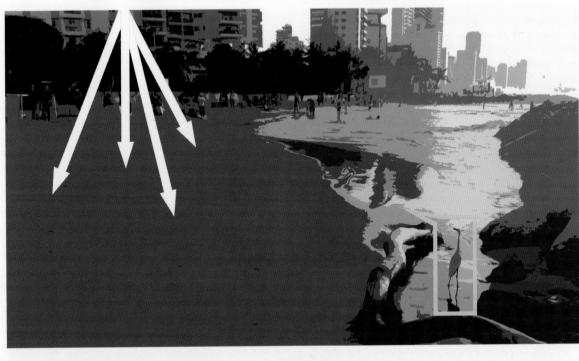

advantage is being completely inconspicuous. Even if they had suddenly turned around, I still wouldn't have looked like a photographer, but rather just another tourist snapping the sea. Shooting meant walking up very close, stopping to frame accurately, and taking a few frames—and repeating this.

I managed what I had in mind, and moved ahead to try two more things. One was a shot from in front, even though the lighting from this opposite direction was not as interesting. Nevertheless, I was there for a moment when they removed their shoes, and aiming off to the left, which was for reasons of composition (nuns against sea), made it look as if I was just photographing the sea. Continuing on, I finally found something that I could usefully add to the scene—in other words, not just nuns on beach but also nuns plus another subject on the beach. It's always good if you can make connections, and here was an egret. I was by now about a minute ahead of the couple. The egrets here are not at all skittish. They are far too interested in food leftovers, so it tolerated my close approach, just edging a bit forward. I had it neatly outlined in the pool of bright water when the nuns walked by. All in place, and even better, something I couldn't have orchestrated, the bird looked toward the nuns. I imagine it too hadn't seen too many of them here on the beach. ■

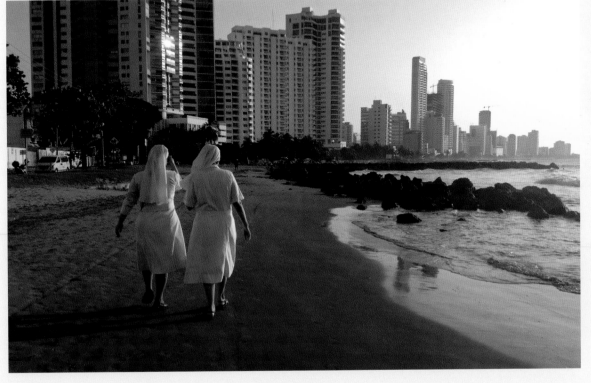

RECEDING MOMENT Walking on the Beach (continued)

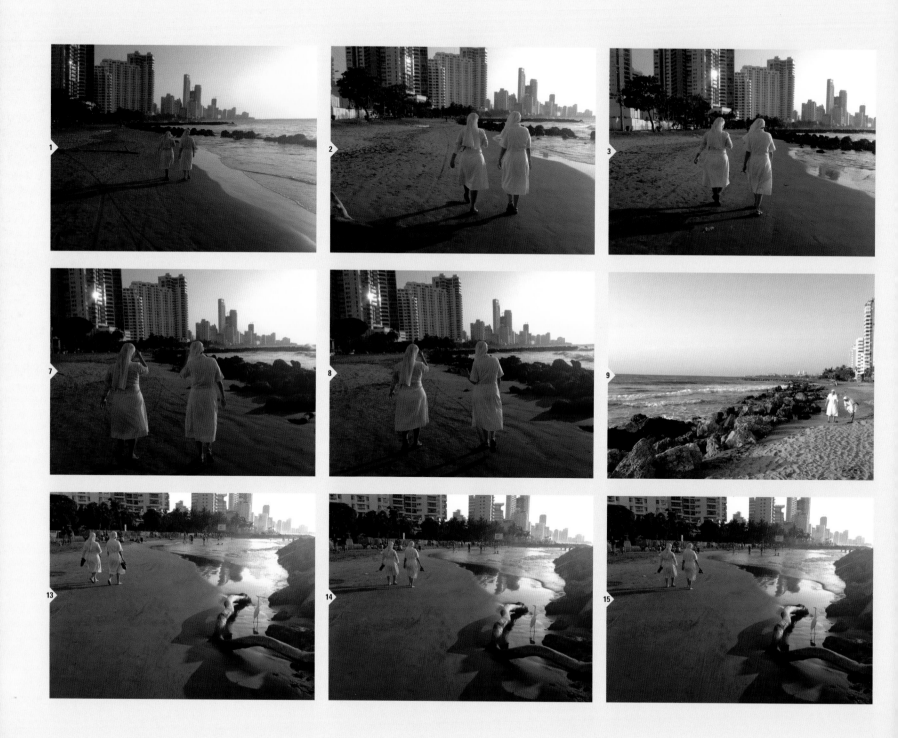

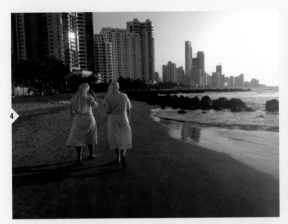

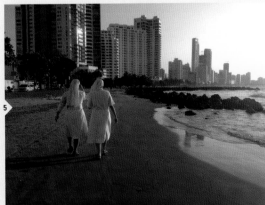

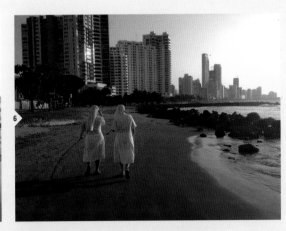

The sequence

Walking, stopping, shooting, then walking again, was the sequence and the stopping for shooting was because this was with an iPhone. The live view on a cellphone in bright sunlight is far from ideal, and the shutter lag makes shooting while walking unpredictable.

SYMMETRICAL MOMENT Oil Palm Plantation

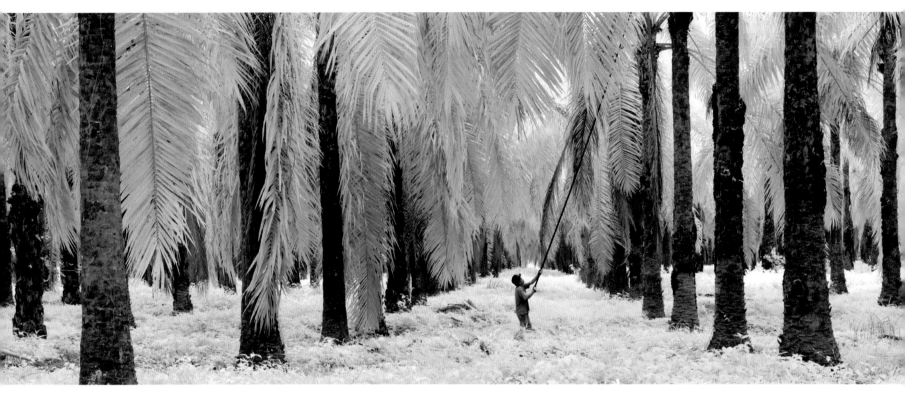

Moment can sometimes have very little, almost nothing, to do with the actual movement that is happening. If this sounds contradictory, because moment always relies on some form of activity, just think of the balance between action and viewpoint. In one sense, this is what this chapter is all about, dealing not just with how real movement appears to the camera position, but which of the two is the more important. Take a situation where the movement is slow and the viewpoint makes a major difference to the scene, and you have one extreme.

This was the situation here in an oil palm plantation. It was a commercial assignment, so the shot had to be done, and had to be attractive and striking. It became a shiningly clear example of moment in the pure service of composition. This was very much needed, because the monotony and density of a tree plantation needs effort to turn it into any kind of strong image. The aerial view in dull weather gives some idea of just how

monotonous and dense an oil palm plantation can be (this helicopter flight was a total write-off photographically, and we flew only because there was nothing else better to do). The first decision, nothing at all to do with moment, was to shoot in infrared with a converted DSLR, to heighten contrast. This happens because green vegetation reflects strongly in infrared, so that, in a normal exposure, plants appear white and bright. The color shot, taken only to show the difference, is lackluster.

In any case, the black-and-white infrared serves only to heighten whatever the composition is going to be, and in pursuit of turning a monotonous mass of trees into something graphically striking, I went for the obvious under the circumstances, which was to shoot down the line of planted palms. This in turn suggested a symmetrical composition, with receding tree trunks on either side. And this is where moment came in. We had stopped in a

lane where one of the workers was trimming the dead palm fronds with a blade on the end of a long pole. That gave scale and activity. But which position? Over a quarter of an hour, I watched him move from tree to tree, and it seemed inevitable, now that I'd decided on a symmetrical framing, that to have his figure dead center would just reinforce the idea. This moment, incidentally, also made sure that he was completely outlined against the white vegetation. ■

In normal color

Shot for comparison, a straightforward color version lacks the graphic contrast of the infrared version.

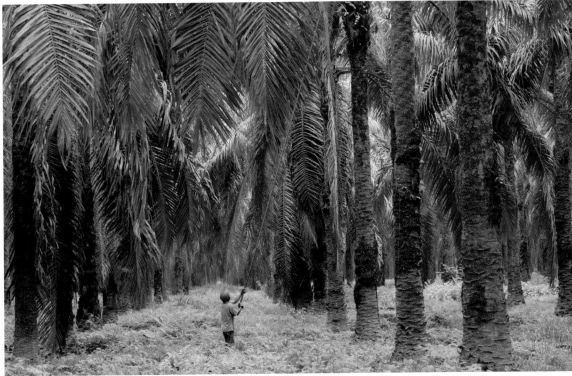

Oil palm plantation, Aracataca, Magdalena, Colombia

All for symmetry

Once the idea took hold that the image needed symmetry, everything from viewpoint to framing and moment was made to work toward this. Even the high contrast of the infrared capture played its part by emphasizing the trunks and the figure against white vegetation.

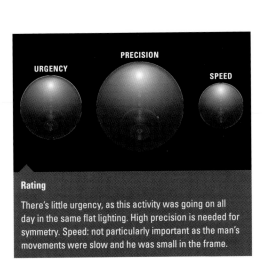

URGENCY PRECISION SPEED

Rating

There's little urgency, as this activity was going on all day in the same flat lighting. High precision is needed for symmetry. Speed: not particularly important as the man's movements were slow and he was small in the frame.

SYMMETRICAL MOMENT Oil Palm Plantation (continued)

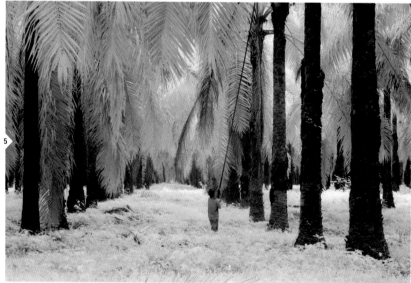

From the air

An aerial view, no use in itself because of heavy haze, shows the densely packed arrangement typical of a plantation.

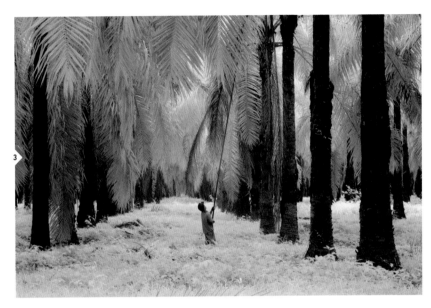

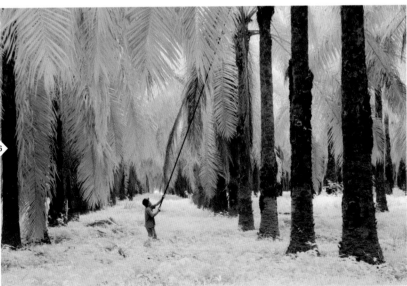

The sequence

Most of these positions were acceptable as the man worked from tree to tree, but the final one completes the symmetry I was aiming for.

COMBINING MOMENTS London Bridge

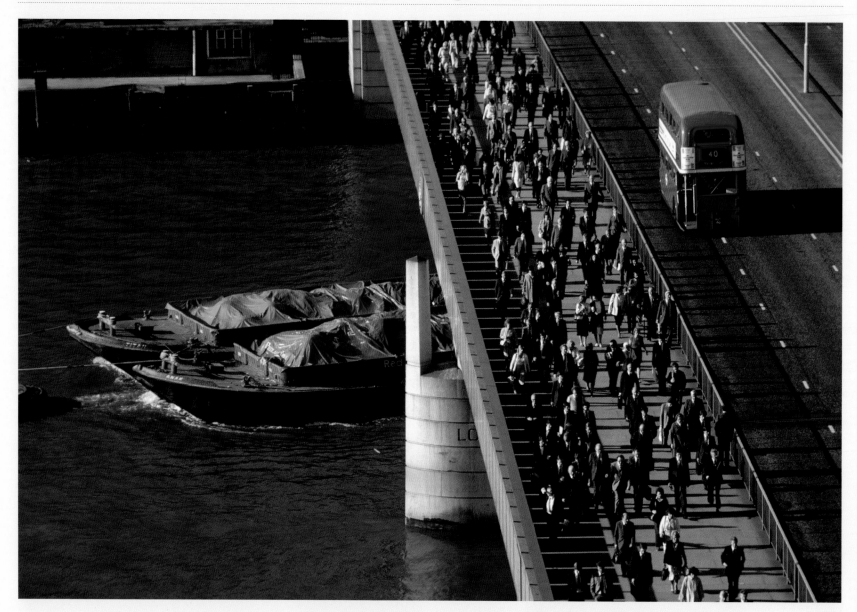

London Bridge, City of London

The right moment is often hard to separate from composition, simply because when different things happen in different parts of the frame, they pull the attention around. This commissioned shot for *National Geographic* had a much tighter link between moment and composition than usual, and all because it had a job to do—showing London Bridge in the morning rush hour. This is not Tower Bridge, which is farther down the river, and it has no special features (and in any case, the original is in Arizona, but that's another story), so the shot had to close in on the city workers crossing from London Bridge railway station on the south bank. I needed to show it busy, and to locate it somehow. One way would be to get in there among them, but I had a different plan, which was to get permission to shoot down with a telephoto from an office building on the City side. Less street energy, of course, but the possibility of a graphic treatment, which I intended to make the most of by framing tightly and precisely.

The Horizontal Sequence

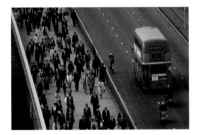

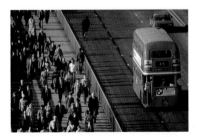

River context
Telephoto
Iconic red bus

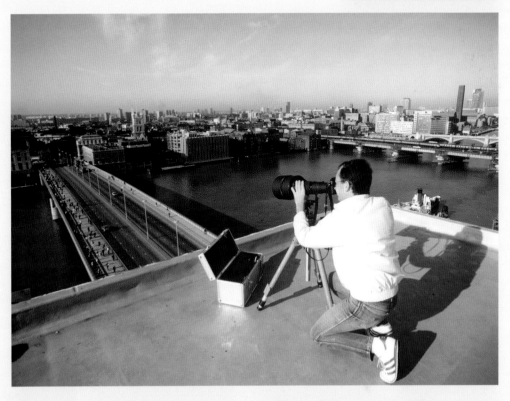

The Wider View

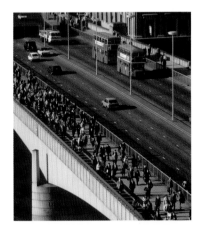

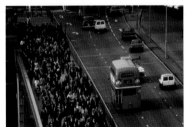

There were just two useful ways of framing this; the viewpoint was fixed. One was to show some of the water on either side—a bridge-like view, in other words. The other was to forget bridge stuff and close right in on the people. There were pros and cons for each, and I shot both. The bridge view from this diagonal angle on the roof worked better as a horizontal, with the bridge slightly offset to the right. I had only prime lenses with me, no zooms, but the 180mm was perfect for this shot. The advantage of this framing is that it emphasizes the bridge, and the low morning sunlight picked out plenty of detail and color—especially the London buses. It introduced the need for an additional moment—some river traffic passing under the bridge, which is the reason for this final select. The disadvantage of this scale of view is that the crowd of commuters is less prominent, and it was this that made me concentrate more effort on the second framing.

Shooting from an elevation

The camera position, from the top corner of the block next to London Bridge, was ideal for this kind of shot, with an unrestricted view. This 600mm lens was used for the vertical framings on the following pages.

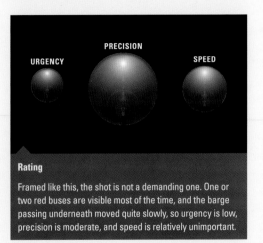

PRECISION

URGENCY SPEED

Rating

Framed like this, the shot is not a demanding one. One or two red buses are visible most of the time, and the barge passing underneath moved quite slowly, so urgency is low, precision is moderate, and speed is relatively unimportant.

COMBINING MOMENTS London Bridge (continued)

The tight vertical, shot with a 600mm lens, is a very different picture from the previous. There's nothing in view to show that this is a bridge, which for an assignment is a slight concern. But it does concentrate fully on the mass of pedestrians, and the key element in the story is the large number of City of London workers flowing into the financial district. A caption can probably take care of "London Bridge." Even so, the shot needs more than just filling with people. Emphasizing the inward rush-hour flow is the almost deserted outbound lane on the bridge, and it can make a good counterpoint to the pedestrians if I have just one or two vehicles. Naturally, the vehicle of choice, which lets the viewer know where we are, is a red London bus. From this height, I can bisect the frame quite neatly on the diagonal, and that helps divide the two components: pedestrians in, London bus out. I must also shoot a horizontal frame because I need to give the art director a layout choice. This halves my chances of getting the right moment in each, but with almost an hour, I can manage it.

However, doing it this way means matching two different moments. Getting a clean right side of the picture is not so simple. I don't want a vehicle breaking the frame, but there's no control over this. What I want is what's shown here, with a red bus and, as a kind of grace note, a lone cyclist, who's clearly not part of the City office rat-race. On the left side, though, the pedestrian flow is not constant, and the reason for this is that they're coming from a railway station on the opposite side. The crowd is at its fullest two or three minutes after a train arrives, and thins out in between. Juggling the two sides of the frame takes a long time and a lot of frames.

Shooting with a long telephoto like this is like no other lens experience. Even after aiming and straightening up, things move in and out of frame

The Tight View

very quickly and with next to no warning. The open-eye technique doesn't work here. That trick means keeping both eyes open, so that the clear view with your left eye helps you anticipate people and things about to come into frame. At this high magnification, however, the jump in scale from left to right eye is too big, for my brain anyway. If you take your head away from the camera to look, you

can certainly concentrate on the action, but you're very likely to miss the shot in the time it takes to get back to the viewfinder. The usually best method, not ideal, is to stay glued to the viewfinder with a finger half-pressed on the cable release, and concentrate hard, without letting your attention waver for an instant. As a result, there's a certain amount of visual stress in shooting like this. ■

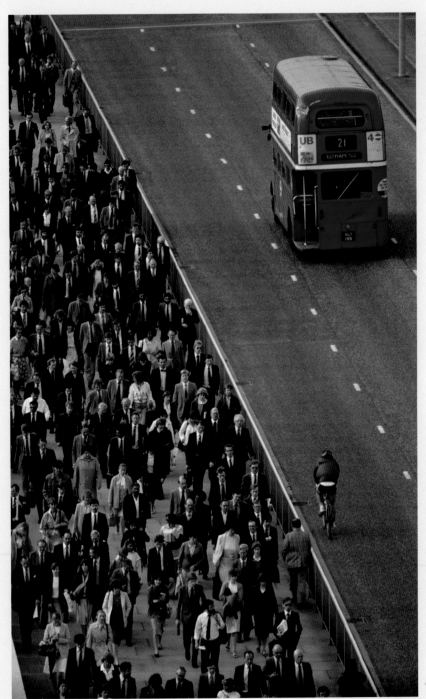

Matching two traffic flows

The shot depended on matching two best moments of opposing flows. One was predictable—the surge of pedestrians after a commuter train arrived at the railway station near the far end of the bridge, which filled up the bridge from average (left in the illustration above) to packed (right). The other was a neat, simple, and sparse arrangement of traffic that included a red London bus.

London Bridge, City of London

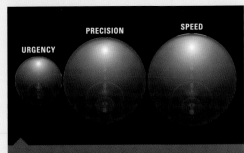

Rating

The only urgency was in connecting with security early in the morning and getting onto the roof. Once there, I had almost an hour. Precision for the final selected shot was high because of the position of the bus, and the cyclist. Speed: absolutely critical, as at this magnification the traffic moved across the frame in a fraction of a second.

ADDING ACTION TO COLOR Marigold Garlands

In Old Delhi's market area, close to some temples, there's a busy trade in marigolds threaded as garlands. In fact, throughout India, these intense orange colors are a relatively common sight, as the threaded flowers are used in pujas and other religious ceremonies. They are a natural target for anyone with a love of rich hues, not least because they make such a contrast with the drab grays, blues, and browns of Indian streets, as you can see from the overall shot opposite. There are a number of ways of handling this rich color, and the one I favored was to make a mass of it, filling the frame as much as

Marigold garlands, Chandni Chowk, Delhi

possible. In other words, a medium telephoto shot—180mm—to compress the perspective and isolate the flowers. But flowers alone were not going

Key Points

Capitalizing on color
Tight framing
Lifting action

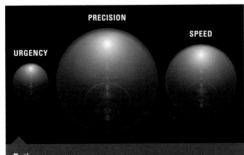

Rating

Urgency fairly low, as the man was staying put at his trade, and the only likely disruption would have been if he had objected to being photographed. Precision was high, both for composition (maximizing the impression of flowers) and for capturing the arm held high. Speed was quite important in the low lighting for reasonable sharpness, even though in one shot there is a blurred hand and this hardly detracts from the image.

to make much of an image, and I looked along the stalls until I found the most compelling face, which belonged to a bearded, turbaned sikh.

The framing was good, with the man on the left and most of the area right of him covered with a mass of marigolds. I increased the mass of color by changing my viewpoint slightly to the left, to bring a second mound of flowers into view—slightly out of focus and taking up the lower-left corner, so that the man was sandwiched between the orange masses. He was threading and adjusting the garlands, so the final choice of shot depended on moment. For most of the time, his hands were low and not particularly active, and while the shots taken like this were acceptable (his face and turban contributed greatly to the shot), it was a moment of more exaggerated action that made the final select, as he raised his arm to lift one garland clear of the mass. ■

Alternatives

The lower hand positions, though satisfactory, lacked the action that lifting a garland in the main shot offered.

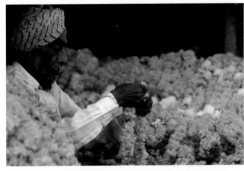

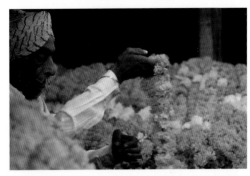

Sandwiched between flower masses

The viewpoint and choice of flower stall were careful, so that the man's head and arm emerge from a mass of golden flowers. The moment of lifting not only gives more information about the scene, but adds energy to what could otherwise be simply a shot of flowers.

A very Indian trade

Flowers for religious ritual, and especially marigolds, are a major business throughout India, where worship at temples and shrines remains an important part of daily life. These stalls are in Chandni Chowk in Old Delhi.

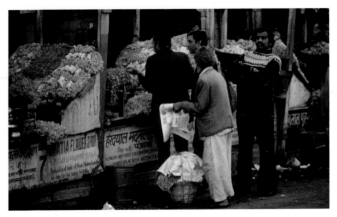

SHIFTING LAYERS Eggs In Tea

Still lifes are not always still. This is an impromptu, found still life in a market, and is as static as you would expect any food display to be—except for the way in which I wanted to photograph it. These are quail eggs being slowly heated in tea, but not anywhere close to boiling, and there was no visible movement of the liquid. The attraction was the color; each one surrounded by a rich orange-brown halo where the liquid was shallow, and the slowly shifting grouping of just three eggs floating. This was an abstract shot in the making, added to by shifting wreaths of steam in the cold air. It was this extra layer of steam above the pot that made it tricky. What could have been a simple two-or-three-shot close-up became four minutes of searching for just the right combination of eggs and steam, all the while trying to keep the frame within the circumference of the metal pot. The final frame count was an unreasonable 36, full of not-quites.

The ideal moment, as it gradually presented itself to the camera position directly overhead, was a neat alignment between a clean gap in the steam and the three slowly drifting eggs. Also, one in which the pattern of steam would appear to have some sort of structure. This took more work than expected. The space available for framing was limited by the confines of the pot—I needed to stay inside the metal rim in order to keep the image abstract—and the three eggs were slowly changing position. I had several off-center positions for them in my mind, but these were also influenced by the steam, and its shapes were moving quickly. Once I had decided to include the pattern of steam, I could not just have some of it partly obscuring an egg. That would have just looked sloppy, and indeed would have been careless. In the end, I had just three satisfactory shots. ■

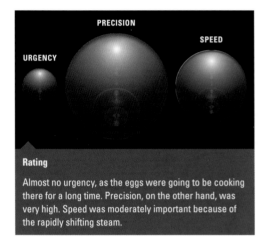

Rating

Almost no urgency, as the eggs were going to be cooking there for a long time. Precision, on the other hand, was very high. Speed was moderately important because of the rapidly shifting steam.

Subtle shifts of framing

In an abstract, there's no point of reference, so your framing options open up almost limitlessly.

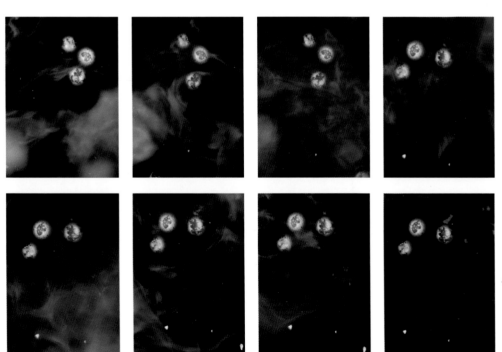

36 for 1

What might have seemed a simple one-off shot turned into a 36-frame sequence searching for the exact moment, taking almost five minutes. I've included just these eight representative frames, but the point is clear.

Key Points
Moving still life
Abstraction
Gaps in steam

Quail eggs in tea, Lijiang, Yunnan, China

TABLEAU MOMENT Lakeside

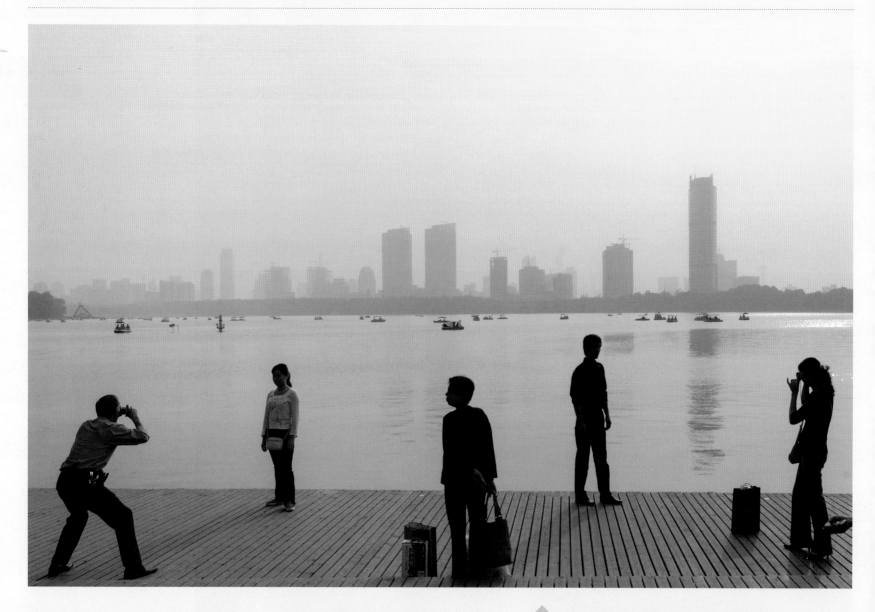

In art, a tableau is an arrangement of several figures who appear to be functioning in some way together, with a suggestion of being deliberate and formal. Inevitably, there's an element of the theater in a tableau, a stage-like setting, and this little scene on the edge of a lake had the makings of just such a picture. Indeed, the decking definitely looked like a stage, and from the start that suggested a viewpoint from exactly in front, lined up, and straight.

People drifted in and out like actors, usually in pairs, and the backlighting helped to make them all seem like a cohesive group (even though they weren't) by suppressing details like the color of clothing that would normally differentiate them, and by showing them in part-silhouette. There was an additional graphic touch that made the shot worthwhile—the correspondence between these figures on the deck and the buildings on the

Xuanwu Lake, Nanjing, China

skyline at the other end of the lake. They, too, looked similar because of the backlighting and because of the late afternoon haze that rendered them all the same pale, warm-gray tone. The numbers of each, people and buildings, was also about right for the comparison.

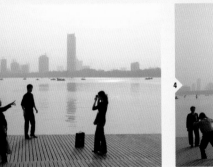

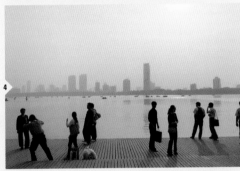

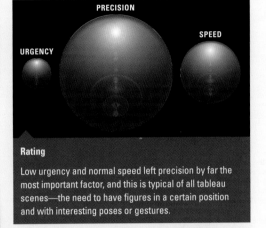

Rating

Low urgency and normal speed left precision by far the most important factor, and this is typical of all tableau scenes—the need to have figures in a certain position and with interesting poses or gestures.

That was the general idea, but what about the best moment in a constantly changing arrangement? I was looking first for separation between the figures, because that would bring a purely graphic order to the image. One of the most basic ideas in composition with photography is to impose order on chaos—a way of putting the photographer's personal stamp on a scene. Not everyone agrees that this has to be done, but it is the tradition in street photography, and it was the one I was trying to follow here. Over a two-and-a-half minute period, I shot just seven frames that made the minimum requirements of separation. All the in-between moments were messier.

Beyond this, I was looking for stance and/or gesture, with a premium on anything that looked interesting or active. Within each picture, there were contenders, such as two people pointing, or an almost balletic walk by one couple, and of course people photographing each other. The moment that worked best for me, and I knew this at the time, had an extreme camera-pointing pose on the left of the frame, matched by another figure on the right also taking a picture. This, as the illustration shows, gave me two inward-pointing pieces of action, which in a way enclosed the scene. ◼

The sequence

The starting point was that almost any arrangement of figures was worth shooting, but catching a moment with some order in it would add significantly.

Stage dynamics

Beyond the natural shape and arrangement comparison between the foreground figures and the distant buildings, the dynamics of the scene were of figures moving in and out, occasionally resolving themselves into little groups, such as the interaction of a couple photographing each other.

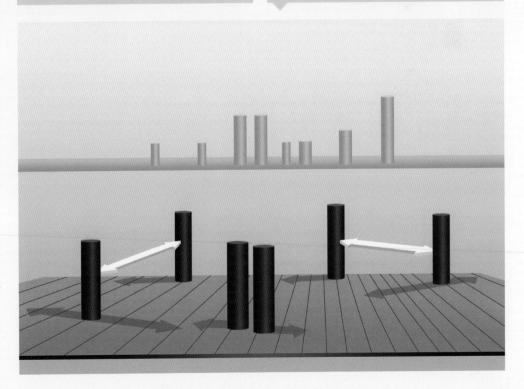

WORKED-FOR MOMENT Falconers

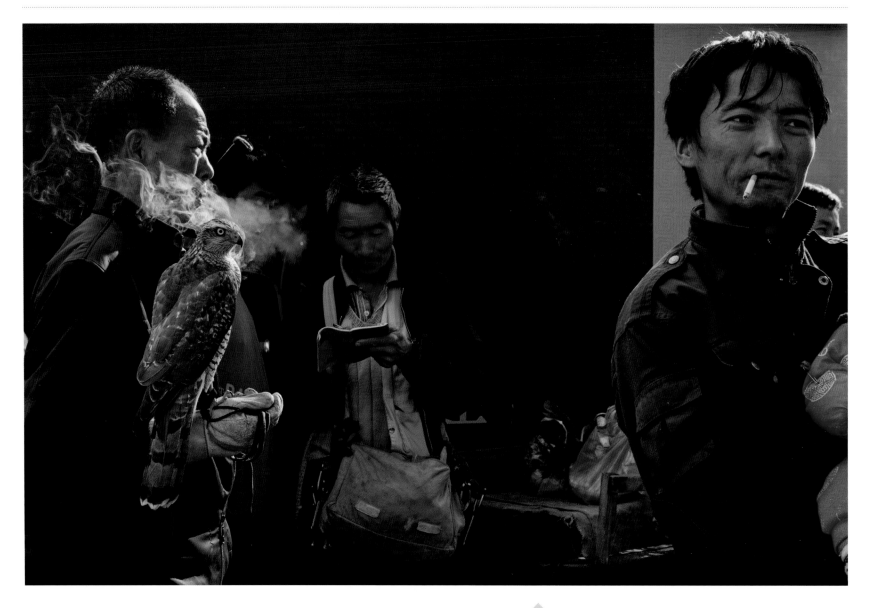

Falconers, Lijiang, Yunnan, China

It's true that any situation with a picture potential that goes on for more than a few seconds needs to be worked at in some way, but certain moments are distinctly demanding, and deliver themselves up only after what feels like real effort. This happens particularly when you're trying to balance more than two shifting elements while discovering, during the process, new ways of combining them. This is one such example, the morning falcon market in the Chinese city of Lijiang, in Yunnan. Falconry is a long tradition among the local Naxi men, and it is absolutely vernacular. These are enthusiasts who have grown up with birds of prey since children, and there's no tourist promotion involved (I'd better say "yet"). Most of the falconers buying, selling, or just discussing were fine with being photographed as long as it wasn't really intrusive, but a few were not, so some social skills were involved in shooting. In a scene like this, it's inherently interesting and unusual, so any competent image will be satisfying. Naturally, though, you would want to take it further and find a telling moment.

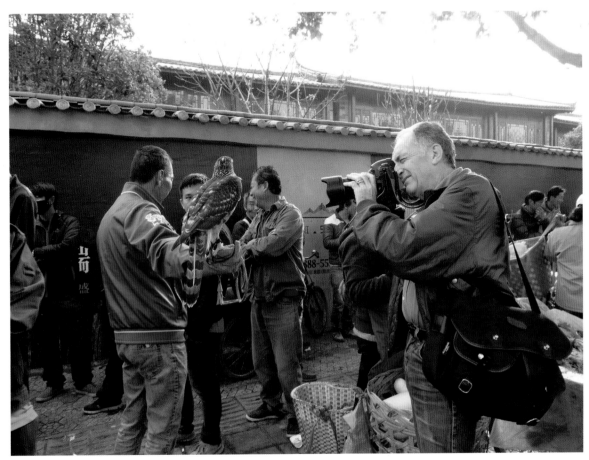

The situation

Against this wall, just outside the city market, a number of falconers had gathered for the morning.

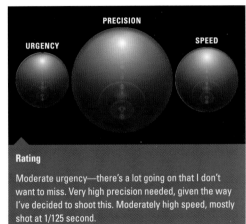

PRECISION

URGENCY

SPEED

Rating

Moderate urgency—there's a lot going on that I don't want to miss. Very high precision needed, given the way I've decided to shoot this. Moderately high speed, mostly shot at 1/125 second.

Within this group of about twenty men against a wall (the wall was good, providing a clean backdrop), there were several units of activity as people got together to examine birds, broke apart, turned away, turned back, and so on. This particular scene looked to have the best potential because there was one man alone for a few minutes, in good light, smoking a cigarette. The edge lighting from the sun outlined him nicely, and every time he exhaled cigarette smoke, that lit up also. That's a moment I would like, but there's more.

I begin by shooting the man with bird on his own. It's pleasant enough, predominantly a lighting shot that will do best if processed for contrast. But it seems a shame to miss out on all the activity and interaction going on around here, so I step back to

find another figure to include. I settle on another man lighting up. He has quite a good face, and I quite like the fact that he has nothing to do with the other man—it gives the sense of different things going on at the same time, also a sense of depth to the scene, and compositionally he blocks off the right side of the frame. He's actually holding a baby, but its red jacket is too colorful for my liking, so I need to crop there. Fortunately, the way he's leaning slightly to camera left, and from this viewpoint, I can keep his head in frame without the baby's.

As I'm moving around to sort out this matter of cropping out the child, I notice the change of color in the wall behind at right. I realize I can use this as a mini-frame for the man's head. It will add just that bit more order to the scene. He's moving, turning his

head, and making it not easy to frame him exactly in this tight space in the top right, while I'm also keeping an eye on the man with the bird. I've only just solved this balancing act when a puff of backlit cigarette smoke wreaths the falconer's face perfectly, for just an instant. It's good, and I realize it, but keep working anyway for another half a minute in the hope of an improvement. But that doesn't happen. The cigarette-smoke instant was the moment. Total shooting time was four and a half minutes.

In summary, there were five elements: the falconer, the edge-lighting (which depended on him standing just in that position and against the dark background), the man on the right, keeping his head inside the frame of light-colored wall, and the wreath of backlit smoke. ■

WORKED-FOR MOMENT Falconers (continued)

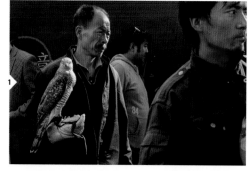

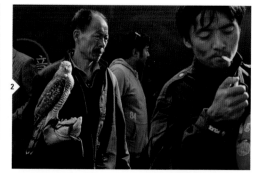

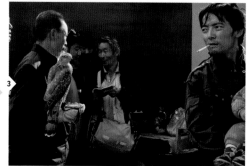

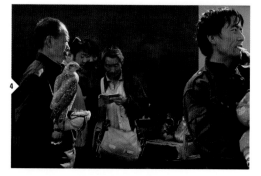

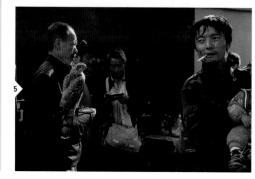

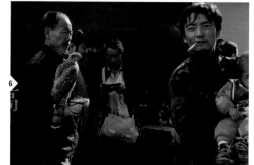

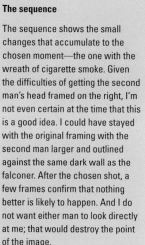

A slightly shifting viewpoint

While the focus of attention is the man on the left, much of the work is managing the figure on the right by moving the viewpoint so that his head is framed neatly. The difficulty here, which I've brought entirely on myself by wanting to have his head enclosed rather than cutting the dark-light dividing line on the wall, is that he's moving and there's very little room for maneuver. I need his head within the overall frame, but am trying for the precision of keeping it neatly against the lighter section of wall. I know it will make a difference, but more of my attention has to remain on the falconer.

The sequence

The sequence shows the small changes that accumulate to the chosen moment—the one with the wreath of cigarette smoke. Given the difficulties of getting the second man's head framed on the right, I'm not even certain at the time that this is a good idea. I could have stayed with the original framing with the second man larger and outlined against the same dark wall as the falconer. After the chosen shot, a few frames confirm that nothing better is likely to happen. And I do not want either man to look directly at me; that would destroy the point of the image.

Viewpoint + light

Recognition of the final moment is triggered by the sunlit wreath of cigarette smoke. However, even before I started working for this particular shot, I had noticed that the position of the morning sun and the dark wall was giving this pleasant backlit effect—an attractive edge-lighting to the birds and falconers, and an even stronger effect on the smokers whenever they lit or puffed. Timing for this, however, when you factor in all the other framing details, was not anything I could rely on, so that when the falconer drew on the cigarette just as I had the second man positioned neatly, I pretty well knew that was it.

BLIND MOMENT Telephone Boxes

British Telecom ArtBox, Chinatown, London

Shooting blind may be a slight exaggeration, but there are some moments that you can anticipate, yet, because of the camera position, give absolutely no warning for shooting. This was one, in London's Chinatown, as part of a story on a city-wide art project. Following on from painted statues of bulls in Chicago and baby elephants in London, British Telecom had commissioned 82 telephone boxes in fiberglass and invited artists to paint them. Here, as there was a traditional red telephone box nearby, it seemed natural to juxtapose them. I tried different viewpoints, and finally went for the graphic option, settling on a very tight crop in which the entire frame was filled with the box and painting—no

94

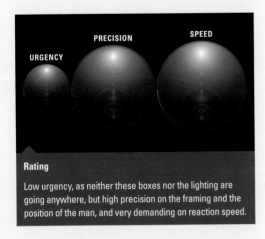

Rating

Low urgency, as neither these boxes nor the lighting are going anywhere, but high precision on the framing and the position of the man, and very demanding on reaction speed.

surrounding street scene at all. As often in a city location where there's an interesting view, it needs the human touch to bring it to life. Framed the way I had it, at this point it was just a street furniture shot—graphically OK, but static. Some human intervention would definitely be desirable, but I'd locked myself into a view that gave me no room to move.

With a standard focal length of 50mm from very close to the painted box, I needed ƒ/22 to guarantee full depth of field. That meant raising the ISO on this cloudy day, and I settled on ISO 800 and 1/100 second, which I judged fast enough to show enough of a passerby while adding just a little blur for motion. But now there was only one place to fit a passerby—left of the dividing line between the red telephone box and the painted one. To begin with, as these boxes were in a small, open square, there was very little foot traffic going between them, so I could be there for a long time. Next, a passing figure would have to fit in the left quarter of the frame, without breaking out of the frame at the left edge, so there was very little room. This is proved by the first two people to pass, from left to right. They hardly fit, and in any case, I mess up both shots by failing to keep the all-important "Telephone" sign in shot. There's

The shooting position

As described, there was just one exact position which would both fill the frame with "phonebox" and leave room for a passerby, but only just. As a result, there would be no warning of someone walking through between the boxes.

BLIND MOMENT Telephone Boxes (continued)

an odd temptation to move the camera when the action appears, and I couldn't resist it. So I move a little to the left to expose a bit more of the red box, and wait for the next person.

But the real problem is lack of warning. If someone comes from the left I can spot them with my left eye (open), but they're moving away, which is not ideal. Best would be coming from right to left so that I can see their face, but then I'll have no warning. Fortunately, I have an assistant who can see if anyone approaches, but she can't tell me exactly when they will appear to the camera from behind the

painted box. Very fortunately, just ten seconds after I've tweaked the camera position, she tells me there's someone approaching, and I catch him, also holding the frame exactly as it was. Even better, he's an acceptably iconic, white-shirted Chinese businessman—we are, after all, in Chinatown. This is a real stroke of luck, and as I half expect it isn't repeated. After three minutes of nothing, I try for another way of doing this, moving to the right so that the red telephone box butts up to the right edge of the painted one. It's easier to catch people, but a much less interesting, untidy composition. ∎

A weaker alternative

Easier for shooting because passing figures could be anticipated, this framing to the right lacks the graphic simplicity of the main image, and was abandoned after three shots.

The setting

From just across the street, this is the setting for the brightly painted phonebox and its real counterpart in red.

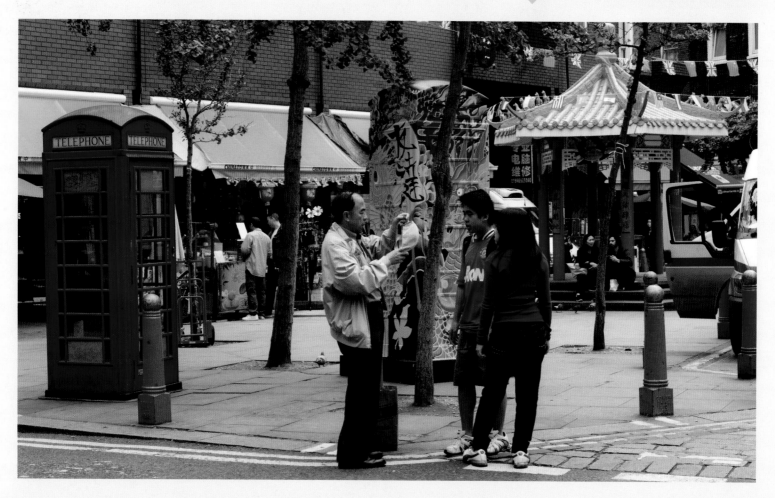

Alternate view, not as tight

Almost, not quite

The first shot here sets the framing. The next two miss but show that success might be possible if there is a little more room on the left. The fourth shot is a new framing with the camera position a step to the left.

PLANNED MOMENT Alms Collection

Staying in a small town in the Chin Hills, Myanmar, on assignment for the book mentioned on page 41, early on the first morning I explored the winding main street that followed the ridgeline. Some time after 8 o'clock I suddenly came across a line of monks walking down the road, collecting alms. Alms collection in the early morning is typical in Buddhist countries, especially in the small towns, where shopkeepers and house owners, usually the women, stand outside their front doors to offer food to the passing monks. Most of Myanmar is devoutly Buddhist, and this is such a standard event that I was sure that almost all the other 30 photographers working on the book would be searching them out in their different locations. Ordinarily, I would pay some, but not a great deal of attention to this, unless there was something special added to it. This was special, it turned out, because the local abbot was well known in the country, and charismatic, so his monastery had many monks and novices. Here was a much larger alms collection than usual.

There was an extra photographic element also. I mentioned this was a ridgeline town, and that meant the road wound through it in a succession of S-curves. A snaking line of orange-clad figures was definitely worth working for; on the graphics alone, it should make a good image. This first morning was too late for that, as they were already past and there was no high viewpoint nearby, so later in the day we drove up and down the entire town looking for a view down on an S-bend. That done, and having asked around for the exact time the procession would pass, we returned early the next morning, and there were no surprises.

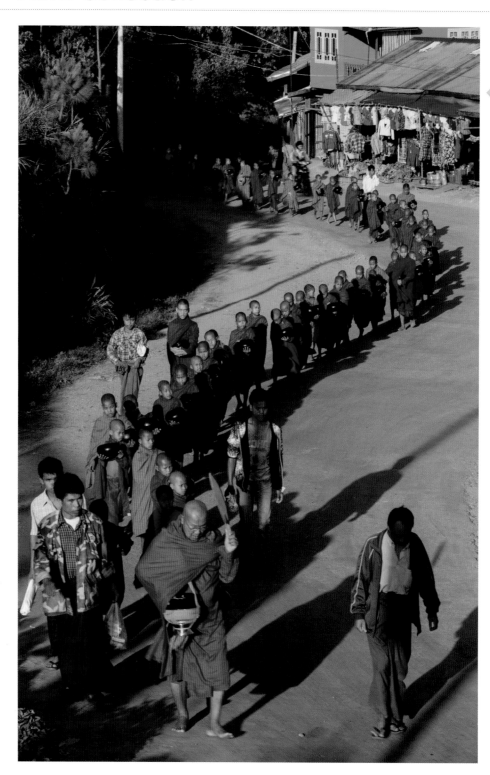

Buddhist monks collecting alms, Mindat, Chin State, Myanmar, 2013

Buddhist monks collecting alms, Mindat, Chin State, Myanmar, 2013

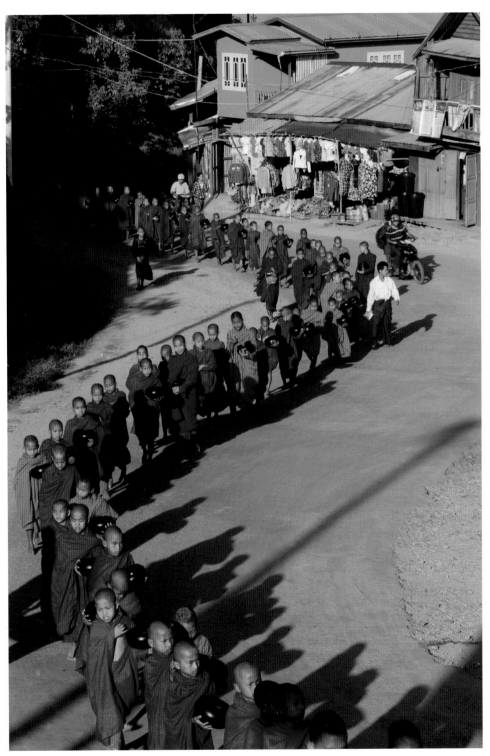

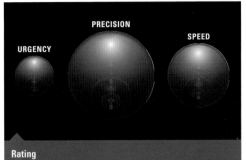

Rating

I removed the urgency almost completely by planning the day before. Precision was key, though not difficult. Speed was moderately important—the lowest possible to freeze walking movements so as to allow maximum depth of field, meaning 1/60 second and *f*/22.

The question was which would be the best moment. One possibility was simply maximum orange, a moment after the head of the line had passed and before the last stragglers when there were the most monks visible in frame. The other possibility that I had to cover, for journalistic reasons, was the best moment to include the abbot, who naturally led the line. I shot for both, the publisher used the first. ■

The previous day

Too late to consider finding a good overview, this was the alms collection line seen the day before.

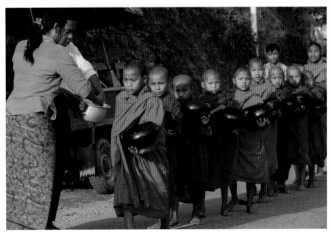

PLANNED MOMENT Alms Collection (continued)

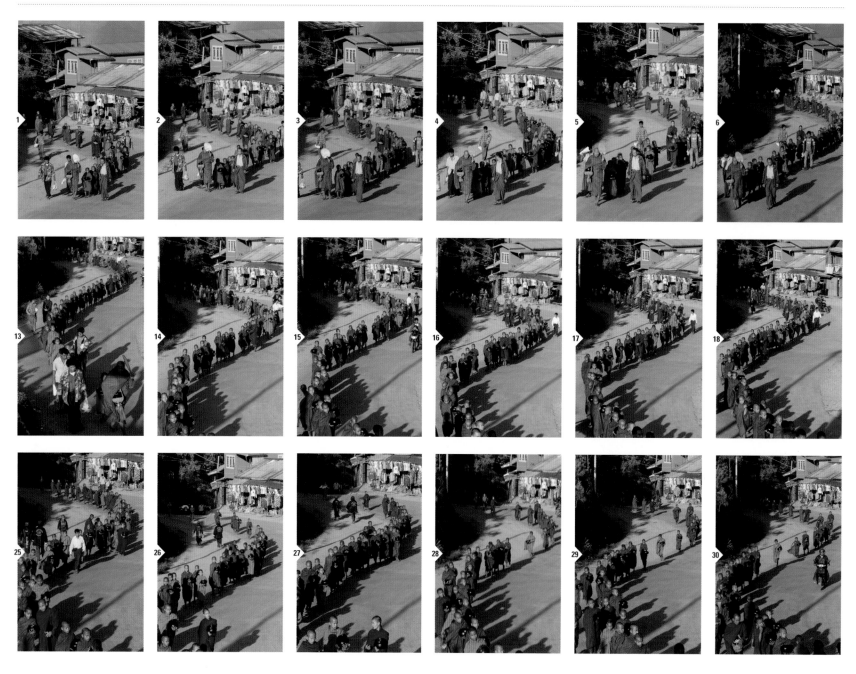

The full take

From first appearance to stragglers at the end, the entire sequence took a little under two minutes and 31 frames.

Two competing moments

The two moments for shooting, equally valid, were with the abbot at the head and a full line of winding monks. Both needed to be shot, and the final selection was influenced by an unexpected factor—the visual similarity with another image, shown on page 80.

101

AMBIGUOUS MOMENT Arlington West

Crosses & coffins, Santa Monica beach, California

Underlying the choice of most moments is the unspoken principle of aptness. We all have our own, independent ideas about what the apt moment is for any situation, but the most common ground has something to do with explaining the action or the activity. It's the ball-in-the-net principle, the natural moment that makes sense of what has been going on. However, against this basically journalistic approach to photography, there is the appeal of

ambiguity, of unsettling the viewer's expectations by showing something strange, mysterious, or out of kilter. This doesn't always depend on moment—it can be done by a certain kind of framing or a juxtaposition—but here is one such image that needed a choice of moment (combined with framing).

When I visited Santa Monica pier on a weekend, I wasn't at all familiar with this regular event, called

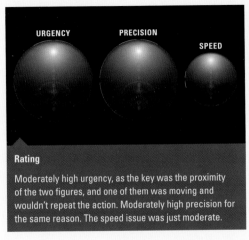

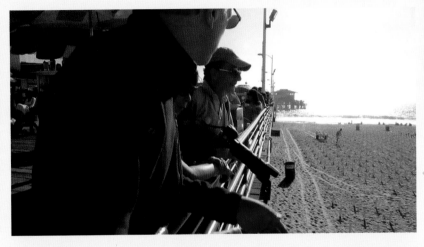

Rating

Moderately high urgency, as the key was the proximity of the two figures, and one of them was moving and wouldn't repeat the action. Moderately high precision for the same reason. The speed issue was just moderate.

The viewpoint

The scene was shot from the pier at Santa Monica, right next to and above the crosses and coffins.

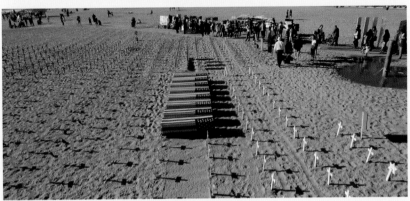

The sequence

The man with the barrow appears in view ten seconds after the first shot. The last frame underlines how different the scene is without the prone figure.

Arlington West (after the military cemetery near Washington DC, where President Kennedy, among many others, is buried). This is a memorial to war—and particularly the wars in Iraq and Afghanistan—that goes up and is taken down each Sunday. So, it took me by surprise, and it seemed unusual enough to merit a shot. The angle and height from here on the pier also seemed right, and I first framed it in a natural, explanatory way, with the row of coffins taking up the foreground, all the way to a thin strip of the Strand beach path and sea, to show its location. Straightforward, but then I noticed a figure lying down in the middle of the crosses. What was he doing? Drunk, asleep, or both? It was an odd choice of place for a nap. I waited, because as it was, it wasn't too interesting, and yet there was clearly the potential for a strange image. That was going to need a moment of one kind or another. By good fortune (actually, the time of day, late in the afternoon), along came someone with a barrow, and this, it turned out, was for stacking and clearing away the crosses.

What now goes through my mind is the crop. How am I going to frame this with the barrow-man adding action? Could be vertical right up to the sea, or a simpler without the sea. Then I realized that while the man with the barrow and the prone sleeper had nothing to do with each other, I was intrigued to see what would happen when he got closer. Would he wake him up? Tell him off? Nothing did happen, and the sleeper went on sleeping for as long as I stood there, but when the barrow approached to the point in the main picture, I had the weird thought that he was about to carry a corpse away. It all remained unexplained, which I liked, and I had the good sense to re-frame to exclude the sea and people. Less context meant even less explanation. ∎

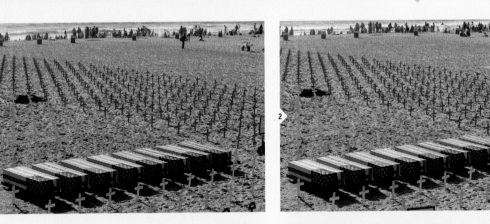

1

2

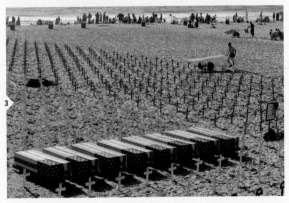

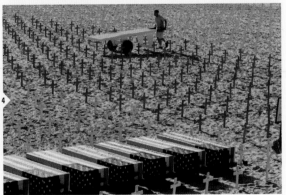

3

4

103

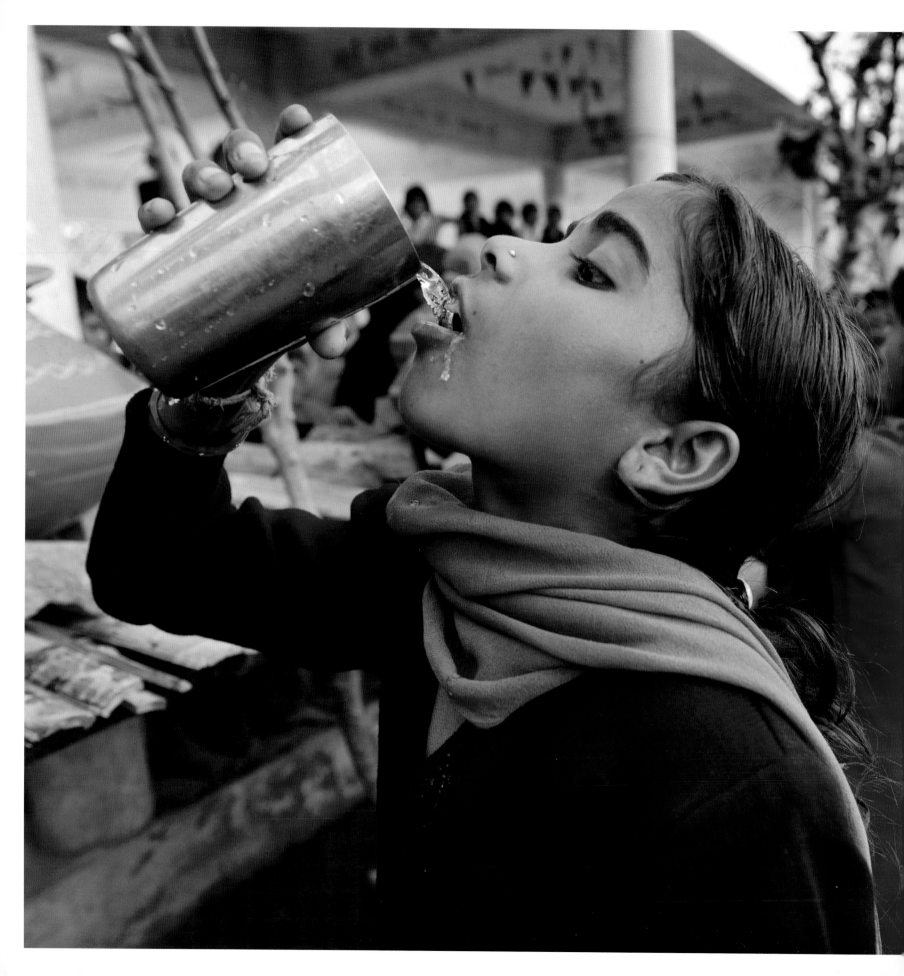

FAST MOMENTS 3

Many of the moments in the last chapter were fast, but their essential quality was that they had everything to do with viewpoint, and that outranked everything else. Here in this chapter, what the moments have in common is that they happen rapidly, and this takes precedence. There are two dimensions to this. One is their pure speed. The other is their onset and how it relates to us as photographers.

Speed first. What actually counts as fast is a purely practical matter, both for the shutter speed setting and for the photographer's ability to react. By convention only, and for no other reason, action that can be caught at 1/125 second is generally considered average. In fact, most of us are in the habit of unconsciously rating action by the shutter speed we know or think will stop it. 1/250 second and above is conventionally fast. This is just what the camera can do, and the photographer's own reaction time is more important. This is an eye-finger coordination that you can actually work on to improve by

practice. The electronics in some digital cameras inconveniently add a time lag to shooting, and it's a good idea to check a new camera's performance before committing to it. It may sound odd that the practical benchmark for shooting is still a cocked mechanical shutter.

Second, the onset of the moment: This has nothing to do with the camera and lens, and everything to do with being primed for any situation. Any warning that you can get helps. Even a second or two is time that you can spend working out the framing and even the meaning of the shot. Situations are highly specific, but here I'm showing them as much as I can as examples of types of fast moment. And, as you might expect of our three qualities of moment, while Precision ruled in the last chapter, here you can see Urgency and often Speed take over. It's worth stressing again what I said in Chapter 1, that with Speed we're looking at how important it is to a shot, not necessarily whether it is high on the camera dial.

CLASSIC MOMENT Japanese Cranes

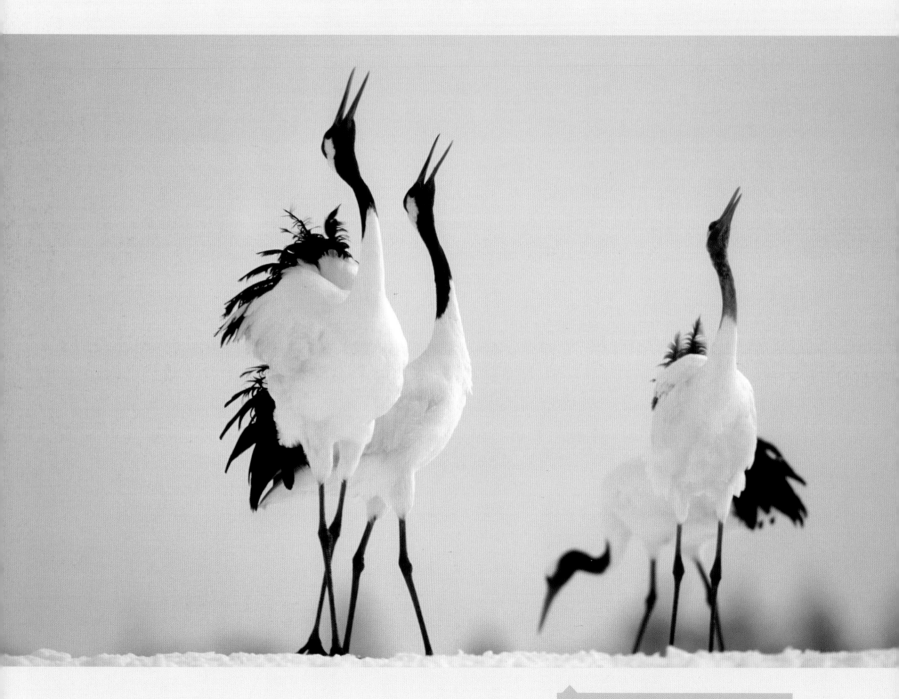

Japanese Cranes, Kushiro, Hokkaido

Some situations, simply because of the subject, contain an audience expectation. It's the ball-in-the-net principle again. The viewer expects to see the ball go into the net, and any moment short of that is likely to disappoint. Not all photographers are comfortable with this, because it seems like an external measure of success or failure. If you don't get it, you missed. In many ways, independently discovered moments, even something as small as the silhouette of the man walking home his cattle on page 68, are easier to deal with, because they don't have the pressure of the audience. If a moment like the girl on the bench on page 166 didn't come off, no one else would be any the wiser.

Wildlife photography seems to have a large share of this kind of expectation, what I'm calling the classic moment, because what drives it is behavior. Top-level wildlife photography focuses on the behavioral, and it's less that the viewer knows what different species are capable of, than wanting to see and learn more. Gone are the days when a well-lit shot of a pride of lions sitting contentedly, looking out over the savannah, could make an admired shot. We now need things going on, ideally moments of behavior that are specific to the creature in front of the camera. If you were in position at the place and time where a key behavioral moment is likely, it would be perverse to ignore it. That was the situation here, in the Kushiro wetlands of eastern Hokkaido, Japan's northernmost island, where Japanese Cranes gather for elegant and delightful winter courtship rituals. There are a few key moments in the ritual, and one of them is this, the part of the dance in which the couple walk together, heads raised back, both making a long fluting call. If you don't catch at least this, then you've wasted your time on the long journey to reach here in January or February.

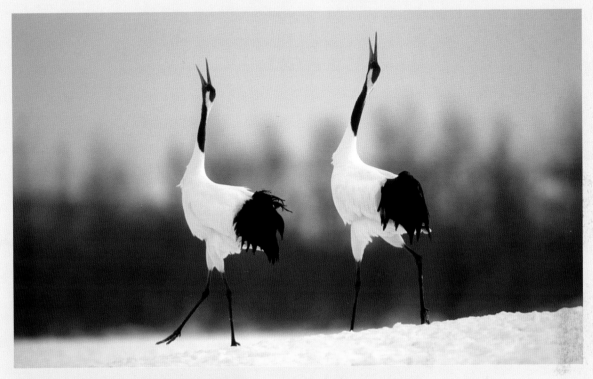

URGENCY PRECISION SPEED

The background makes the difference

The position and moment of the pair here is spot-on, but the shot is marred slightly by the dark mass of trees behind—at least in comparison to the main shot, which is much cleaner and simpler.

Rating

Fairly high urgency, as the birds were moving around quite a lot and the 600mm lens is heavy and slow to use. Precision was also moderately high, because the shot needed clear separation of the birds and clearly outlined heads and beaks to work. A fairly fast speed of 1/250 second was needed to keep the action sharp.

CLASSIC MOMENT Japanese Cranes (continued)

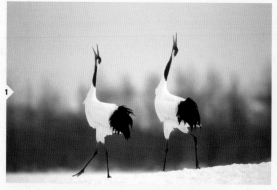

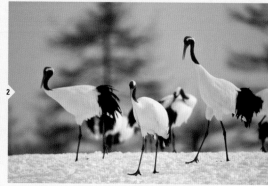

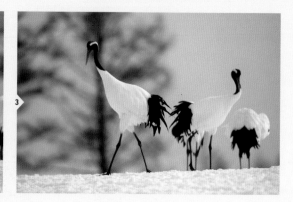

Pair calling in unison, background slightly confused.

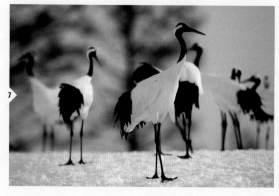

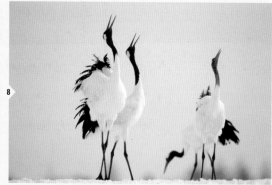

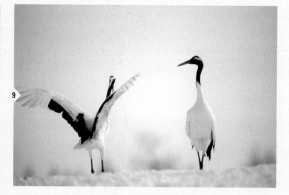

Pair calling in unison, very clean.

ence
point
me telephoto

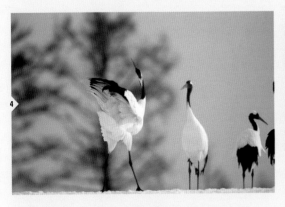

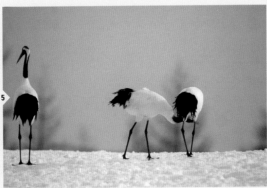

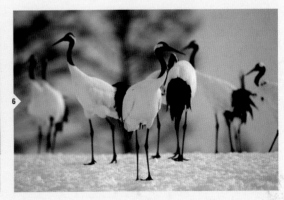

Nice display, but visually confused against other birds.

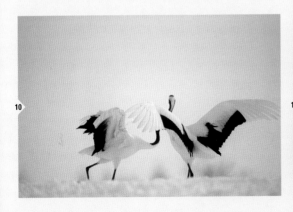

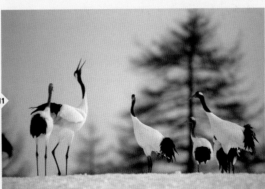

Clear and good arrangement, but only one bird calling.

Of course, every other wildlife photographer knows this, too, and I was certainly not alone. One picture I missed shooting, and wish I had, was of the line of dozens of Japanese photographers shoulder to shoulder, each with a tripod and very long lens, behind a fence that allows the cranes space. Well, you didn't really think that this winter scene was taking place far from human gaze, did you? This at least removes one variable from the shooting. Once in place, there's no room to move about. Shooting means having the right focal length for the scene (here a 600mm $f/4$ lens wide open), constantly following the birds and keeping them in frame, patience, and some luck in catching the display against a clean background and with a pair neatly separated. As the outtakes show, there is a lot of movement and changing of positions. When it comes to the fine details of moment, the clearest, classic instant is in profile so that the open beaks show clearly, and with at least the dark parts (neck, head, beak, legs) separated.

This is a moment for which prior knowledge helps. I suppose you could work it out on the spot, and realize that certain actions were more special than others, but in practice, wildlife photographers do their research first. ■

MID-AIR MOMENT Coconut Monkey

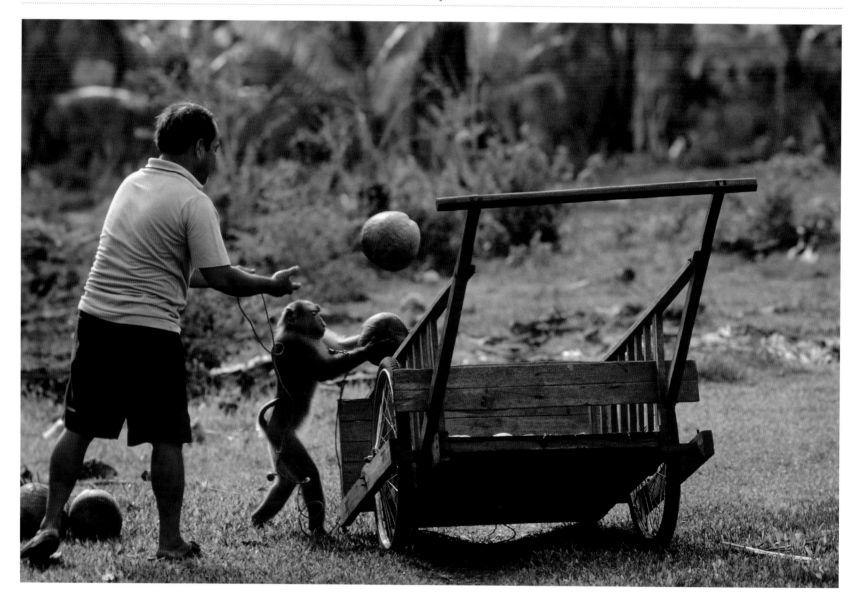

One of the earliest fascinations with photography was that it could show things that the eye and brain cannot (or rather, do not). Walter Benjamin, quoted on page 12, was just one of many commentators who recognized that the frozen moment was unique to photography, and was more than just technically interesting. A horse with all four feet off the ground, as in the sequence on pages 20–21, is something our vision system just

doesn't process, and so seeing it caught seems special. Mid-air moments in general have this quality, to the point where the audience now expects them. Things thrown in the air have the same quality, and reactions are ingrained. Put almost any photographer in front of a scene where some object is being thrown a short distance (it stays in the frame), and they will try and catch the same mid-air moment. This is the peak of the

Coconut monkey training school, Surat Thani, Thailand

parabola. There is some logic in doing this, because not only does the thing suspended in mid-air catch the attention strongly, but it also connects the thrower with the destination.

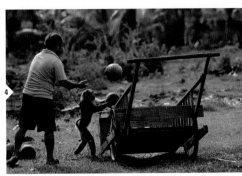

PRECISION

URGENCY

SPEED

Rating

Average-to-high urgency, because while I was spending the day with this couple, this particular situation happened within the space of a minute. Precision had a high need, both in terms of catching the coconut in mid-air and getting it cleanly outlined in the space to the left of the cart's handle. Speed, too, was important, in that the moment needed to be frozen, and 1/250 second took care of that.

That was the case here, part of an unusual story on macaques trained to work in coconut palm plantations in southern Thailand. They have to select ripe coconuts, twist them off, and throw them to the ground, and they seem to do the work better than people. This particularly smart macaque, called Nooey, was a star employee at a training school in Surat Thani. As you see, he also helped with other matters, so this was a key shot. Getting this kind of moment right involves not just the timing, but also the viewpoint, because the coconut needed to be center-stage, and outlined as clearly as possible against its background. In fact, there were two coconuts, because Nooey placed rather than threw, and what makes the difference is that his owner, Somporn, is doing the throwing. A competing frame was #2 above, in which the man stands back and lets the macaque get on with it. It qualifies mainly on the grounds that the macaque is being independent, but in the end it became second choice to the main shot, which has the advantage of a coconut flying in the air.

The sequence

This activity did not last long before the macaque tired of the effort.

Coinciding mid-points

What determined the success of the final moment was that the two coconuts, one thrown by the man, the other by the macaque, are in line for a fraction of a second.

MID-AIR MOMENT Coconut Monkey (continued)

But this was not the only good moment in the extended action of gathering and loading the coconuts that the macaque had twisted off their branches and thrown to the ground. It had been trained to help in collecting them, and was quite comfortable walking on two legs, as long as it needed to occupy its arms. Much of this, naturally, was for display, but mastering different routines was part of the training. Carrying coconuts slung from a pole was, in fact, useful, and certainly looked quite amusing. Without stage-managing the routines, which I didn't want to do and didn't feel was necessary, my options for best moment depended on how I chose the viewpoint. Using a wide-angle to standard lens and walking with the pair would have been one option, but I decided

Coconut monkey training school, Surat Thani, Thailand

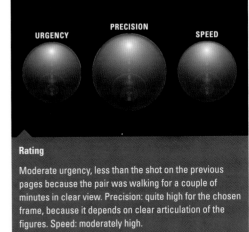

URGENCY **PRECISION** **SPEED**

Rating

Moderate urgency, less than the shot on the previous pages because the pair was walking for a couple of minutes in clear view. Precision: quite high for the chosen frame, because it depends on clear articulation of the figures. Speed: moderately high.

instead to stay with the 180mm lens, for two reasons. One was that with this longer focal length I could frame them without the sky or distance, and that kept the scene simpler. The content of the shot was all-important here, and the clearer the better. The second reason was that I could shoot a number of frames without having to move much. As the sequence shows, I started with them coming toward me, then passing to one side. This gave me two kinds of shot, and each works well in its own way. With all this planning making it slightly predictable, it fell to an unexpected action to deliver the most interesting moment—when the trainer turned to call out to another person well out of shot. The macaque couldn't care less about this, with the result that it seems to be pulling the man along as if to hurry him up and not get distracted by other matters. ■

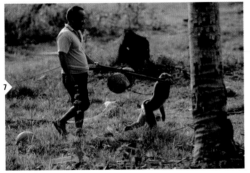

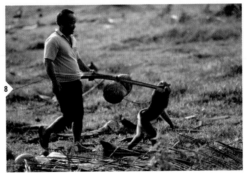

The sequence

The basic configuration of the shot changes from walking toward the camera, to side-on, which gives the clearest view of the macaque walking.

STILL-POINT Sufi Dancers

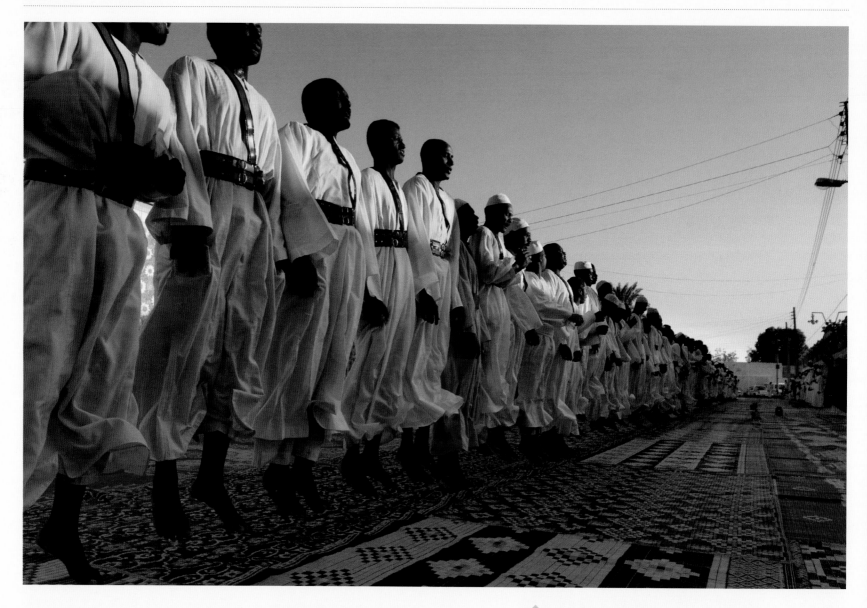

Sufi adherents jumping, Omdurman, Sudan

This is a kind of mid-air moment, but without the forward motion. This is Friday in Omdurman, Sudan, just across the bridge over the Nile from the capital Khartoum, and with a number of prominent Sufi sects, the normal Friday prayers in a Muslim society take an unusual form. Sufism stresses the mystical dimension of Islam, and some of the orders, or tariqah, perform trance-like group actions that involve whirling, spinning, or jumping. Here at the Sammaniya mosque, adherents stand in a long line and jump in unison, while chanting the names of God. This is impressive to watch, not least because almost a hundred men are in the air at the same time. And that clearly is the time to catch them in a photograph, so the key is to show that their feet are above the matting. With no direct shadows from the feet, which might have helped, and a

busy pattern on the woven mats, the answer was a low, kneeling viewpoint and maximum height of jump, which in turn meant catching the still-point at the top of the jump. In addition, given the overall tonal contrast, local processing slightly enhanced the contrast between dark feet and lighter matting. Because of the way the light fell, the upper torsos of the men compete strongly for attention in this image, so the feet need this help.

A telling aside on this is that this was my crossover year, and for the book I was working on, about Sudan, I was shooting both film and digital side by side. Generally, I would shoot film when there was ample light, and digital when not. Here, at sunset, I did both. The big difference was the speed rating, fixed at ISO 50 for the Velvia I was using, adjustable for digital. It meant that the still-point was technically essential for the film shots—the only way to guarantee sharpness at 1/60 second and ƒ/5.6. That heightened the need for precision with the film. I played safe with the digital, setting the rating four stops higher at ISO 1000 and shooting at 1/1250 second. A slight failure of nerve on my part. ∎

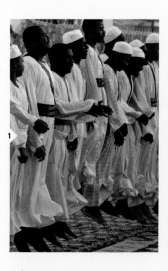 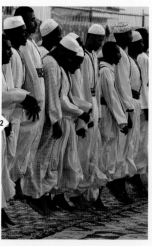 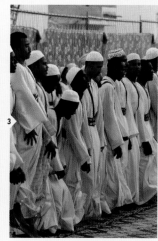 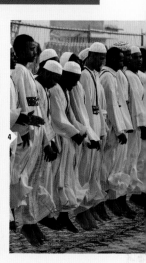

Vertical frame

Another approach was from a standing viewpoint and vertical framing. Less immediately obvious than the main shot, but for that reason also a strong candidate, with a slight built-in delay to seeing what is happening. This can sometimes and for some viewers be more effective.

The feet are the key

Catching the moment at which the feet are most prominent, and in particular most strongly separated from the background. The camera viewpoint is critical: low, and at an angle that takes in the most number of men clearly.

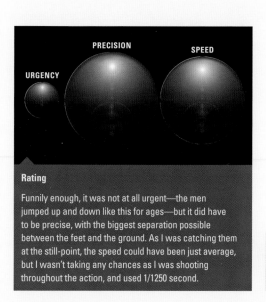

Rating

Funnily enough, it was not at all urgent—the men jumped up and down like this for ages—but it did have to be precise, with the biggest separation possible between the feet and the ground. As I was catching them at the still-point, the speed could have been just average, but I wasn't taking any chances as I was shooting throughout the action, and used 1/1250 second.

TIGHT MOMENT Trooping the Color

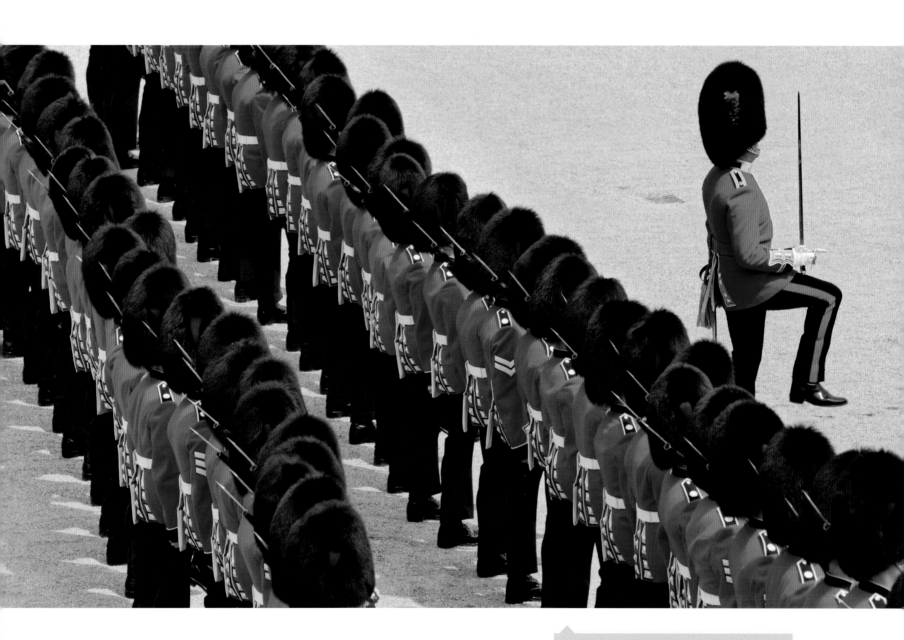

Trooping the Color, Horseguards, London

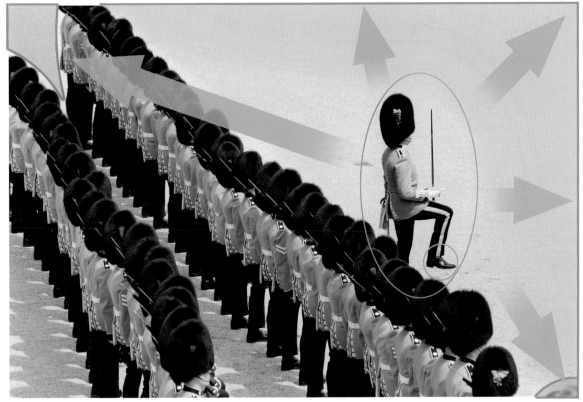

The need to crop

Tightening the frame removes the distraction, represented by the arrows, of empty parade-ground space (and an out of focus spectator's head at bottom right).

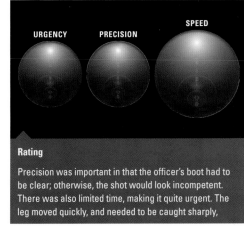

URGENCY PRECISION SPEED

Rating

Precision was important in that the officer's boot had to be clear; otherwise, the shot would look incompetent. There was also limited time, making it quite urgent. The leg moved quickly, and needed to be caught sharply,

Total organization and a locked camera position, coupled to a thoroughly over-photographed occasion, made the annual Queen's Birthday Parade in London, otherwise known as the Trooping the Color, a challenge, to say the least. The only thing that could possibly set an image apart from all the other millions would be moment, plus judicious framing. This is a ticketed and controlled event, held each summer at Horse Guards, in central London. The shooting position was restricted, as all guests were in tiered seats, although I managed to get higher to some unoccupied ones. This still made little difference, because here I was shooting with a fairly long lens from a distance—200mm focal length—and this

meant that there was hardly any parallax to play with. Moving to one side gives you a different composition only if you are fairly close to the subject, and here I was not.

There were many views of massed ranks of colorful troops, some mounted, but I wanted something more idiosyncratic. That moment came at one point in the parade when the ranks of infantrymen are marking time—marching on the spot—and the officer in front was at just the right distance that as he stepped, his boot just cleared the bearskin helmets. This looked like a worthwhile moment, because of its innate simplicity—diagonal rows of troops contrasted with single figure, and nothing else in sight.

This opportunity would not go on for long. They were simply marking time before marching again. There was time for just eight frames with the leg raised, and three of these seem to be mis-timed badly, but this is because the officer failed to raise his leg fully (you could imagine the drill sergeant doing a postmortem on this). Two were almost, which is the same thing as missed, leaving just three with the boot clear. Add the small but important detail of which leg—only the right leg showed the red stripe—and there was only one frame of choice.

There was also a need for a crop, which the illustration explains. Too much empty parade ground space distracting the eye away from the

TIGHT MOMENT Trooping the Color (continued)

officer and his boot. The crop, at least to my mind, solves this. Unfortunately, precision isn't what it used to be in the army, and the ragged line of the troops would surely offend the commanding officer if he saw this picture! It certainly offended my photograph.

What amused me later was that my photographer friend Steve Vidler, who bought the tickets and persuaded me to dress up in a suit and tie and join him, used exactly the same moment and crop for a double-page spread in his book on London. I didn't until then know that he'd been shooting just as I was. Less a case of great minds thinking alike than two professionals thinking a scene through in the same way. ■

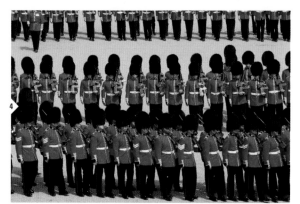

The lead-up

The ranks approach the camera and then wheel left. The final shot comes just after, from zooming in.

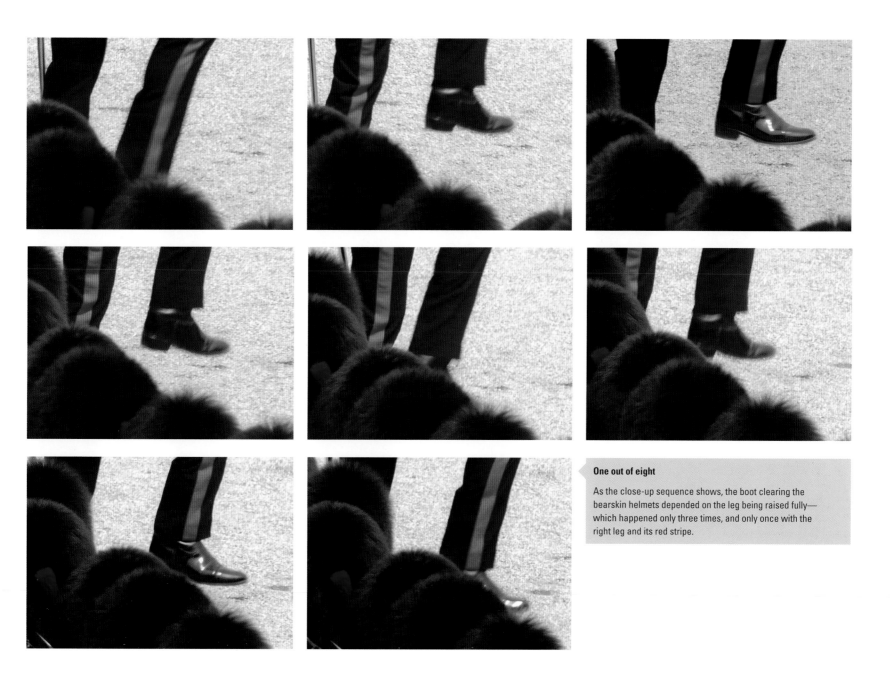

One out of eight

As the close-up sequence shows, the boot clearing the bearskin helmets depended on the leg being raised fully—which happened only three times, and only once with the right leg and its red stripe.

INTERACTION MOMENT Canal Boat

Canal boat #1, Grand Union Canal, England

This situation, on the Grand Union Canal in the British Midlands, differs from the other two interaction moments that we just saw in that the couple was fully aware that they were being photographed. In fact, I was spending the full day with them, as part of a magazine assignment on the British canal system. This kind of situation, pre-arranged but ultimately fly-on-the-wall, is normal in assignment reportage, and gives a kind of hybrid people photography, somewhere between portraiture and street shooting. Here were two of the personalities of Britain's canal system, Ivor Batchelor and his partner Mel, and the job was to spend the day with them and follow their work on the Grand Union Canal, delivering coal—the only people still doing what used to be common long ago.

At one point they were moored by the canal bank, and using the phone to take orders. Ivor was quite extroverted in his way, and added to that, maybe, was the fact that I was there. Sometimes there's a kind of extra impetus from the presence of a photographer, though that depends on the personality of the subject. To some extent they were, if not exactly acting up to the situation, at least aware of being on camera. With some subjects this can be too much, but this couple was just right for the occasion, so there was a choice of good moments, and enough to prompt a mini-essay on delivering coal from their barge.

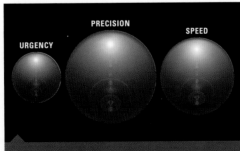

URGENCY PRECISION SPEED

Rating

Both selected shots share the same balance of urgency, precision, and speed. Urgency is very low for the entire situation, as we're all together for the day, and quite low for this specific situation, as it's held together by a phone conversation that goes on for several minutes. Precision, though, is high, both for composition and the quickly changing expressions. Speed is moderately important, as everything in view needs to be sharp. Motion blur would definitely detract from this scene.

The neat view, amused expression

To simplify, I've here prepared two ways of looking at this shot: composition and interaction. Composition, which depends on timing as much as viewpoint, rules the scene quite strongly, and hinges on a comparison between two simple shapes: Mel quite clearly triangular, and Ivor behind more compact and rectangular. Contributing to the neatness of the shot is the way in which Mel's head and arms stand out clearly against darker backgrounds.

The second diagram focuses more on the content of the picture. The most obvious part of this is the moment of the two expressions and directions in which each faces. These are separate, and yet acknowledge each other. Also, parts of the content are the tellingly coal-stained hands and arms of Mel in the foreground.

INTERACTION MOMENT Canal Boat (continued)

Left **Frontal** **Right**

Three viewpoints

A progression of three shooting angles in the search for the clearest way of telling the story. The first is the least effective; the second aims for neatness; the third showing the coal.

The viewpoint and framing were important to the moment—an example of how usually everything is linked in some way in a photo, however much we try to break it down into components when we talk about imagery. From where I was standing, on the bank, I could get both people neatly and clearly in frame, and after the first three shots, taken from the left at an angle to the barge, I moved so that I was exactly side-on to the boat. From here, I had Mel very firmly in the foreground, and the telling detail of her coal-blackened hands was important tot he story. This worked for the next four shots, the last of which was on of my two final selects. I then moved right to get a clearer view of the coal lying in a mound at their feet, and stayed with that viewpoint until the end. Through the course of this, the interaction of expression between the couple dominated the scene, Ivor jokingly on the phone, Mel's expression going from neutral to amused to finally turning and laughing at Ivor's conversation.

All the shots work to an extent, showing the couple, their relationship, the barge with its coal. The final choice is open, but the logic of my two alternatives goes as follows. Ivor on the phone behind stays consistent throughout, so I concentrate on Mel. I first eliminated her neutral or turned-away expressions, which are nearly all at the beginning. It's then a choice between amused and turning-and-laughing. In the first selected shot, in addition to the amused expression, we have simply have a very clean and neat composition that explains things very clearly—Mel with her blackened hands set against Ivor on the phone, and the lines of the barge simple and horizontal. The second select is more active, less tidy, but with an obvious, almost touching bond between the couple as she turns toward him laughing. ∎

Canal boat #2, Grand Union Canal, England

The active view, turning & laughing

A looser composition, less tidy, but here we see the coal that is the basis of their daily canal lives, and above all the spontaneous reaction that connects the couple as she turns and he grins. In other words, this is a moment with more content to it.

123

INTERACTION MOMENT In Darfur

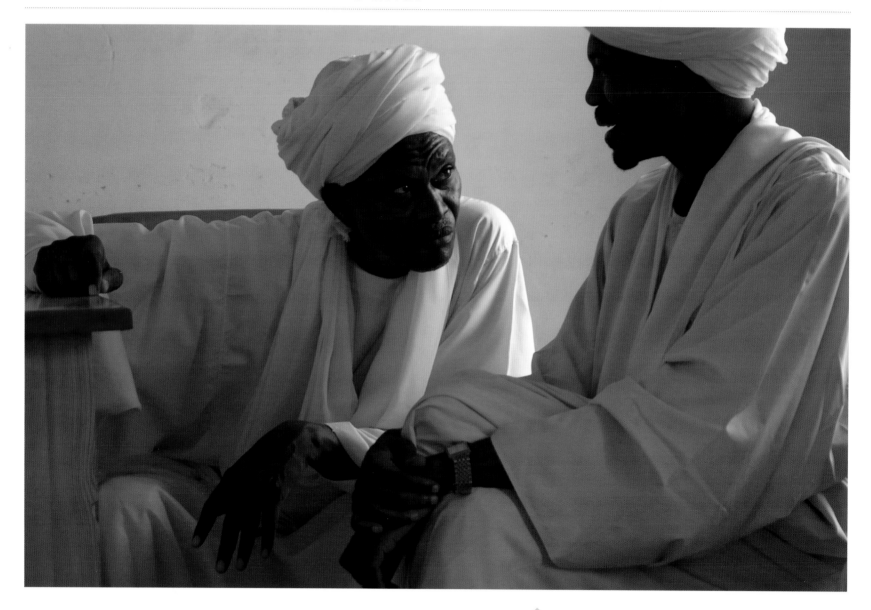

People together interact—usually. Limit the framing of a shot to two people and you can expect that interaction is what will make the shot as good as possible. So, it was here in Darfur, Sudan, at the height of the crisis, at a meeting between omdars (sheikhs). The room was not large, certainly not enough for me to move around, and in any case I wanted to be a fly on the wall as they talked. In this political crisis, I need a shot that would show a serious level of engagement, so expression and interaction were important. It lasted for an hour and a half, much of it in different discussions between two or three people, and occasionally they changed places. From where I sat on one side of the room, I had a good potential framing of the far wall. Two things going for it were good cross-lighting giving nice modeling, and a great color palette. Here is how it went, shot by shot:

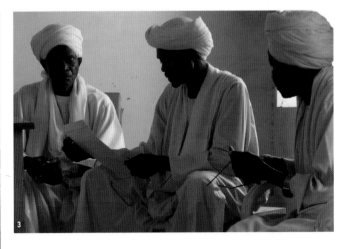

1 Not much of a picture, but it has potential. The window light from the right gives very good modeling, the color palette is a harmonious desert-like one of yellows, browns, and chromatic whites, and above all the omdars look exceptional dressed like this. One big problem is empty space separating the two figures, and indeed, they are not interacting and are not expressive. Also, the desk at left distracts—that will have to be the left stop to my frame for the rest of the shoot.

2 Things start to take shape. Crucially, the figure at left has changed places with an older man who has more to say and has an expressive face. He has pulled the chair out away from the desk and closed the gap. The two men are getting engaged in discussion. Dark faces and hands punctuate the white jalabiyas and yellow wall, and this contrast dominates the composition. I try a vertical framing, but it doesn't really work—too much useless space below and to the right.

3 Just four seconds later, I see a slight improvement when the man at right shifts his head a little and I get a separation of his head from the window. But this hasn't solved the basic issue of interaction between the omdars, and frankly, that's likely to be stronger between two of them rather than three, so...

INTERACTION MOMENT In Darfur (continued)

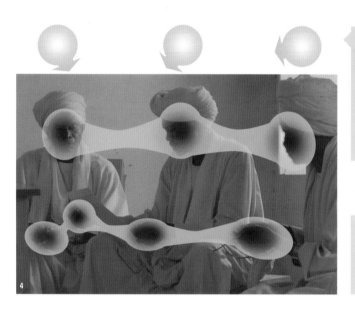

4 Back to horizontal, because I spot a neat 3-shot, with faces and hands aligned in two rows (the contrast continues to dominate). This works pretty well as a composition, but I'm not going to leave it like this, because there's only a middling amount of interaction. I suspect it should improve.

5 I zoom in for a 2-shot, because I can see that this pair are beginning to talk more seriously. For the remainder of the shoot I'll be concentrating on them.

6 But it's another four minutes before the paper gets put down and they start to talk in a more animated way. This is my first real expressive interaction of the shoot, exactly what I'd been hoping for.

7 Then the nearer man says something about the time, and shows his watch. I see this about to happen, and expect the man to lean forward and look at it—perhaps I'll get a useful expression from him. But no, because in shifting his gaze he looks at me instead. Not at all what I wanted or expected.

Key Points
Sequence
Interactive two-shot
Faces and hands

8 After 10 seconds, we get another interaction, and it's quite good, with the raised hand at right, although the older man is not looking directly at the other. Also, the nearer man is turned more away from the camera.

9 The piece of paper comes out again. It focuses both their gazes and creates a triangular structure, so gives some cohesion. On the other hand, inevitably, I no longer see the eyes, and right from the start, I've known that catchlights in the eyes are ideal.

10 But they stay with it, so I have time to switch to vertical, as the triangular structure is slightly deep. Just as before, it still doesn't work.

11 The paper gets put away, and they're back to talking eye to eye. Then this happens—the older man leans forward. Suddenly the shot has just about everything I could want: intense look from the older man, active face profile from the other man (and I'm never going to see his eyes anyway from this angle and in this light). And that hand is expressive, too. There's just a very slight frame cut at the bottom, so...

12 I pull back on the zoom a fraction (from 102mm to 95mm) to widen the framing, but in those three seconds, while I still have the older man's expression, the profile of the other is more static—mouth closed—and the pull-back has brought in something unwanted in the lower right corner. Still OK overall, but it confirms that the previous shot was the one.

Rating

This shot is very much about precision, and given that no one was moving very much, hardly at all about speed. However, urgency was more important than a casual observer might think, because expressions can be fleeting.

127

EXPRESSIVE MOMENT Baseball

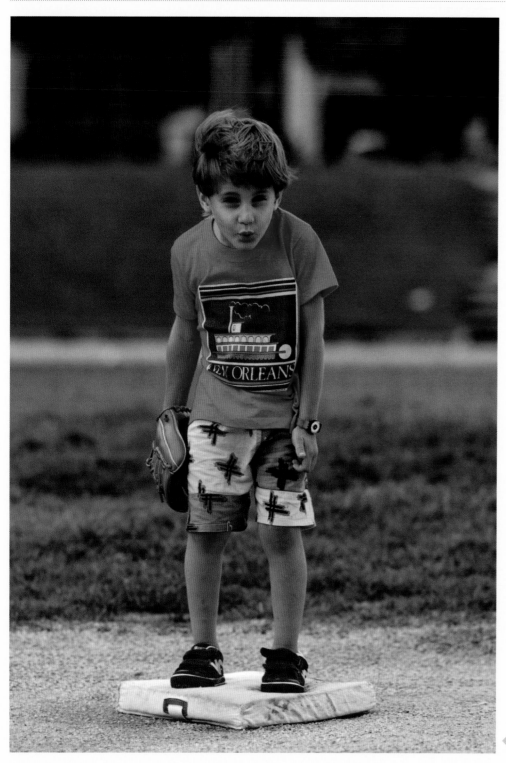

Expression (and to be fair, also gesture and posture, which are never far removed) can make or break the shot. In this case, without the unexpected expressive moment, the take was frankly dull. The assignment was for a Time-Life book on Canada, and specifically about the daily lives and activities of a few selected families. Here we're in Toronto, and the scene is kids' baseball.

Children can come up with the most entertaining and unpredictable faces. More than with adults, there's a need to stay alert, on the off chance that they will give some character to a photograph. This expression came from left field, as it were, and made a very usable shot out of a mini-assignment. Two of the boys were off to play baseball with friends in a local Toronto park. So far, so predictable, and the obvious thing was to work around the subject, from different viewpoints, different focal lengths, from wide establishing shots to closer shots of individual action. Light wasn't interesting, and neither was the location, but the job means extracting something interesting out of this.

Closing in from wide to individual was inevitable, given the low visual interest of the setting. But then, something was said, or perhaps gestured. To be honest, as I was already focused on the younger boy ready with his glove, I missed what that was, but the reaction was full of expression. What was it, actually? Annoyance? Challenge? Your guess is every bit as good as mine, but it certainly made the shot. Extreme, and uncalculated expressions are prizes to capture in photography. They only ever happen once, and if you're into street photography and its variants on human behavior, you have to be on-duty with all camera settings ready to stand a chance of capturing them. ∎

Baseball, Toronto

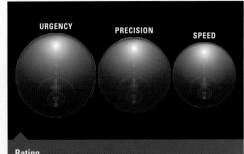

Rating

Urgency: absolute. Precision: equally important, though in this case the shot was already set up and focused. Speed: reasonably important, in order to capture fast movement sharply, although again this was anticipated.

The setting

A local park in more-or-less downtown Toronto. Not much to the scene photographically, but it needed a wide-angle treatment, in this case a 20mm lens.

The rest of the sequence

Competent but not remarkable, the other images of the boy's actions work predictably, until the odd, expressive moment that makes the main shot.

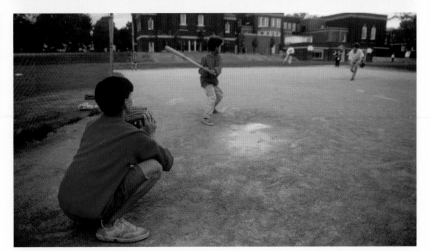

EXPRESSIVE MOMENT Barley Harvest

Barley Harvest, Wu Ya village, Eastern Tibet

Of all forms of work, bringing in the harvest resonates well beyond the actual labor. It's ancient, marks the end of a season, and celebrates the success of creating each year one of the basics of life. So, there are undertones to any shots of a harvest, and this one was in eastern Tibet. It's a good time for the community, but hard work. Photographing any harvest usually means looking for moments that capture something more than just physical action.

People were scattered around the field, and for this reason I was more interested in finding a small group or an individual working. After a few unsuccessful attempts like the ones shown here, I found a man and two women close together, bending to gather. They made a neat group, compact, and framing them quite tightly kept the background full of barley. They were working as a unit, and so it seemed apt to try and have them at the moment when they were all performing the same action together. I needed to wait only a few seconds before all three were bending and reaching out at the same time. In fact, there was another reason in my mind for this, because I immediately thought of *The Gleaners* by Millet. By that, I do not mean that I was pitching myself against the great French painter, which would be ridiculous, but the similarity—a coincidence—was strikingly obvious. I didn't have an interesting distant view as in Millet's 1857 painting, and that was already a pity even without thinking of *The Gleaners*. Some interesting activity beyond them would have changed the image, and frankly, from my point of view, would have improved it, but it wasn't there and so I stuck to just the group of three.

An unexpected coincidence

Harvest the world over follows similar patterns and flows of work. And has done throughout time. Millet painted his French scene (sketched out below) in 1857, and intended it as social comment. The same postures happen today in many places, including eastern Tibet, though the trio of workers is a visual coincidence.

EXPRESSIVE MOMENT Barley Harvest (continued)

Selecting from a sequence

I settled on one individual, this man with a strong face, and shot as he carried the barley from the field to the collecting point. The kind of shot changed as he approached, from moving figure in a field to the more intimate image of effort conveyed by facial expression.

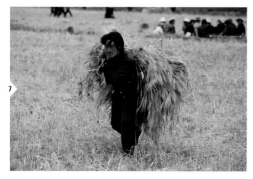

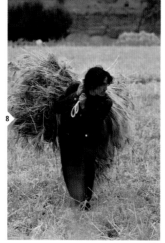

A slight diversion here into an important difference between photography and painting. Some of us, and I suspect most photographers, are attuned to spot things that align themselves or arrange themselves neatly, which was happening here. That's because visual disorganization is much more usual, so we tend to value the coming together of shapes and actions and so on. Paintings, however, are constructed, not caught; so coinciding forms mean nothing in themselves. Nevertheless, Millet has two of the gleaners acting together, while the third stands. His real point was to make a comment on class division, with the faceless women's menial work contrasting with the bright and bountiful harvest beyond; they are not sharing in that. These Tibetans, by contrast, are working communally and all for themselves.

This triplet working in unison made a successful image because of the timing— the actions happening at the same time—but necessarily this meant no faces visible, just like Millet's gleaners. From the same situation, I also wanted some facial expression to show the effort involved, and the best opportunity for this was when people came, singly, to the near edge of the field to stack their loads. Full-figure shots, of which I tried a few, were too distant to show much of the face, so instead I tried for the final moment when they were close to me and just about to put the stack of barley down. There was only a second or two at best when the faces were clearly visible, and the shot here was by far the most successful, due partly to the man's expression, but also to the viewpoint. I intentionally tried to frame him with golden barley, out of focus with the shallow depth of field from a longer lens—ƒ/6.3 and 150mm. It would have been neater if another man had not been directly behind him, but then, in photography you can sometimes be too neat—though you may find that a bit rich coming from me. ■

URGENCY PRECISION SPEED

Rating

For both shots, urgency is average, initially propelled by discovering the harvest scene and not knowing how long it would continue. Precision: very high for both— for the trio of gatherers, this combination of postures happened just once, while for the man unloading his burden of barley, the moment was rapid. Speed was quite important, because in both cases it made sense to capture the action crisply, with no motion blur.

The face of labor, framed by the harvest

It's the moment of expression, showing physical strain, that carries this picture, but the expression itself is heightened visually by the golden frame of barley that draws the attention inward to the face.

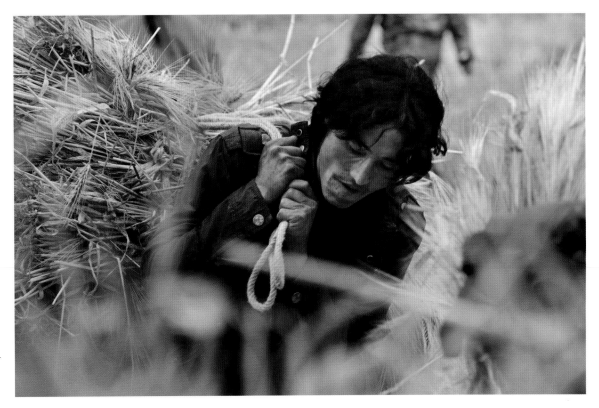

MOMENT OF GESTURE Calcutta Commodity Exchange

This is a scene from the past, but a fascinating one: the old commodities exchange in Calcutta, with trading conducted in a very old-fashioned, and picturesque, way. The activity, the blue paint, the two tiers of boxes neatly separated, all made for an irresistible scene for shooting. There were several ways of treating this situation, and I felt spoiled for choice. It was so inherently strong as a scene that almost any treatment would be good. As the sequences of images here show, I ended up going for three approaches, and the first, inevitably, was a shot that would take in most of what was going on, and explain quite clearly the context, while still framing quite tightly to let the blue-painted wall, with its two tiers of tiny traders' boxes dominate. At the same time, I was using this general view to explore, and changed viewpoint first to let the left-hand of the frame fill up with blue. I liked the graphics and color of this part of the frame, and decided to move in closer to make more of it. But first, I tried a camera position from the right, aiming head-on so that the rows of boxes would be aligned to the frame.

Pigeonholed was the exact expression for this noisy, ramshackle scene, and it seemed natural to close in so that the frame would fill with blue, and I could have a few black boxes with figures inserted, as it were, in them. This led to two rather different approaches. One was to go for moment in what was a very active scene. The other was to go for maximum graphic effect, even slightly abstracted. This was, after all, an unusual situation visually: men boxed on a blue background.

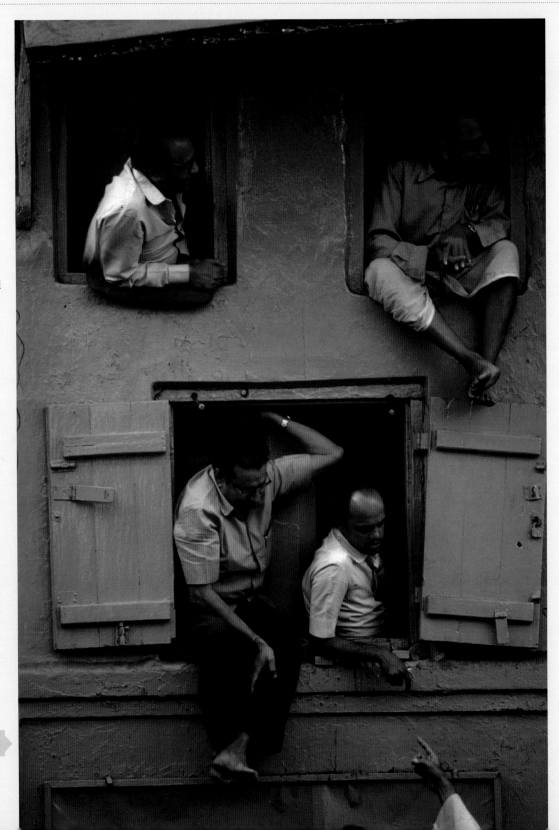

Commodity exchange, Calcutta

Overall view that takes in the corner of the building, perfectly explanatory.

The setting

This general view showing the location and the numbers of people was a shot in its own right, although I'm using it here to show the process of honing in on the final image.

Looking for gesture

There's a large variety of hands and arms, each caught in the moment of their own gestures, which together form the visual focal point of trading in this scene, and created the second-to second choice of moment while I was shooting. Cropping in on a few boxes allows me to keep the background blue, with the visual suggestion that it extends well beyond the bounds of the frame.

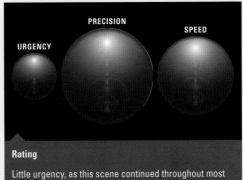

Rating

Little urgency, as this scene continued throughout most of the day in the same way. Precision, however, needed to be high, both in the framing and in gestures. Speed: moderately important, as this situation called for sharply caught action.

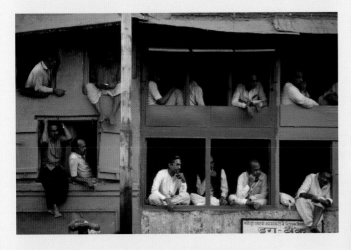

Different position and tighter framing, beginning to explore the possibilities (on the right) of cropping in to an all-blue frame

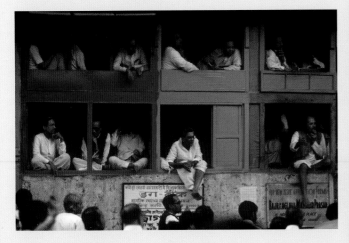

Changing the viewpoint to head-on for a more graphic, aligned treatment of the rows of boxes.

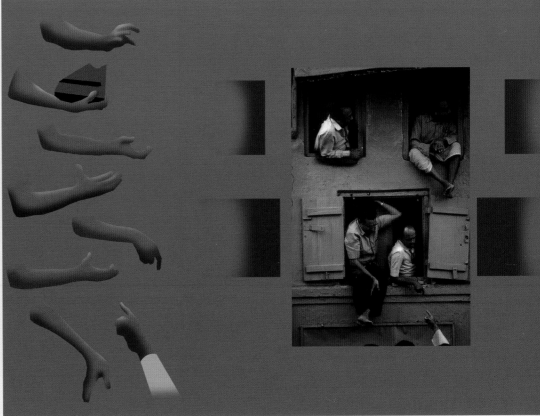

MOMENT OF GESTURE Calcutta Commodity Exchange (continued)

The most graphic treatment possible

The wider view suggested a treatment with maximum graphic geometry, hence the left-right symmetry, reinforced in this group of boxes by the two profiles men facing in opposite directions. The only thing missing is action.

Adding symmetry to the graphics

The purely graphic potential of the scene lies in the overall field of blue and the neat arrangement of black boxes within it. Symmetry is always graphically strong when you can find it, and here in this shot it does the job of enhancing the graphics.

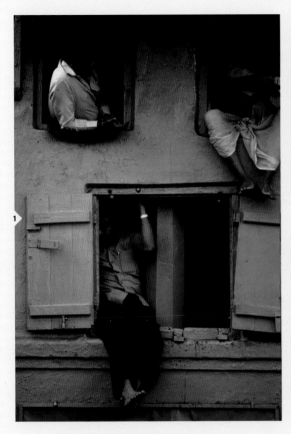 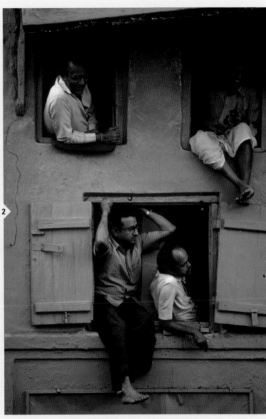 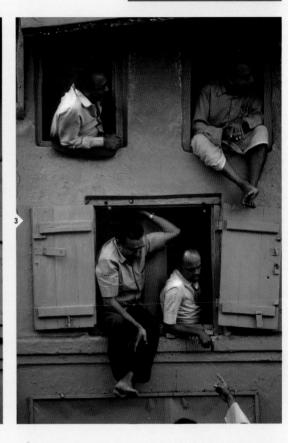

First, the moment: Indians generally use gestures in a particular way, and the hand gestures were full of character. Here in a trading situation, hands and arms moved around even more distinctively, and the communications were between the men in the boxes and those on the street—the trading floor if you like. I switched to a tight framing, looking for several gestures happening in one frame, and in particular an occasion when one of the traders in a box was dealing with someone standing on the ground in the street. I found a framing which a neat arrangement of "boxes," and waited for action. In the end, the best moment came when an arm pointed upward from street level, matched by the pointing finger of the trader at right. Framing this shot to take in more of the man in the street would have been more explanatory, but less interesting. The two arms pointing at each other do the job.

But there was still the other, alternative possibility of making as graphic an image as possible. I already had the men in boxes against a field of blue, and looked for another graphic device to heighten this. I found it in the form of symmetry. When that's a possibility, it always adds order to an image. Two particular adjacent boxes caught my eye for this. Both men were dressed in white, backs to each other, in profile. Framing it symmetrically gave a mirror-like effect. This was good, though it inevitably lacked one thing: the energy and activity of the trading. ■

Looking for moment

In the run-up to the final shot, I chose another group of boxes in which there appeared to be some active trading going on.

POISED MOMENT Lock Keeper

Earlier, in the first chapter under Posture, I touched on the idea of elegance, suggesting that some movements, particularly whole-body ones, have the possibility of looking naturally elegant. Underlying this is a key thought, that most of us will agree on what looks elegant. If this were true, then elegance in a movement would be a natural moment to aim for. Some people perform similar actions more elegantly than others, but even within one short action by one person, it seems reasonable that there will be one moment in that operation that looks more graceful, more poised. And that's why I'm calling this a poised moment, with its suggestion of balance and control.

This is one of the clearest and simplest examples I could find, a lock keeper on one of the canals that were the backbone of Britain's Industrial Revolution. Locks are the way of dealing with gradients on a canal system, and this is the steepest in the country. Called the Bingley Five Rise, it has five levels one above the other, and is important enough to still have its own full-time lock keeper (most locks gates have to be raised and lowered by the boat owner traveling through). This is a straightforward turning operation, and these four pictures capture it all. Also, this is the only variable. There is nothing else to choose between other than the man's posture.

As I shot the sequence, I knew which the moment was—the third frame, with the body at full torsion. That's to say, I immediately knew which moment of the four fitted my own preconceptions of poise, and it's no surprise that there are four shots and that the best was number three. The first frame was worth shooting because

Lock keeper, Bingley, Yorkshire, United Kingdom

138

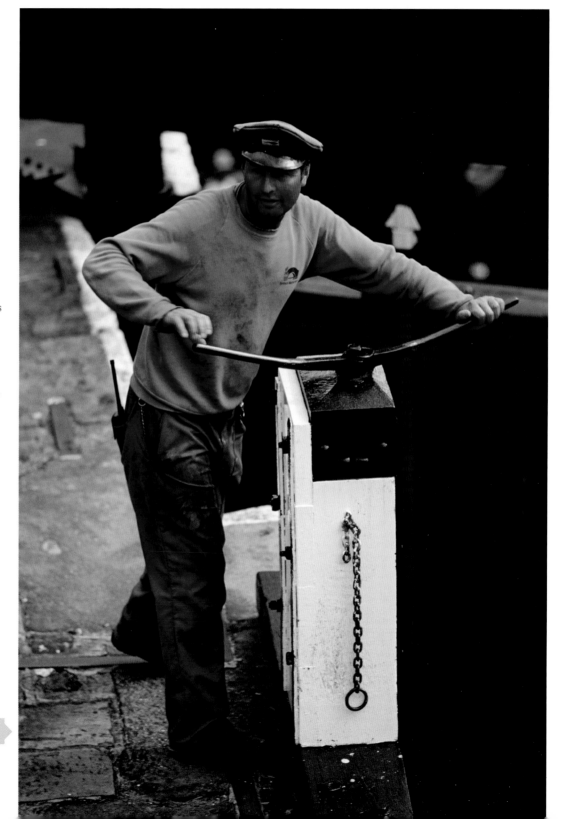

URGENCY **PRECISION** **SPEED**

Rating

Urgency and speed: both low-to-moderate, as I had a clear overlook for shooting and knew in advance what would happen. Precision: moderately high in order to catch the exact position.

the framing is neat, the colors simple, and it's telling part of a story about how canals work in a clear way. I continued shooting simply to improve the moment. The second frame was a little more to my liking and the third very much more so. The fourth was less good, confirming that number three was the shot.

But what would an audience think? The whole idea of elegance depends on most people agreeing, as it means nothing if it isn't a shared, common taste. I thought it would be useful to test this, and many of my Facebook friends helped in a survey. The results were that 78% agreed on number three, which was a relief. In this case, conventional elegance seemed to work. But note that about a fifth preferred another moment. I think I would have been worried if the results were unanimous. ▪

Twisting torso

The most expressive moment in this short, simple sequence is when the lock keeper is at full turn, his upper body almost at right angles to his stance.

The sequence

Four frames were sufficient to capture the peak of this action. Once the main shot, number three, had been taken, the fact that number four was not as strong confirmed there was no need to continue shooting.

What the audience thought

Submitted to more than a hundred people who were asked to choose one frame, the results were 5%, 6%, 78%, and 11%.

1

2

3

4

POISED MOMENT Drawing Water

Here is a second short sequence that hinges on the poise of a single moment—or so I thought at the time. This is the western edge of Rajasthan in India, a desert culture in which water has a critical place. Among the daily activities is the trip to the well, often communal as in this village, where a number of the women go together. Colorful saris and a clear late afternoon light promised some sort of picture, and I began with the women walking in line abreast toward me. With a telephoto lens (400mm) to compress them against a background of sand, this worked pretty well. With the same lens, I could then concentrate on each one drawing water from the well with the bucket. A very concentrated shot, and this woman, in her desert-matching colors, looked the best to me. The light was beautiful, also. Toward the end of drawing up the bucket, she stood erect, and this, when it happened, was for me the moment, with the added bonus of the way she lifted the loose end of the rope.

Flushed with my meager success at predicting an elegant moment with the lock keeper on the previous pages, I tried the same survey on Facebook with the same people, and learned something new. Rather more people indeed preferred the last frame, but only just, and there were two other candidates, the first and third. The voting went 40% for number 6, 26% for number 3 and 18% for number 1. This I had not been expecting, simply because I was fixated more on elegance of posture than on anything else, and hadn't paid as much attention to the details of what was happening in the other two earlier frames. The first frame is a more compact view,

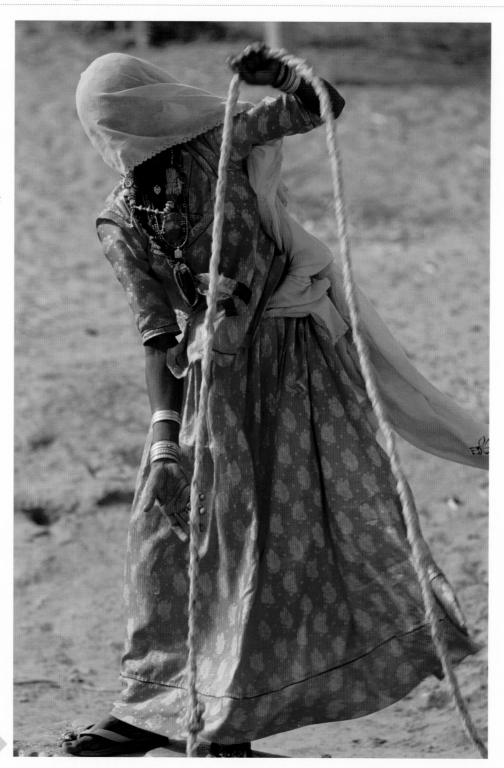

Village well, Thar Desert, Rajasthan, India

Key Points
Sequence of action
Elegance in posture
Telephoto

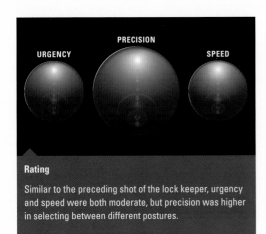

Rating

Similar to the preceding shot of the lock keeper, urgency and speed were both moderate, but precision was higher in selecting between different postures.

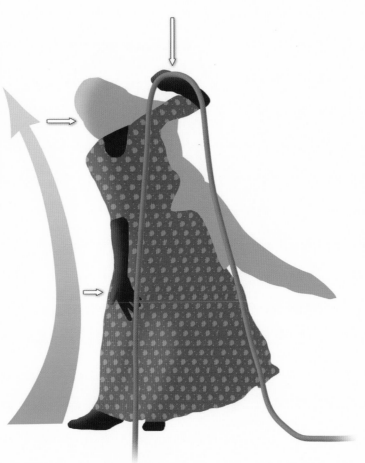

and slightly less usual in its triangular shape than expected. The third frame contained something extra—the woman lifts her veil and seems to peer down the well. In other words, according to my analysis, the last frame, my choice, ticks the conventional boxes of elegant posture and fully explained action (she holds a full length of rope), but the other two candidates appeal to people who prefer something not quite so obvious.

These are small details about a single image, and no one was being asked whether they liked it in the first place, but it was a useful lesson. First, it was a reminder that there may be different reasons for choosing a moment. Second, the audience for a photograph is important, but do you want most people to like your choice, or just some? If you want most people, it's worth knowing about conventional appeals. ∎

Four reasons for choosing

The final select was chosen for the following key qualities: the elegant leftward curve of the body, the rope being raised to full height, the face covered with the yellow cloth, and the open-hand gesture.

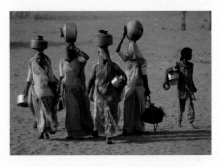

The setting

In the run-up to the shot, there was another, also useful, as a group of women from the village approached the well line abreast, walking directly toward the camera.

The sequence

Compared to the lock keeper on the preceding pages, there was more variety of action as the woman lowered (first two frames) then raised the bucket.

What the audience thought

These were submitted to over a hundred people who were asked to choose one frame. The results were 18%, 5%, 26%, 4%, 7%, and 40%.

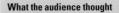

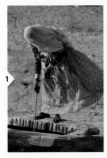
1

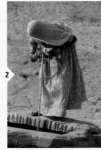
2

3

4

5

6

141

MOVING TARGET Flamingos

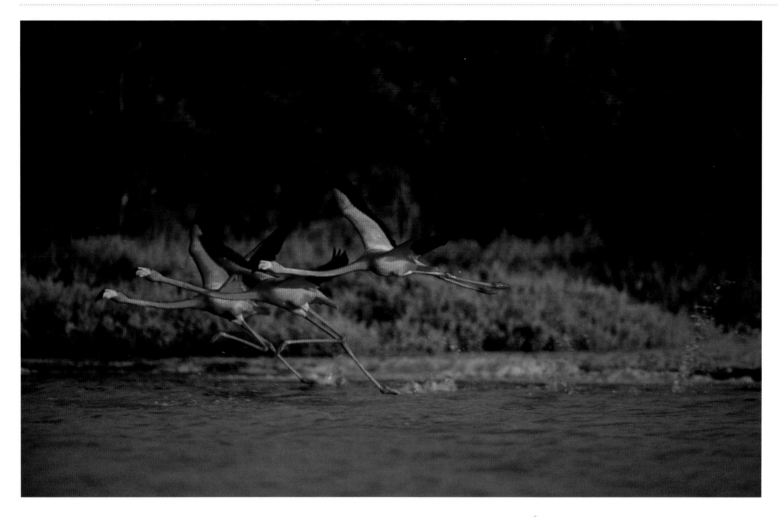

The telephoto pan is in a class of its own, and while there's nothing particularly complicated about it, the extra demands of focus and framing, and of simply having clear room to swing with the movement, can distract from the most important issue, which is judging the best moment. The example here, in the mangrove swamps of Rio Lagartos in Mexico's northern Yucatan, had extra technical demands, even though in the end it worked well and smoothly. These were the focal length and weight of the lens—600mm and 14lbs (7kg) respectively—and the fact that the focus was manual. You only realize how soft and reliant on technology you've become when you have to focus manually and critically.

Panning is such a natural action that it hardly merits a name. You aim, you follow the moving subject, and that's really all. But a lot can go wrong, and interfere with the basic idea of keeping the subject sharp in the frame while you concentrate on its individual movements. With a prime lens like this, the distance has to be right, as there is no optical adjustment to help keep the subject a good size in the frame. I was in a boat, so almost the first priority was to get it to about 100 yards from the shallows where these flamingos were. Being close enough is key, but being too close so that a single bird would not fit in the frame would be a disaster. The small flock was wading, and in a situation like

Flamingos, Rio Lagartos, Yucatan, Mexico

this, you're always hoping that they'll take off—and more, do it conveniently side-on to the camera—but this is not controllable. Birds in flight, by the way, take up more of the frame horizontally than they do when parked, so that had to be anticipated, too. As this was across water, there were no foreground obstructions to spoil the clear view, and the background was a consistent wall of trees, so these were two potential problems fewer.

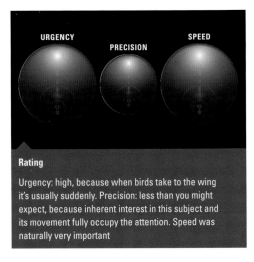

Rating

Urgency: high, because when birds take to the wing it's usually suddenly. Precision: less than you might expect, because inherent interest in this subject and its movement fully occupy the attention. Speed was naturally very important

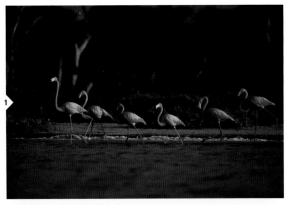

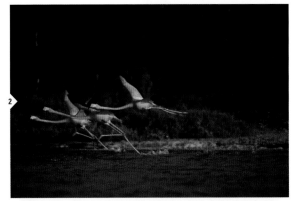

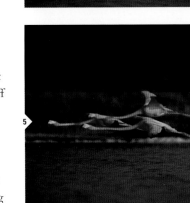

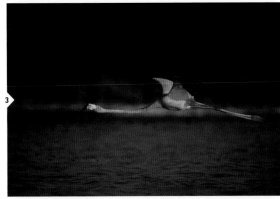

The small flock began walking more quickly in the shallows, a telltale sign that they were not comfortable with the boat and might be preparing to do a running launch. Which they did. Fortunately for me, the wall of mangroves meant that their logical flight path was at right angles to the camera, so the focus would stay the same. I shot while they were walking, mainly because it was a reasonable and efficient shot, but the few seconds as they began to stride for takeoff were the key. This, rather than mid-air, though I shot that too, was the moment of maximum action, with both leg and wing activity, as well as splashing water.

You might wonder why bother thinking about any of this, when a fast continuous shutter setting would capture many more frames to choose from. That is definitely an option, but not one I like, because when the shutter is firing at 20 frames per second in a DSLR, the flicker makes it almost impossible to concentrate on what is going on. For me at least. Yes, true, a mirrorless camera does not have that problem, but I still prefer to actually choose a moment rather than hose it. ■

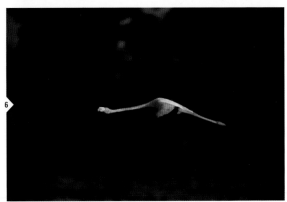

Flight sequence

There was time for just a few shots following the birds as they launched into the air and flew to the left. The most activity visually is when their legs are still treading and splashing water, and that was the reason for choosing the main shot.

REPEATED MOMENT Rice Warehouse

Phew. What a relief to find yourself in front of an action that you absolutely know is going to be repeated. Like a craftsman hammering a tin pot, or someone hanging clothes out to dry on a line. Time to relax, watch it a few times to get the rhythm and the little details of action, then take your time and settle down to shoot. Really? Relaxing because we think we know what's going on is so tempting and so often fatal to the shot. Nothing is totally predictable, least of all human activity. Repetitive action is immensely valuable when you're shooting, but it needs to be treated for what it is—probability—rather than the certainty we would prefer.

Here is this little scene going on for maybe half an hour. A small town in central Myanmar, where farmers bring their harvested rice to a central buying depot, pretty common around Southeast Asia. The focal point of activity, at least from here on the outside, is the doorway to the rice warehouse. All the farmers here are women, and as each one arrives, she carries her load in, then a minute or two later steps out. The first attractant, to be honest, was the light: sharp and across, with high contrast, and the blackness of the open doorway serving as a natural frame for whoever was stepping though it. Stepping indeed added to the possibilities, because the raised sill of the doorway not only slowed people down (very useful for shooting when they exited) but made their action more interesting visually.

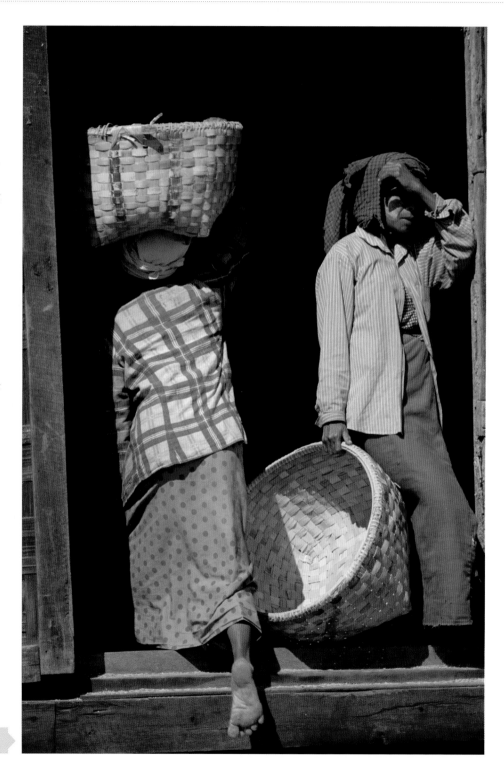

Rice warehouse, Wetlet, near Shwebo, Myanmar

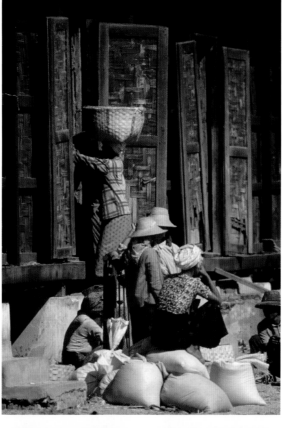

The setting

From more of a distance, this was the scene in front of the wooden communal warehouse.

If you stop to think about this, which naturally I had to at the time, and you've agreed on shooting the doorway, the choices are between entering and leaving. On the plus side for someone entering is the load of rice (adds more to the content of the picture) and plenty of warning for the moment to shoot. Against that, it's a rear view. The main arguments for someone exiting is that we see them from the front, and we also get the most visual value from the raised leg, but against that is that their basket is empty, so less muscular effort. The practical solution is to shoot both—every instance of someone stepping through. However, after several minutes of settling into shooting, the ideal became clear. That would be both together. It happened only twice in the twenty minutes I stood there, and I missed the framing on one of those. So much for the certainty of repetitive action. Though I was very taken by the trailing foot against the sill. ∎

Rating

Urgency: very high indeed, because of the lack of any warning of someone exiting. Precision: high also, as the shot hinged on framing people neatly against a black rectangle. Speed: as important as in most moderately active situations.

1

2

3

4

5

6

7

Repeated attempts

Not a great deal of shooting here, because each moment of someone entering or leaving was very brief.

MULTIPLE MOMENTS Water Worship

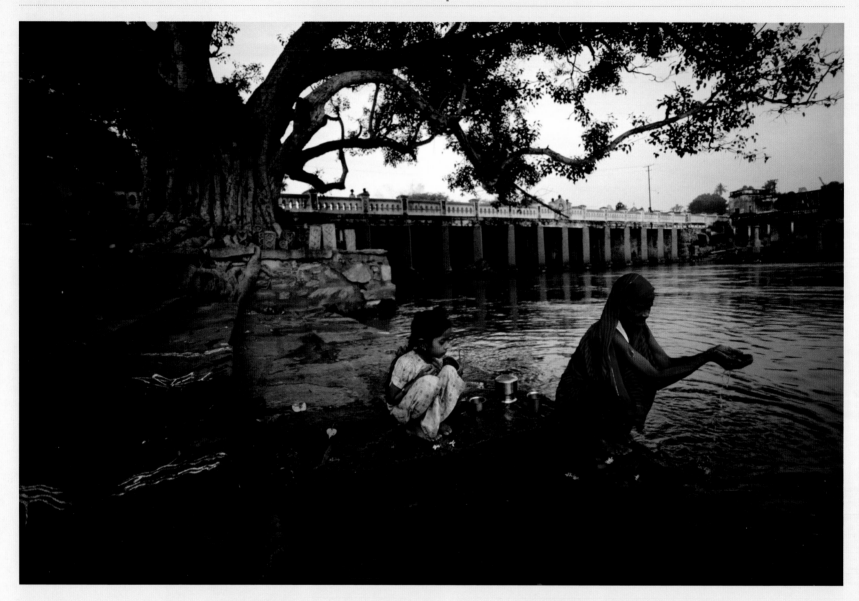

Sometimes one moment segues into another in such a way that they both seem to be part of the same larger moment. They need individual treatment, but at the same time, you stay conscious that they're closely linked, and this can affect both the shooting and the editing. One carries over to the other, and while within each there is still a best moment, there are pending decisions, even while shooting, about whether they may need to be used together. As a result, this is more about multiple than about choice.

To begin with, I should give a word about the situation: This was in the Indian state of Karnataka and it was a fortnight-long traveling assignment for the *Sunday Times Magazine*, completely dependent on what we could find that was interesting. This was the tank (that is, a large artificial pond used ritually) of a southern Indian temple, by the name of

Puja at Venugopala Swamy temple, Mysore, India

Venugopala Swamy, and this was early on the day of a religious festival. Much more happened later, but before the crowds arrived, this woman and her daughter came for a puja (Indian term for a form of prayer ritual). The old tree growing by the side of the tank was sacred also.

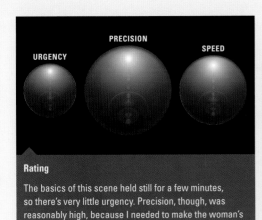

URGENCY PRECISION SPEED

Rating

The basics of this scene held still for a few minutes, so there's very little urgency. Precision, though, was reasonably high, because I needed to make the woman's posture and outstretched arms as clear in the picture as possible, so had to get myself in just the right position. Speed: less than average in importance.

Emphasizing water

The most water-connected moment here was the combination of the woman's arms outstretched, which created a rightward dynamic, and distinct ripples as she pours water from her hands into the lake.

This was typical of a moment about which the photographer had not much idea of what would happen (well, an Indian photographer probably would), so it meant continuing and reacting. A wide-angle lens makes this uncertainty easier, as the field of view can take in most of the unexpected activity with only a little change of viewpoint— stepping in, pulling back, swinging sideways— and in any case the context of tree and tank was important to include. This is a highly inclusive 20mm and it takes in 94 degrees on the long side.

The possibilities in this situation were good because the elements were simple and few: the water and the old tree, only the woman and daughter with no one else complicating the scene, the waterside setting, simple gray light giving moderate contrast, the splash of color of the woman's sari against the monochromes. In addition, the puja itself promised to have some useful moments, and the woman was unconcerned about my presence, so I had a free hand.

1

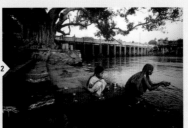
2

A choice of water ripples

With the figures clear against the water, there were only small differences between the frames, although hands raised made a clearly stronger image than hands dipped. The water ripples were what made it the decisive final choice.

3

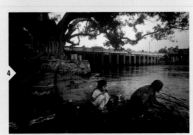
4

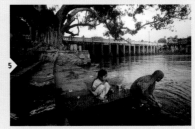
5

MULTIPLE MOMENTS Water Worship (continued)

Now, water is one of those commodities that is not so prominent in small amounts. Photographing drops of water, or handfuls in this case, wants some help. The problem is usually lighting and speed. Basically, a drop or two of water tends to look best, or at least reads best to a viewer, when it sparkles (means catches some bright light) and is frozen at an instant. This is not, however, what usually happens, because it's heavily dependent on the lighting, and/or on being close enough, as in the case of the school water break on pages 154–157. Here, soft gray light and my choice to shoot it with this kind of framing to show the entire figures, worked against this, so I was going to have to do something else to get across the idea that this little ceremony was about water.

This thought lay behind the first part of the puja, which was less about the sacred tree and more connected to the water tank. The woman squatted at the water's edge, to gather small handfuls of water and then hold out her hands to trickle back. She stayed like this for a few minutes, which removed urgency for framing and timing the shot. The wide-angle lens let me include part of the tree and give a more spacious feeling to the picture. I was clearly important to be in the position that had her outlined cleanly against backlit water, and that was about it. That she faced out of the frame added an extra dynamic. The choice between the six frames that I shot was small, as both woman and daughter stayed in the same positions, and the only significant difference was the ripples in the water of the tank. They were most prominent in the seconds after she had dipped her hands in, and that was what I used to select the final.

They then moved to the tree for a second part of the puja, and the water component was lost visually, as there was no good way to keep the tank in shot. A female temple attendant briefly appeared, sweeping, and that made a different kind of shot, though nothing special. I suspected that nothing out of the ordinary was going to happen, and while that stayed true, I was surprised (once again), that a couple of things came together which suddenly lifted the scene into a worthwhile image. At the final point, the woman stood upright, raised her head to look upward, linking her hands and raising them too. The gesture and expression were fervent. The straining intertwined fingers and her eyes made it a powerful moment of almost rapture. And secondly, it wasn't lost on me that woman's up-spreading posture mirrored that of the tree; it was fortunate that I had decided to keep using the 20mm lens to take this in. ■

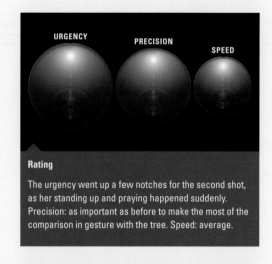

Rating

The urgency went up a few notches for the second shot, as her standing up and praying happened suddenly. Precision: as important as before to make the most of the comparison in gesture with the tree. Speed: average.

Saved by the final moment

The part of the puja under the tree looked less promising for a photograph, but ended up having more emotional charge.

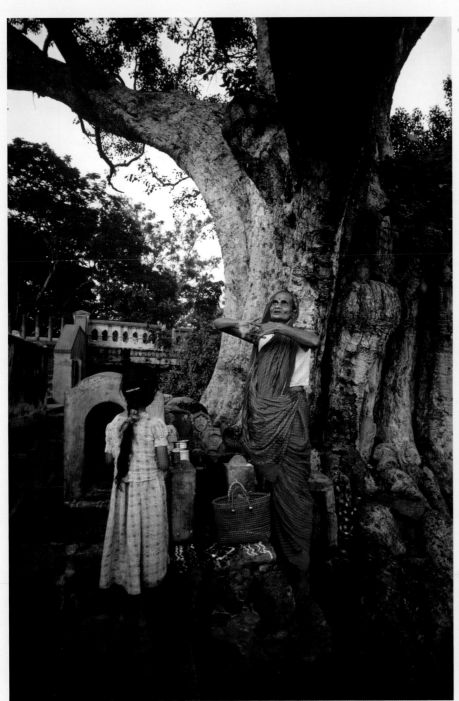

Puja at Venugopala Swamy temple, Mysore, India

Spreading upward

A coincidence of gesture holds this composition together. Her face and hands make the shot.

149

A REWARD MOMENT Glass of Spirit

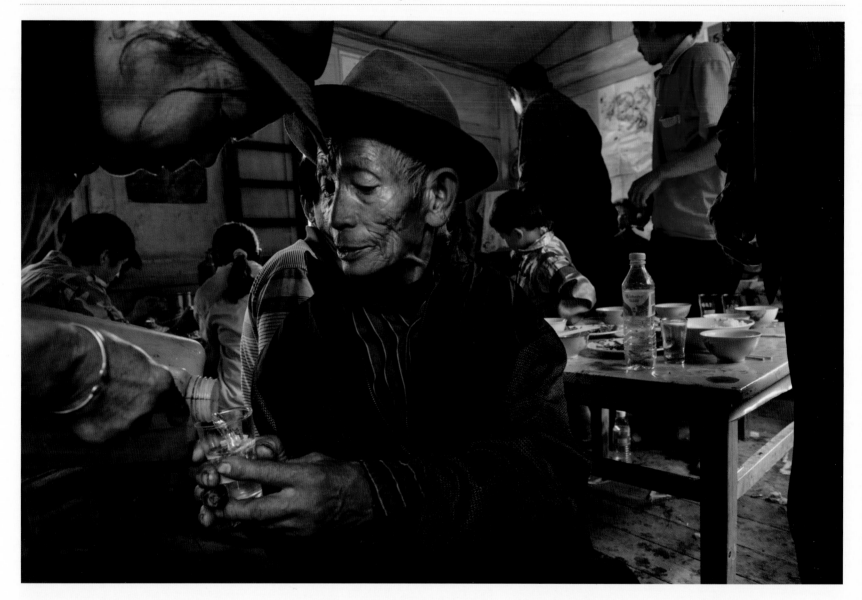

The reward in the title may seem to be the glass of high-octane white liquor that this old man is receiving, and he probably thinks so, but in fact it's my reward for waiting so long. This was the weekly market day in a small town in the backcountry of China, and the local cafe was crowded with mainly men, eating and drinking. It was a noisy scene, and I started by working my way into it, very conspicuously as a westerner, politely declining the offer of 50-proof alcohol, as I had work to do. At the beginning, I had no idea that there was a shot to be had here, but the energy level seemed to promise something, and I began by shooting just to show that that's what I was interested in doing, so that people would get used to the idea, which they quickly did. I could as well have deleted these first few, but kept them just to show the sequence.

Market-day drinking, Guo Le, Yunnan, China

I eventually settled down by this old man close to the doorway, as he had an interesting face, and also partly because the room was crowded and this space was available. However, it was clear that something needed to happen in order to make the elements of a picture hang together. In a situation

Shooting the scene

Me shooting this scene, up to the point where, in the last frame here, the cafe owner takes up the container with the alcohol to bring it over to the man.

1 A completely ineffective shot, taken only for the benefit of the people here, to show that I'm here to photograph.

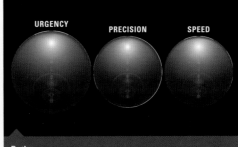

Rating

Urgency was moderately high, depending on your definition—the pouring went on for 12 seconds and I was already in position. Precision was just moderate, and mainly to do with showing enough of the woman pouring, as was the speed—1/50 second was sufficient for a wide-angle shot with slow movement.

like this, you can't (well, you shouldn't) speed things along by saying "give the man a drink" or something similar, and I wasn't even expecting that particularly. I was crouched low in the hope of some interaction between him and other people, full out on the zoom (24mm with this lens) and stopped down to *f*/8 for enough focus on the nearer figures, compensating with an ISO of 1600. But after many minutes, from behind my back the cafe owner came with some home-distilled baizhou, as it's called here. And the man turned round, offering his glass quite sweetly. I couldn't get back against the wall any further, but still just managed to get it all in: woman pouring, man, and scene beyond.

Call it a reward for persistence, though it doesn't always happen, by any means. If there's a lesson to be learned, it's the importance of being prepared for what might happen, even if you don't know exactly what that could be. Viewpoint, lens, framing, shutter speed, aperture, ISO. Many times nothing happens, but occasionally you're rewarded, and you need to be ready. ■

2 I'm so close that he looks at me. I wait until he turns.

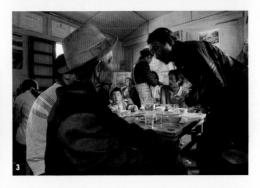

3 Looking away, but nothing much of interest happening.

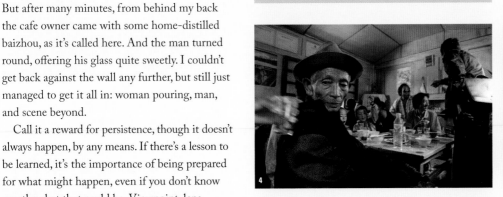

4 A hand with a glass of spirit appears, and catches his attention.

5 Even better, he turns more fully to hold the glass as it is filled.

FROM SCENE TO MOMENT Aix-en-Provence

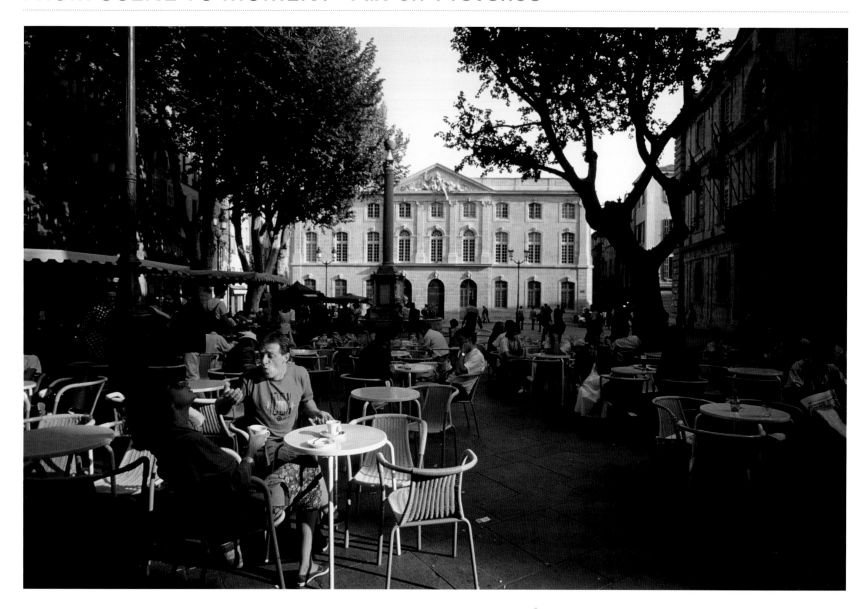

Some kinds of action, even if small in the frame, can change the whole context of a picture. This was going to be a simple shot in the southern French city of Aix-en-Provence—an establishing shot to set the scene of street café life in the south of France. Hence a wide-angle view, 20mm. But within a few seconds, this couple became animated. Who knows what was said, but he appears to have set off on a rant and she looks as if she's heard it before and is gazing at the sky until it passes. Whatever was going on, it was expressive, and the two protagonists are certainly worth looking at.

Not only was there no time to change lenses, but the moment was all the stronger for taking place in a corner of a larger scene. There's an ever-so-slight delay in seeing it, which makes the picture worth looking at for a little longer than usual. At the same time, it's impossible to miss,

Place de l'Hôtel de Ville, Aix-en-Provence, France

because of the gestures and the fortunate play of sunlight, which highlights this little event. But the whole idea behind the picture has changed in an instant, from being a pleasant description of a place to being a small human drama in a short moment of time. ■

A shift in emphasis

As the man suddenly gesticulates and his companion looks skyward, the entire thrust of the picture changes from being a scene to an event—a moment of interaction between two people.

The moment before

At this point, the shot is simply of the square, framed to show the space in general and the building, the Hôtel de Ville, well lit in the background. The couple is included simply for balance and context.

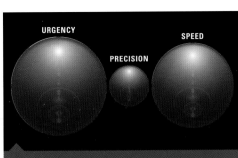

URGENCY

PRECISION

SPEED

Rating

Absolutely urgent—the moment was fleeting and to me unexpected, as I was thinking about a different picture. Precision was fairly low—I simply had to include the couple somewhere in the lower left corner. The need for speed was average to high.

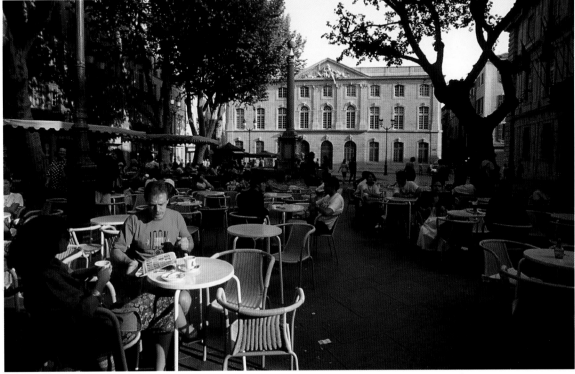

153

DETAILED MOMENT School Water Break

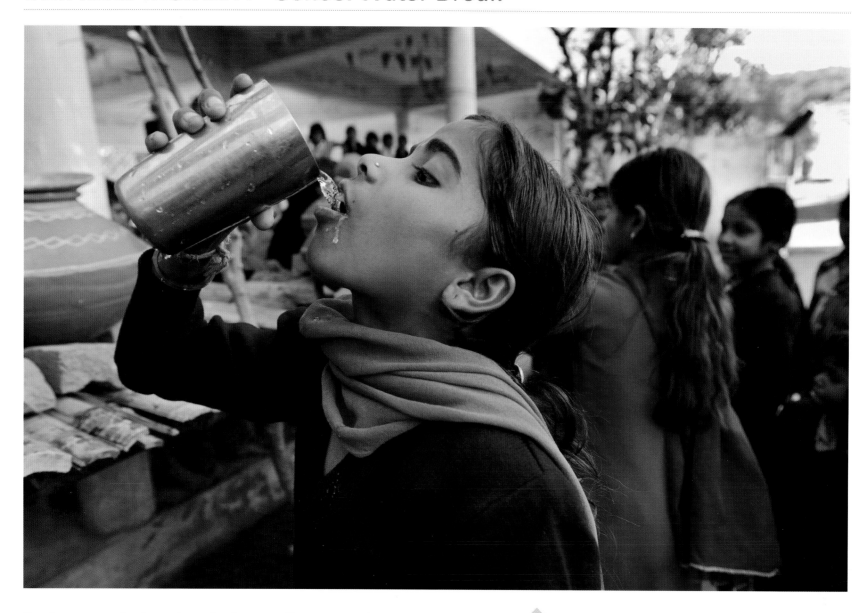

Certain moments end up being about a detail that might not have been obvious at the start. In the process of honing in on exactly what the scene is about, you discover that there's a focal point—small but essential. This is where the idea of moment meets reporting. A lot of documentary is about discovering facts on the spot and through the lens, and that's how a story evolves. It changes according to what you learn as you go along.

Here was one such case. I was photographing at a school for children of the Bhil minority in the eastern hill country of the State of Gujarat, India. The state school system doesn't extend this far into the hills. The main event, at least for me, was the water break between classes, and I was interested because of an ongoing project I have on water. Here, it's served from large earthenware jars by older children.

Water break at a Bhil tribal school, near Baria, Gujarat, India

How to get the most out of this situation? The scene is quite charming and has a lot of energy, but immediately I notice that there are two distinct ways of drinking the water that I had not expected, or rather not remembered. This is India, where

Rating

Very little urgency, as there are many children, and if I needed more time I could ask. Precision: high, however, to get the most backlit water in shot, and this means choosing an exact viewpoint. Speed: average, as I need the shutter just fast enough for the water to be sharp—1/200 second and *f*/4.5.

The school

One of the school's classrooms, with children writing in their exercise notebooks before the break.

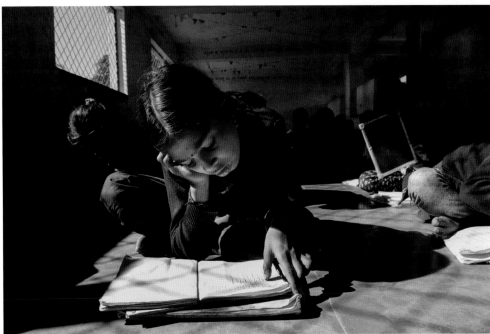

Moment as focal point

Having settled on one of the two ways of drinking water, and on a framing tight enough to actually show the water clearly, all concentration was on few centimeters of sparkling clear water flowing from cup to mouth. Small details, including the bead of water trickling down the girl's chin, were important.

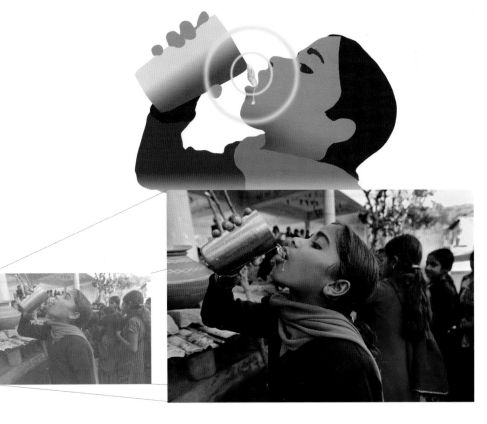

there is, in matters of food and drink, more consciousness about personal hygiene than there is in the West. Sharing drinking utensils is not acceptable, so here there are just two correct ways for the children to drink. One is to pour the water into a cupped hand and drink from that, the other is to use a stainless steel cup (standard throughout India), but not let it touch the lips. Both are a point of interest for a Western audience, and I shoot both, from this position to one side, so as to get the action in profile.

155

DETAILED MOMENT School Water Break (continued)

But in terms of a story about water, there's more to it than these two specific Indian actions. Cupping the hand is interesting, but I don't see much of the water itself. On the other hand, those children who choose to use the cup drink in a way that allows a couple of inches of the water to pour through the air into their open mouths. That means from this angle, with a bright background, I have the possibility of showing sparkling, backlit water, not possible in any other drinking situation anywhere else. A small point, perhaps, but an important one if the ultimate subject of the picture is water itself. So, after several pictures of different children doing the cupped-hand routine, I switch entirely to the airborne water stream. One young girl in particular has a nice face and good profile, and after I've seen how it works with some other children, I concentrate on her. The moment is all about the water in mid-air, and I know that I will process carefully to enhance this a little. And as a bead of water also trickles down her chin, I know that I have the complete event. ■

The cupped-hand method

One way of drinking without lips touching the utensils is to pour the water from a metal cup into one cupped hand and then drink from that.

Chosen sequence

This was the girl and her sequence of actions chosen for the main shot.

Key Points
Sequences
Learn from previous
Refining the subject

Cup from a distance

The second method, which offers sparkling water itself as a subject for shooting, is to hold a stainless steel cup higher than the lips and pour it, with the head tilted back.

SEQUENTIAL MOMENT Tea Factory

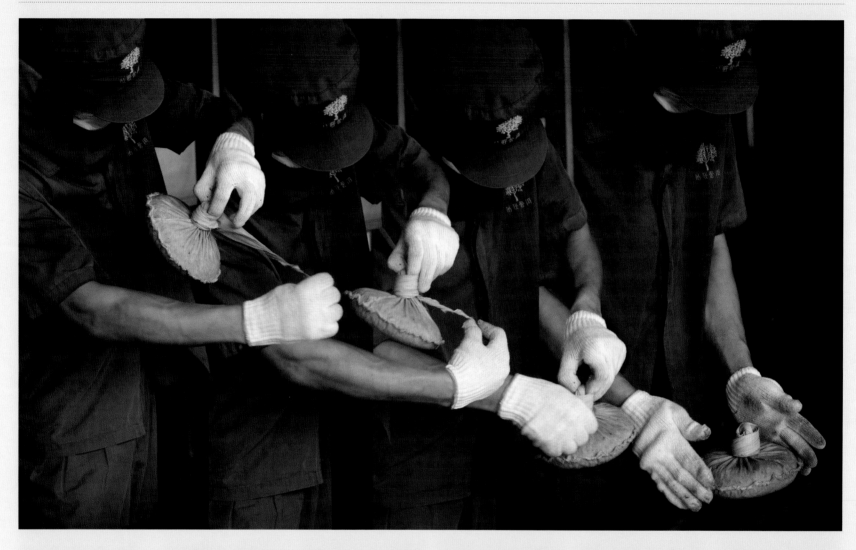

Wrapping Pu'er tea, Huiming, Yunnan

Wrapping Pu'er tea, Huiming, Yunnan

Sometimes, there's a need to explain an action, particularly if it is involved or complex, and typically this means breaking it down into parts in some way. The result is typically going to be a sequence of moments, and the challenge is compacting them in such a way that they make visual sense, one following the other, without having them spread out or separated to the point where they lose connection with each other. This was exactly the issue here, in a tea factory in China, where the final product is a discus-shaped cake of compressed tea that is wrapped in cloth in a special way. The worker spins and twists the cloth around the cake, finally coiling the end in a knot in the center of one side. Shooting the sequence, which took about 20 seconds each time, was simpler and more straightforward than finding a method of combining the frames.

A traditional, pre-digital way of combining them would be to assemble them as a strip, but layering them in Photoshop offers possibilities of blending. When I said "compacting" above, I meant that the ideal would be to somehow compress the strip of many images laterally so that the entire sequence could be contained in a more normal proportion of image frame. The basic technique is first to identify which frames from a long sequence. ∎

Rating

No urgency to speak of, as this action is repeated constantly, and in any case was being made available for the camera. Precision, however, was high, because each significant step in the sequence had to be captured. For the same reason, speed was also important—motion blur would have been unacceptable in a series of photographs that set out to explain an action.

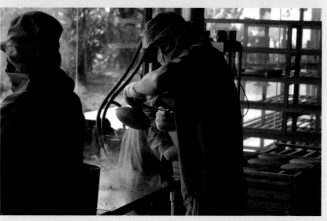

The setting

In this tea factory, the steamed leaves are compacted into round, discus-shaped cakes, and then wrapped.

As a strip

The thirteen frames in traditional left-to-right sequence. Not all of these are needed in compositing, as the two main shots show.

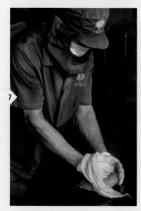

HOPED-FOR MOMENT Butcher & Son

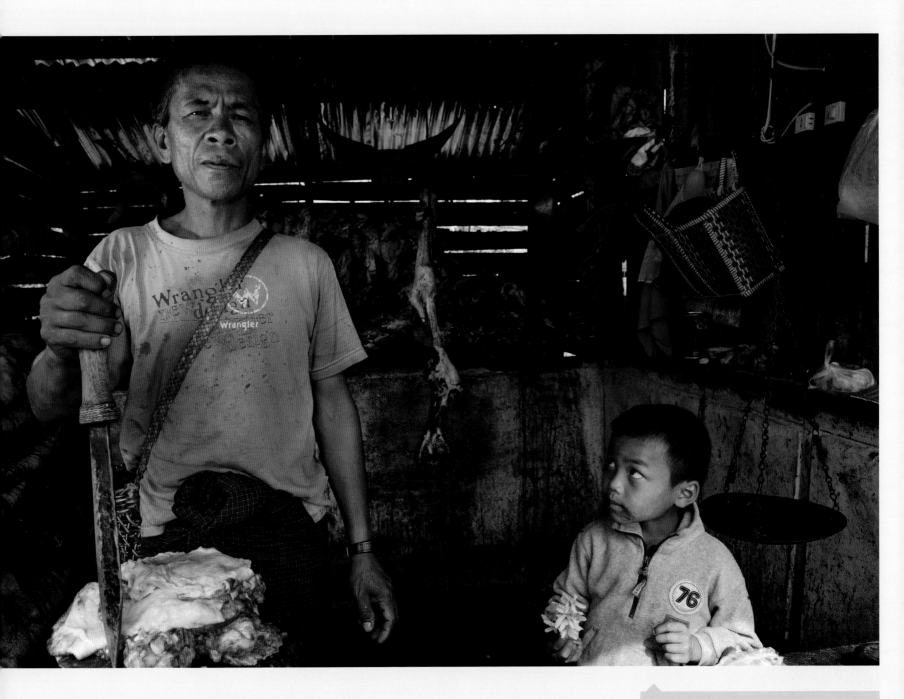

Chin butcher, Mindat, Chin State, Myanmar

Here's a principle: The more you plan an image so that it all works to your satisfaction, the more valuable becomes any unplanned moment within it. It's not that there may be anything at all wrong with the shot as planned, but that the small moment comes as an extra, a kind of icing on the cake. The situation here was an impromptu portrait of a butcher in a small town market in the Chin Hills of Myanmar. There was a reason why I was looking for a butcher in the first place, because one of the local specialties—in fact, part of the culture—is a semi-wild ox (gaur), and this was something I wanted to include in the several-day shoot. Like the picture of the flame tree on pages 40–41, this was an assignment for the book *7 Days in Myanmar*. My focus was Chin culture and life, and so finding the things that defined it was a priority.

Impromptu portrait meant coming across this stall, then asking through a translator if the butcher, busy at the wooden block at the front, would be willing. At this point in a situation like this, you can decide to make a production of it—taking time, bringing in assistants, re-arranging things, straining patience—or you can go for it quickly to keep everything fresh, including the demeanor of the subject. I nearly always prefer the latter, and try to size up the scene as quickly as possible, choosing the viewpoint, framing, and shooting without delay. Like most people asked to be the subject of a portrait, the man adopted an artless pose, full frontal and looking directly at the camera, with no attempt to smile or act. All of which was fine with me. This was a classic tradesman shot, self-arranged. I just made sure I could see some of the wild ox horns on the wall behind. I asked the man to step forward, and as he did, he held the knife with its tip on the wooden block, which was even better.

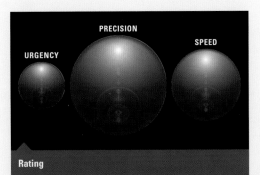

Rating

Not much urgency, but precision is moderately high in terms of the framing. Speed: moderate—the boy stayed looking up for a couple of seconds.

A turn of the head completes the scene

While the butcher is the principal subject, the much smaller figure of the boy makes the difference to the shot when he turns his head. The boy's upward gaze reinforces the strong position of the man. The horns behind register sufficiently to add to the story.

HOPED-FOR MOMENT Butcher & Son (continued)

I next asked my driver to hold a small reflector on the left. The butcher's young son was inside the stall with him, and at first I thought I might just re-frame to crop him out, but then thought that he might be better as part of the portrait. The only problem was that he was occupied with other things and looking down, which tended to pull attention away from the man. Now if only he would look up at his father as the man looked at me. Note that I did not want to make this happen by asking; stage-managing regular people as if they are models or actors can simply stiffen things up and bring a false note. I decided to wait and take a few shots anyway. Within several seconds, the boy looked up, and this little action makes quite a difference. His eye catches the light, and the eye-line directs attention to the man's face. Suddenly there's a bit more happening here than just the man. ■

Strengthening the structure

While the basic structure is evidently triangular, only when the boy looks up to the man does the shape become locked, his eye-line forming one side of the triangle.

The sequence

All of this takes place over a period of just a
couple of minutes. By the last frames, the boy
is becoming self-conscious, but I have the
shot anyway.

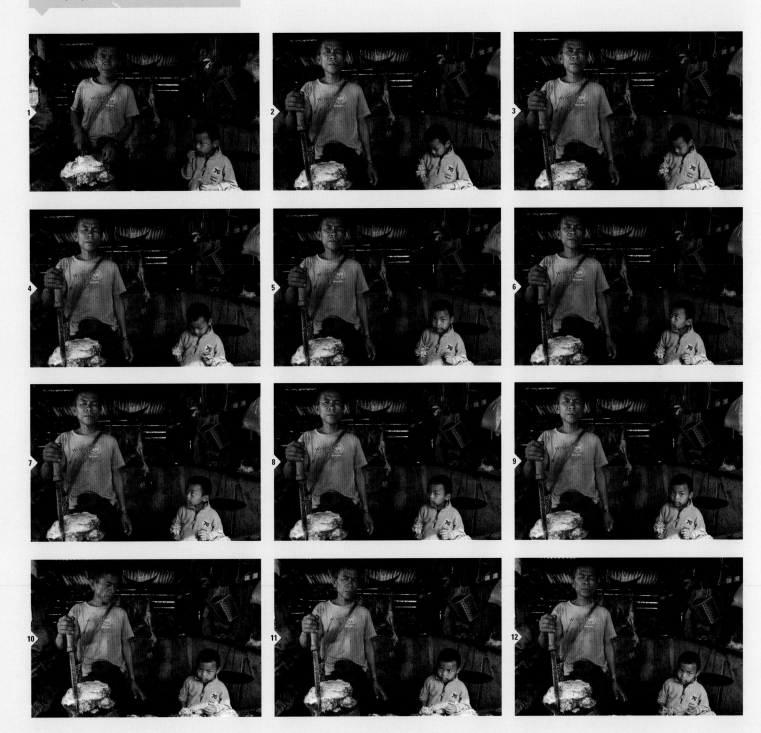

MOMENT WITHIN MOMENT Cleaning the Lincoln Statue

Really famous places can be painful to photograph, as you start by knowing that more or less anything you try has been shot before. On the other hand, there's the sneaking thought that there just might be some new way out of the problem. Because iconic sites like the Eiffel Tower, the Statue of Liberty, and here, the Lincoln Statue in Washington DC have been covered from every conceivable viewpoint, anything new is likely to be because of moment.

This was a commission, so there was no question of avoiding the shoot and going on to something else. The answer in cases like this usually lies in research, in finding out all that can typically happen. It turned out that at that time, once a week, the statue was cleaned. Fortunately, this happened early in the morning, which meant attractive lighting (the statue faces east) and hardly any tourists getting in the way. At a stroke, my particular problem was

Cleaning the Lincoln Statue, Washington DC

solved, at least in terms of the longer moment. All I needed to do was to turn up and
be guaranteed of some sort of picture that would be different from most.

I've titled this Moment within Moment because it's a clear example of times when there is a broader,

164

The sequence

In the shooting sequence, I'm exploring the best viewpoint and framing for making the strongest combination of the two elements: statue and cleaner. Almost inevitably, the best moment will be when the cleaner works on the face.

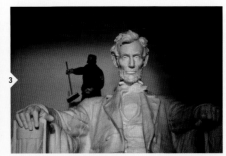

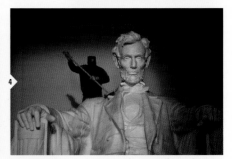

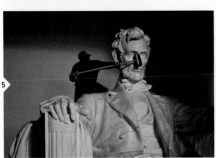

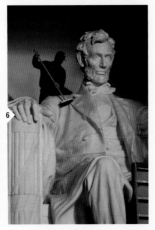

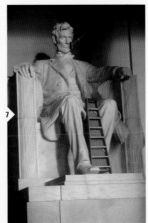

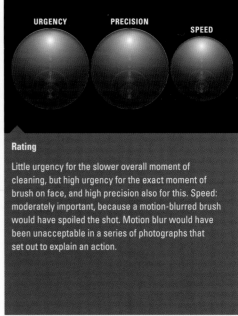

slower moment, but nestled within this was the rapid, exact moment of the final shot. Knowing that someone is going to climb about the statue with a brush is one thing. Getting the viewpoint and precise action that makes a visually satisfying image is another. On-the-spot decisions included whether to shoot head-on or from the side, how much of the statue I need to frame for it to be obvious, and the play of light and shade as the sun rose. At the least, the man had to read clearly.

In the end, as often, it narrowed down to a very few workable moments. In fact, to be rigorous, it narrowed down to just one best shot that, no surprise, has the brush on Lincoln's nose. This happened at the moment I was framing it as a horizontal, but I also, for the usual editorial reasons, was taking time to shoot the scene as a vertical. One of these made the number two select, useful for a full page or cover. ■

Looking for an angle

With such a well-photographed monument, finding a fresh way of shooting the Lincoln statue is a challenge to the imagination. This earlier attempt is set deliberately back.

URGENCY **PRECISION** **SPEED**

Rating

Little urgency for the slower overall moment of cleaning, but high urgency for the exact moment of brush on face, and high precision also for this. Speed: moderately important, because a motion-blurred brush would have spoiled the shot. Motion blur would have been unacceptable in a series of photographs that set out to explain an action.

MOMENT WITHIN MOMENT Girl on a Bench

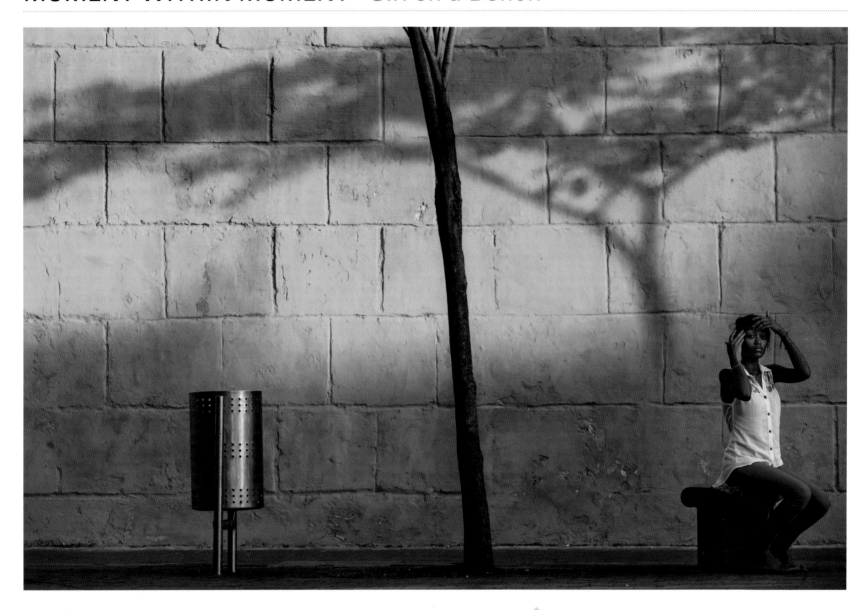

If there is any kind of planning involved, or at least anticipation, having one kind of moment within another is not at all uncommon, and here is another example. The wider moment in this case is the time of day, and is mainly a moment of the shadows cast on a wall—very similar to the shot of Delicate Arch in the next chapter (pages 196–197). A slow moment, in other words, and one that I already had in mind. This is one of the main

plazas in the center of the old city of Cartagena, Colombia, called the Plaza de los Coches, and I had already, on another visit, shot a time-lapse video here, from mid-afternoon to night. Shadows moving across a scene are always effective in time-lapse, and the combination of the angle of this ochre wall and the sun worked very well. For about a quarter of an hour each day, the small tree at the far left cast a strong shadow, and I regularly

Plaza de los Coches, Cartagena, Colombia

had my eye on this part of the wall for a possible shot. There was a constant traffic of people, so it would depend on some interesting passerby, or on someone sitting on one of the benches.

The setting

The old square of Cartagena under the public clock, called the Plaza de los Coches (Horse-carriage Square). Three-quarters of an hour before sunset, the shadows are raking the far wall.

I looked out for this whenever I was passing, and one day saw that instead of the usual groups of people, there was a solitary figure on one bench. I knew the kind of shot I wanted—very simple, minimal, and neat. There are always people crossing the plaza here, walking in front of this viewpoint, so getting a clean gap with no one else in frame was not at all guaranteed. I managed two quick bursts in a rare break in the foot traffic. And this was where the second kind of moment came into play. It was the usual stance/gesture/expression decision, but with hardly any choice, as there were just these two short windows between people passing in front of the camera. I knew it was going to be a case of choosing later between a few frames.

In street photography and reportage, it's a convention, especially among professionals, that you don't want eye contact in a shot. When the person you're about to photograph turns to look at you, that's usually the moment at which you've lost it. But this is, after all, just a convention, and in this case, I ended up with a choice. In four shots, I was unobserved, and then there were four with eye contact. In the overall scheme of the composition, it may seem a minor detail, but in fact, it changes the image drastically. As viewers, in one version we're looking at a street scene; in the other, the girl is looking at us, and we're suddenly involved, whether we like it or not. It's quite likely that she doesn't really like this situation, and that's what often happens in street photography when you get a sudden eye contact. Because it's often a little uncomfortable, such moments tend to get rejected. But that might also be a reason to choose them. There's a steady challenge in the girl's eyes, questioning my right to take the photograph. ∎

Rating

The overall moment of shade and light was predictable, and so not very urgent. For the exact moment, however, there's high urgency because of passersby (the girl may get up or someone else may come in). High precision if you think the expression matters. Speed: just moderate.

Eye contact or not

While shooting it was not completely obvious whether or not the girl was looking, and in fact in two of the apparently eye-contact shots, the girl is looking about a foot to my right.

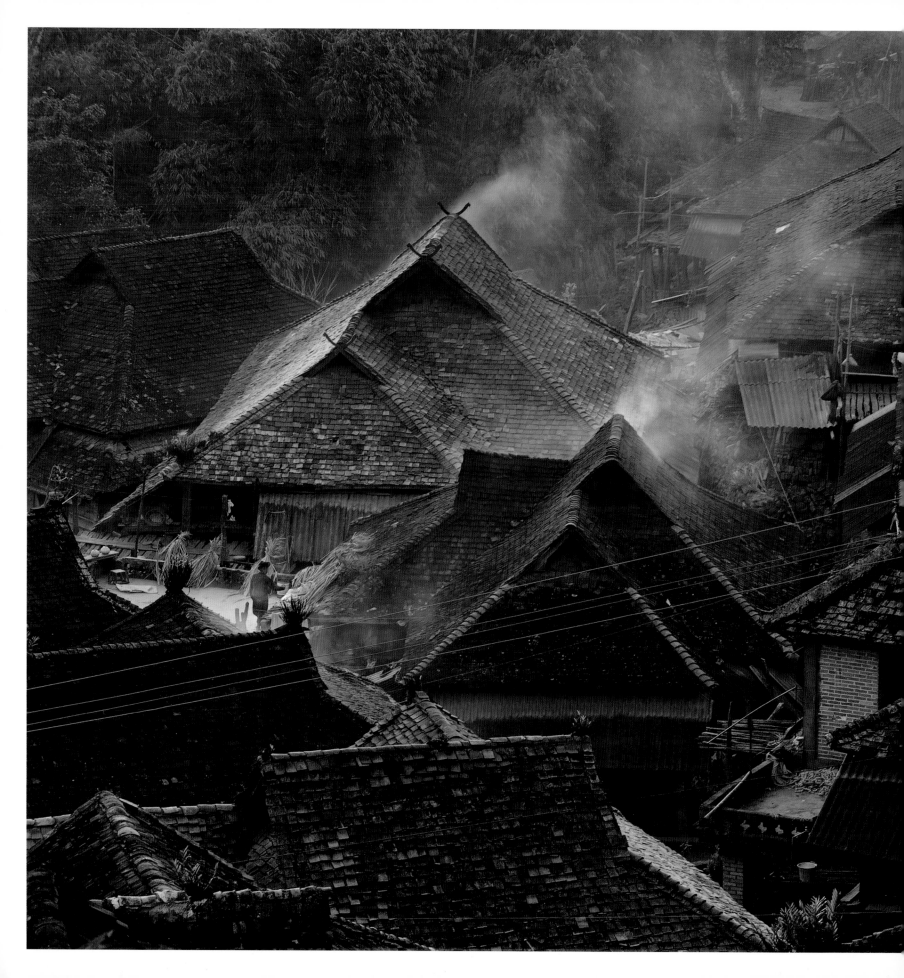

SLOW MOMENTS

4

Slow is relative. Up to now, the moments we've looked at have all involved working quickly in some way, whether thinking quickly, moving quickly, or shooting quickly. Or all three together. This is pretty standard for situations which are obviously momentary. But moments can be slow, as any landscape photographer knows who has had to sit and wait for the sun or the clouds. In this last chapter I want to look at those moments that arrive and take place slowly by our normal standards of perception and experience, but are nonetheless critical for imagery. We're no longer looking at events that unfold in a second or several seconds, or fractions of a second. Here we're dealing with minutes, often many of them, or hours. Urgency takes a back seat, as generally does speed, and this usually elevates precision. There is more time to plan, to move into position, to think in detail about exactly what in the frame should go where, and the minute details of timing.

In other words, the decisions remain every bit as critical to the shot, but we usually have the advantage of being able to consider all the options. Composition, as you might expect, becomes even more important now that there is little excuse for flunking it. You can forgive yourself in an urgent situation with rapid action if the framing and composition aren't exactly as you would have liked, because simply being able to capture a moment at all takes precedence. With time on your hands, however, it had better be just exactly as you want. There are fewer excuses for any weaknesses in the kind of slow-moment situations that now follow. And a small caution against lulling yourself into feeling secure and in full control: The crux of a slow moment has a habit of coming up more suddenly than imagined, and there are few things more embarrassing than failing to capture a moment for which you waited hours.

ACTIVE MOMENT Bodhi Tree

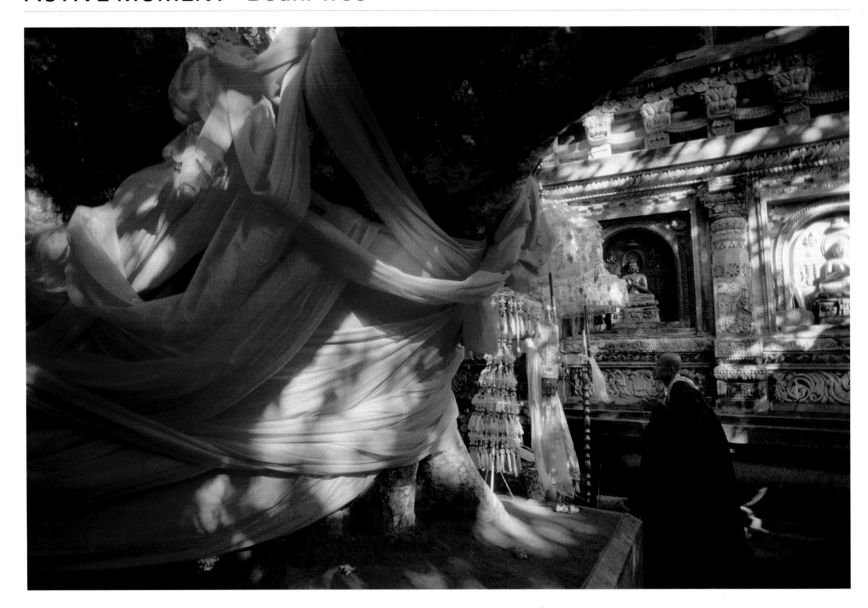

The Bodhi Tree, Bodh Gaya, Bihar, India

I've chosen this little scene as the first of the slow moments because it's fairly typical of a certain kind of situation, and quite a common one at that. There's a well-defined subject, even an unavoidable one, that's not going to disappear, you've chosen the time and day and weather so that the light is good and interesting, and there are no obstructions like scaffolding, a horde of tourists or unexpectedly restricted access. Everything is in place and yet,

there is still the nagging feeling of "is that it?" Is there nothing more special? Can I do more?

This is one of the most sacred places in the Buddhist world, the Bodhi tree under which the Buddha reached Enlightenment (in fact, it's not quite the tree after eight thousand years, but rather a sapling from the original which was supposedly taken from here to Sri Lanka. But it is the place. The location is Bodh Gaya in India, and it's a journey

of several to many hours from whatever major town you begin the journey. I very much needed the photograph for a book I was shooting on sacred sites in Asia, so it merited the trip.

Trees are usually messy subjects visually, and tend to get tangled up (visually) in their surroundings.

Rating

Very slight urgency because of the setting sun which would allow only several minutes of shooting before the chiaroscuro disappeared. Precision was quite important for the framing from this very close viewpoint. Speed: unimportant.

Good, clear tree images are normally the result of hunting down particular specimens and getting the light just right to separate them from their settings. There was no chance of that here, as a Google search of images quickly reveals. Moreover, the tree is surrounded by a small enclosure, which further restricts the view. Nevertheless, the trunk was at the time wrapped in saffron cloth which, in the dappled late afternoon light, looked striking. For lighting, it was the right moment. In effect, I was going for chiaroscuro, and it was working: a 20mm wide-angle view from close, colorful and certainly tree-like.

Yet still, I had run up against the "is-that-it?" barrier. The one where you wonder if it justifies the long journey. This view was as far as I could go with lens, lighting and viewpoint. Not surprisingly, I wanted something to actually happen, though not right in front of me (I was only a couple of meters from the tree). It took about ten minutes, during which time I was conscious that the dappled light would soon fall off the tree trunk, before a Japanese monk arrived, and began praying at the small shrine on the other side of the tree. That, for me, was as good as it was likely to get—relevant activity to enliven the scene and make a moment out of an otherwise static view, yet in the background. Ironically, the final format of the book was set at almost square, and the moment was cropped out. ■

The shot as used

The publisher's art director wanted the shot, but it would not fit into the near-square format. The moment that I had thought made the shot was abandoned.

Light & action

Two things coincide: One is the chiaroscuro from the dappled sunlight, which from top to bottom strengthens as clouds clear away, and then fades as the sun sets behind trees. The other is the arrival of a Japanese monk to pray.

The sequence

I settled in to this horizontal framing, though at first it was unpopulated. The monk arrived and I had a few minutes before the sunlight finally went off the tree.

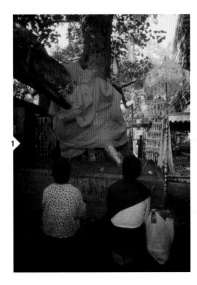

BACKSTAGE MOMENT Devil Dancers

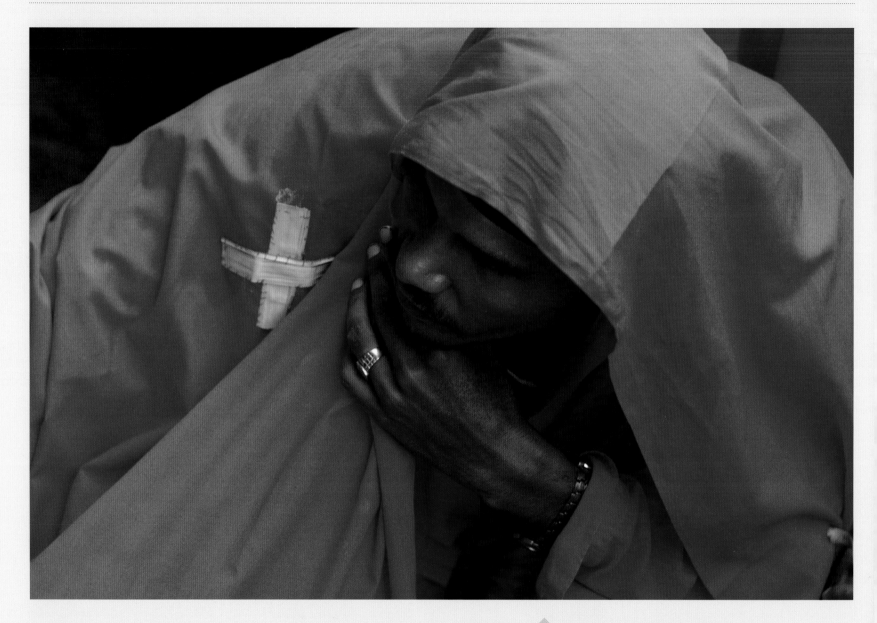

Sometimes the moment that makes the shot—or at least, stays remembered for longer— lies outside the main event. The occasion: Corpus Christi celebrations of a very particular kind in a small Venezuelan town about an hour's drive south of Caracas. This is San Francisco de Yare where, in a tradition descended from African slaves, celebrants don red clothes and grotesque papier-mâché masks

to become devils. The dancing, which reaches its climax in front of the church, represents the fight between Good and Evil. All very colorful and full of action, as you would expect a street festival like this to be. The job: a country assignment on Venezuela for *GEO* magazine. On a day like this, you cover all the bases. Preparation, dancing, details, wide, close, telephoto, the lot. Graphically, red dominated

Devil Dancer, San Francisco de Yare, Venezuela

everything, even more than the masks, I thought. Although dramatic, masks are all over the world and are heavily photographed, whereas these red costumes with crosses of bamboo strips sewn on were more special for the camera.

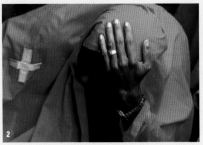

1 The first shot has a lot going for it, with an excellent hand gesture. It's let down only by the face being too hidden.

2 The hand closes up the dark empty shadow area, but still the face is unreadable.

3 He turns to face in the opposite direction. Not bad.

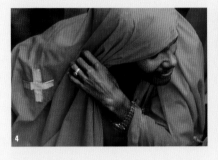

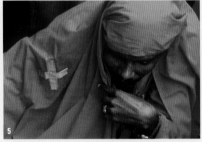

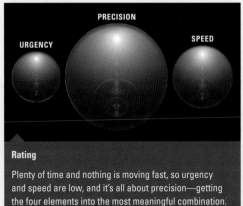

4 A slight improvement with the change in hand position to become simpler.

5 Back to facing down and slightly left. I'm undecided about this one. I feel it's almost there but not quite.

6 The shot I eventually choose. Everything is cleanly in place, even though the hand isn't as good as in the first. The folds and the gaze make it all flow leftward, and there's an almost saintly calmness to it. It coheres better than any of the others.

7 He shifts position and the hand disappears. Compared with what went before, this has much less. Effectively, this shoot is over.

There was a rest between two energetic bouts of dancing in front of the church, and from my slightly raised position I had a view down on the now-seated dancers sprawled on the ground. This viewpoint offered me the possibility of filling the frame with red, and I really wanted that for its graphic strength. I settled on this man from a choice of a few people visible, because the red cloth partly covered his head and so filled the frame more. With a 180mm medium telephoto I moved to get this simple, clean framing with as much red as possible, and waited about ten or fifteen minutes for the best combination of red, face, hand and cross. There's no control in a situation like this, but it helps to know what you would like. I wanted simplicity, which meant clear separation of these elements. I also wanted an elegant hand position, and I needed to see enough of his face for it to be readable. In the end, only one moment really made it, the sixth. Even then, I would have preferred the hand gesture from the first, but that's life. ■

A mix of four graphic elements

The shot reduced to four things, and success depended on how they combined: red backdrop of cloth, brown face, brown hand, and pale bamboo cross. Think of the variables as floating elements.

PRECISION

URGENCY

SPEED

Rating

Plenty of time and nothing is moving fast, so urgency and speed are low, and it's all about precision—getting the four elements into the most meaningful combination.

REFLECTIVE MOMENT A House in Anafiotika

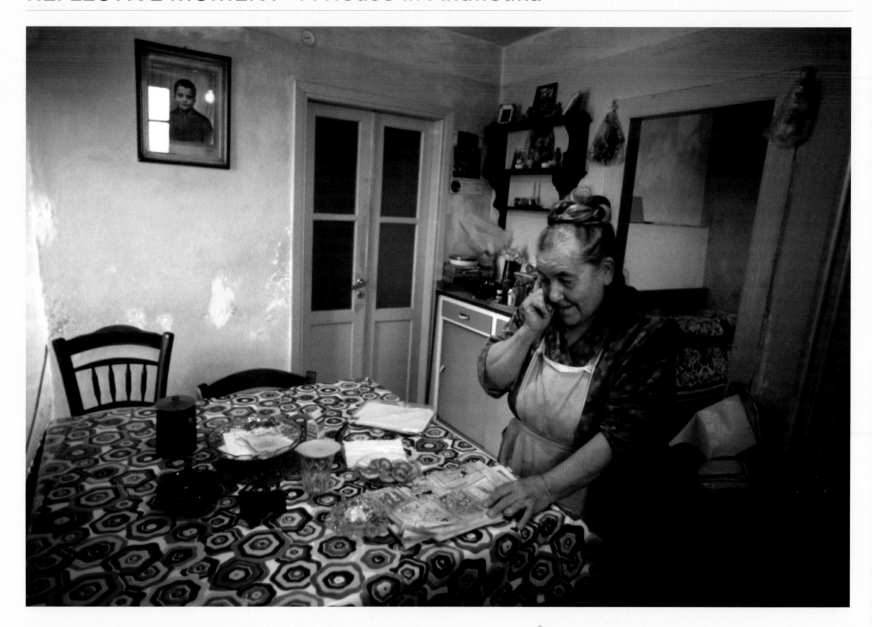

When situations unfold slowly, their meaning— or at least their possibilities—sometimes become clearer, and this nudges the photographer toward one moment that makes more of the scene than others. This is one of the basic advantages of slow moments. There is time to think and to learn, and if you spend the extra time doing this, the image can definitely benefit. Here is one such example,

where a little journalism revealed more than was obvious at first. This was in Athens, and the theme of the photo story was to show how some communities in the big city had arrived from the islands and still functioned as little villages. This was Anafiotika, on the slopes below the Parthenon, before the days when many of the buildings were converted to restaurants and hotels

to cater for tourism. With a Greek journalist I was doing the rounds, and we were inviting ourselves into people's houses to photograph and interview.

This interior was full of interesting detail, and the couple themselves had character that came

Forging a connection

The viewpoint and framing with a 20mm lens already make it fairly clear that the portrait on the wall has a prominent part in the picture—an example of how placing something eccentrically but strongly draws special attention to it. The other major element is the woman, and I needed a moment of expression and gesture to suggest the connection.

across well to the camera. The woman was the more talkative and expressive, so I moved around the room to feature just her. This was standard wide-angle portrait-in-context shooting, with a 20mm, and using a lens like this, small changes to the viewpoint would alter quite strongly the arrangement of things visible. As my journalist companion continued her interview, the topic moved naturally from how long had the family been living here to events in the past. Yes, they had lived here during the war, and under German occupation, when conditions had been very difficult and there was never enough food. In fact, her son had died of starvation. Was that his photograph on the wall, I asked? Yes, it was. I moved to include it in as strong a way as possible, with the reflection from the window lighting it up. This needed some care, because while the reflected light draws attention, it could not fall over the face. There was an important story here, which a caption would explain but which needed the right moment and arrangement to point up. The woman continued talking, and looking at old clippings. I waited for an expression that would resonate. At this point, she raised her hand to her face and seemed to be lost in her memories. This moment connects her with the portrait on the wall. At least, that was what I aimed for. ∎

URGENCY PRECISION SPEED

Rating

The overall situation contained no urgency, but once I understood what I wanted, the urgency increased surprisingly, because the shot would depend on a facial expression yet to come, and I had to be ready for it. Precision was needed in the sense that I was juxtaposing two elements, and one of them (the photograph) needed to catch the light precisely in order to be prominent. Speed was of average importance—I simply needed to avoid any blur in her face.

An unfolding story

From portrait of a couple, to portrait of the woman alone, to the connection with the portrait on the wall, the sequence of shots evolved naturally, as described in the text.

MOMENT IN DETAIL Contextual Portrait

As moments go, these are among the smallest, but whenever there is a choice of moment, of any kind, it still needs attention. These are two portraits, intended to appear in a book as a pair, of the kind sometimes called contextual portrait—essentially the subject in the setting that defines them. This can be workplace, home, or a location that is often the trigger for the portrait in the first place. These two

ladies are among the very few people who still live in the grand old houses that were built around the turn of the twentieth century for the established families of Cartagena de Indias, in Colombia. Most of the houses have since become offices or schools, but these two, both in a Moorish style, have remained as they were, and are still lived in by the families that originally built them.

Teresa Roman, Casa Roman, Cartagena, Colombia

These make ideal examples of contextual portraits, in which not only is the setting as important as the person, but the two need each other. The person belongs to the place as much as the other way round. Proportions are critical

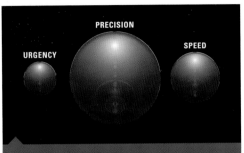

Key Points

Setting as subject
Viewpoint & frame
Attention to detail

Raquel Ochoa, Casa Covo,
Cartagena, Colombia

Changes in expression & action

The mid-talk expressions are less successful than the others, but the drinking shot is finally chosen for the context point mentioned.

Changes in expression & posture

Three choices of posture, the third preferred. Choices of expression revolve around smiling, half-smiling or unsmiling, and these are entirely according to taste.

in portraits like these, and that in turn has an effect on the role of expression and even gesture. The space in the frame that the figure occupies controls the way the viewer will look at the picture. In these two, both taken in the central patios that are the main characteristic of such houses, the framing needs to take in enough of the space to get the idea of the patio across and to show the furniture and pillars. To reinforce the importance of this balance, I'm also including a closer framing that is totally different in its effect—the surroundings become secondary.

Moment is certainly not as important to these planned shots as it is in most of the images in this book, and yet it still matters, and this is the point I'm making here. The camera is on a tripod, and the photographer talks to the subject, shooting whenever the moment seems suitable, and to maintain the flow of the shoot (if there's a long pause between shots, some subjects interpret that as meaning they somehow don't have the right expression, and that can create tension). The edit and final selection come later. In the first shot there was an extra factor—the lady is sipping the soft drink that made the family's fortune, and while this was not a set-up or suggestion of mine, it seemed worth following, hence the shots without eye contact. In the second house, I directed the changes in posture, but left the expression to happen naturally. In both cases there was a choice between smiling and not. There were also, in the first house, some shots taken during conversation; these often do not work out because of slightly odd mid-sentence expressions. ∎

COORDINATED MOMENT Pushing the Boat

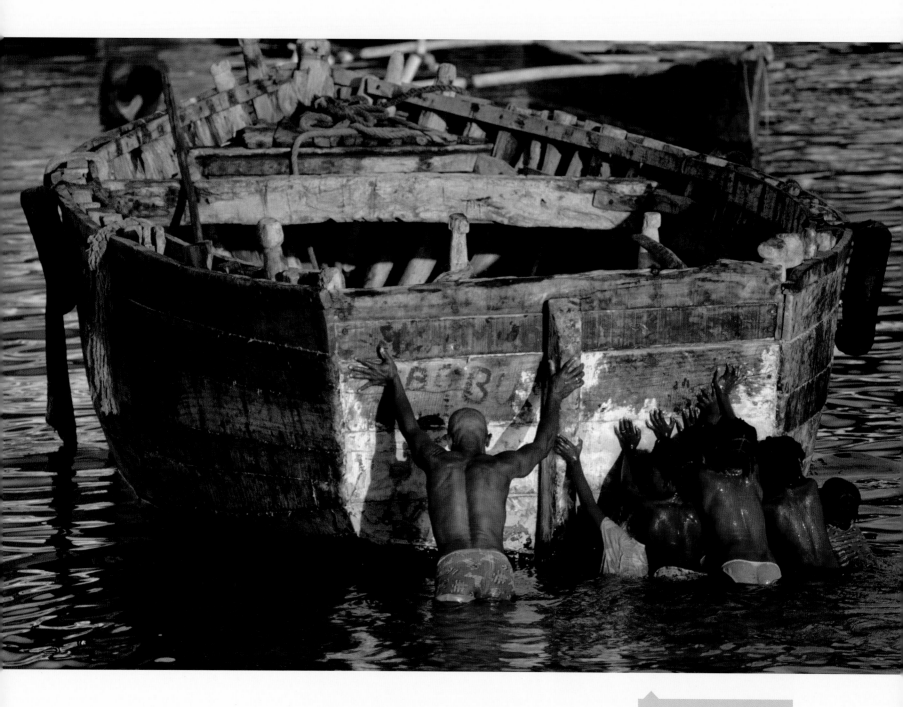

Moroni Harbor, Grande Comore

Here in the harbor of Moroni, capital of the Comoros, a group of islands in the Indian Ocean, the background moment, if I can call it that, was an extended one of a setting sun in a clear sky, from behind the camera. This kind of axial, or frontal, lighting can be wonderful for a rich, intense effect, and you can see another example on pages 188–189 Weather Moment—Gate Tower. As long as the subject has contrast, whether in brightness or color, an intense sun behind the camera delivers a special crispness, a sort of natural, large-scale version of a camera-mounted flash without fall-off.

And there was activity in this time-warped part of Islamic, island Africa. A quiet, end-of-day scene that could have been played out at any time during the past several centuries. That was really the point of the shot, and so it carried the paradox of something timeless that needed an exact moment to bring out the best of it. These pure old wooden boats, hand crafted locally, are not going to survive this century, and the scene was exquisite. The shirtless man pushing his boat slowly toward its mooring. And kids fooling around, jumping in the water. Far from telling them off for using his boat as a diving board for jumping off, the man just recruits them to help him push the boat. You could say that visually, the sharp sun behind the camera sets up the scene, but socially what's behind the picture is a kind of natural harmony. Isn't this what we'd all like life to be like? I would, anyway. ■

The setting

A wide-angle view of the extremely picturesque harbor in the late afternoon, with the mosque on the other side.

COORDINATED MOMENT Pushing the Boat (continued)

The sequence

Children play on the boat as the man arrives to move it, taking the opportunity to jump into the water as they leave—and then join in the operation. In fact, each of these moments has value in different ways, especially that of the boy jumping, but the main shot was chosen for showing the combined effort.

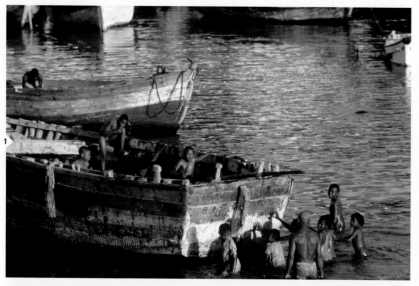

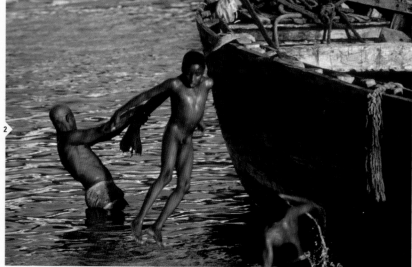

Rating

Urgency: moderately high, as there's a scene unfolding, albeit over several minutes, that may deliver surprises. Precision: very high, as we need a certain coordination of people and boat that will represent the perfection of a communal boat-pushing moment. Speed: not particularly important—needing to freeze the action, which is not difficult in this good, strong light with people moving fairly slowly (apart, that is, from the boy jumping into the water).

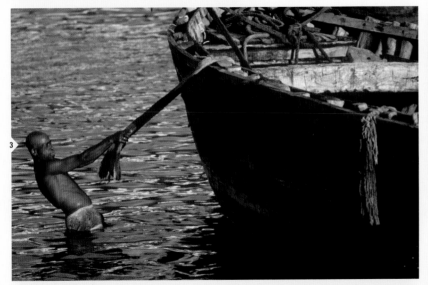

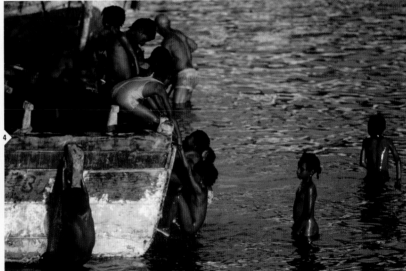

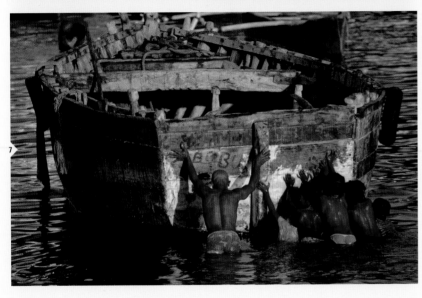

ART-DIRECTED MOMENT Mid-river Yoga

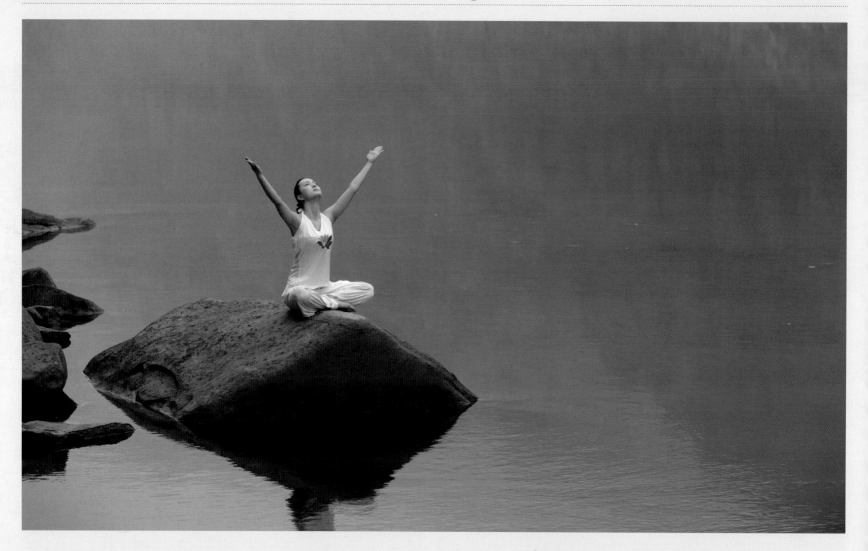

Yoga, Bei Bei, Chongqing, China

Most of the photography here in this book is of situations out of the photographer's control—of scenes and events as they happen, with the photographer just happening across them. But in another world of photography, often commercial assignments for clients who want a particular image, moments are more often created. This is a very different way of working, for two reasons. First, you have to draw on your experience of how things work in real, unplanned life in order to direct models and other people. This is art direction applied to moment. Second, because it's usually obvious to an audience that this is a created situation, there are no excuses for things being not quite right. The stakes are raised.

I include this as an example of that kind of controlled moment, so that we're covering all the bases. There is almost no unpredictability, so it may not be as exciting as images snatched from passing life, but creating a shot (and yes, choosing the moment to shoot it) can be just as rewarding. In its own way. The assignment was shooting a yoga position for Brilliant Resorts in China, and only one shot would probably be used. We weren't looking for a sequence, although we would try different yoga positions for choice. The criteria were, on the one hand clear, clean and simple, and on the other, a soft, atmospheric mood. As usual, with this kind of thing, it's location, location, location. In discussions with the client, we easily agreed on this river setting with boulders, because the weather was soft and slightly misty—the kind of weather that best gives a kind of timeless feel.

More of the setting

An alternative treatment, with the zoom pulled back to 90mm from the 116mm used for the main shot, shows more of the setting, with the far riverbank more visible.

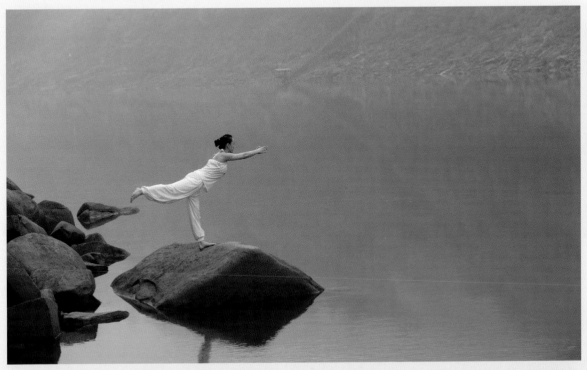

Rating

All the planning removed most of the urgency, and what remained was simply to do with how long the mist would last. Precision was necessarily high, as this is an art-directed shot. Speed: unimportant

Setting

Calmer and quieter

Zooming in slightly more, to 120mm, and dropping the framing to include the reflection of the model, abstracts the setting even more by hiding the far riverbank. The yoga position is more meditative and still.

It was important also to do as much as possible to remove traces of reality from the setting, without resorting to any manipulation. The location was good for this, because the river surface was calm, and there was also an elevated outcrop that allowed a downward view to cut out the opposite side of the valley, upriver. A medium telephoto at 120mm gave the necessary tight framing that kept the background smooth and gray. ■

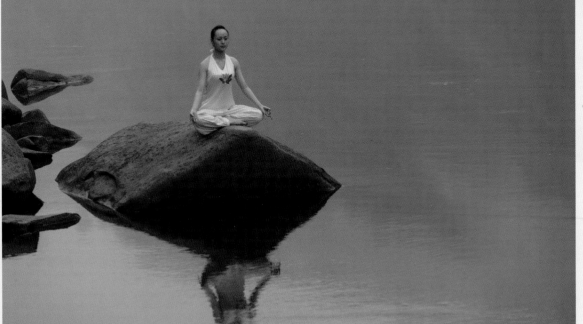

COLOR MOMENT Mount Popa

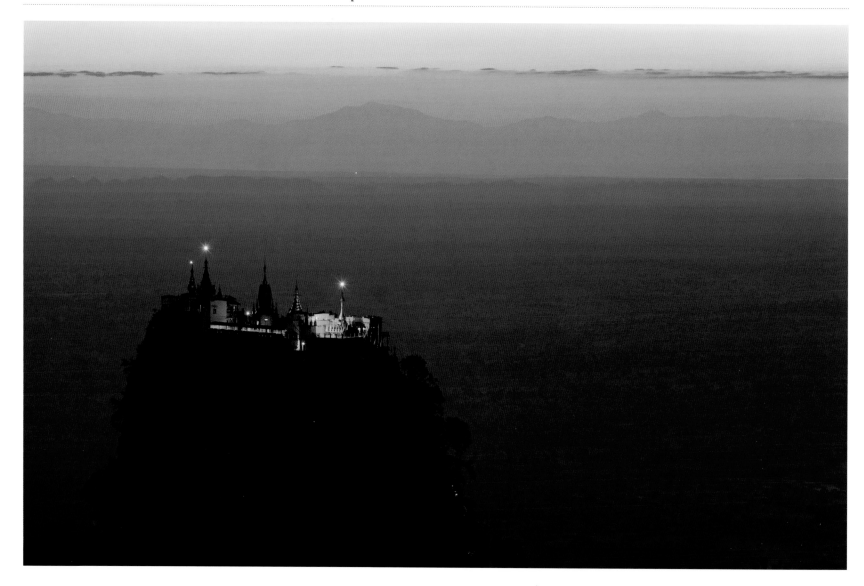

Mount Popa, Myanmar

Waiting for the sun can lull you into a false sense of security that there is plenty of time—even too much time. The reality is that you usually don't know in advance how the shot is going to shape up, and it may be that the special moment of light is much briefer than all that waiting around prepared you for. This is what happened here, on Mount Popa in Myanmar, close to the famous old temples of Bagan. I was with a film crew shooting the movie *Samsara*, and we arrived on site an hour before we even expected to start shooting, a standard precaution. Everything that could be anticipated suggested that this shot would work well—a high viewpoint that would put the rocky outcrop with its temples below the horizon line, and backlighting from a sunset guaranteed by the time of year, December. But exactly which moment remained unknown, so I had to shoot through from the golden light of late afternoon to night. The lighting diagram explains the hidden complexities. There were two obvious and predictable breakpoints: when the sun entered the frame, and when it set. In between there would be lens flare, diminishing only one or two minutes before sunset, and there was one unexpected moment, when the sun for less than two minutes was partially blocked by a thin line of clouds.

Key Points
Preparation
Magic hour
Shifting colors

The camera setup

The real point was the 65mm Panavision shoot, and my role was to advise on location. Nevertheless, it left time for my own shooting.

Lighting breakdown

From top to bottom as the sun sinks, the lighting changes constantly in color. The breakpoint of the sun entering the frame, causing lens flare, is marked by the upper gray plane, and the second main breakpoint of the sun setting by the lower gray plane. After this, the color in the scene breaks into three areas: sky, land, and the artificial lights of the temple, switched on shortly after sunset.

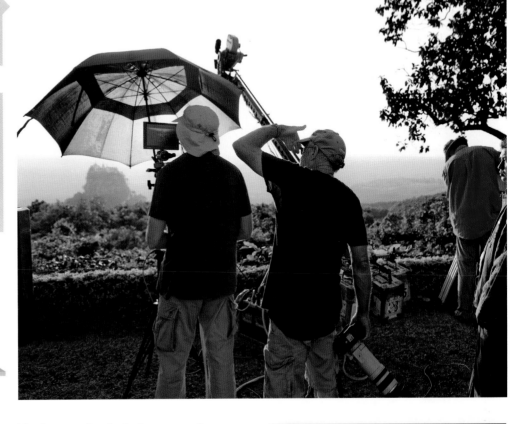

This last, together the final moments of sunset were the only times for shooting with the sun in frame and no lens flare, so they were quite urgent.

Immediately after sunset the color drained from the scene, but temporarily. The illustration shows how the color situation changes from a general suffusion of gold in sunlight to a divided frame, with the sky moving toward red while the landscape moves toward blue, and somewhere between 15 and 30 minutes after sunset they are at their maximum contrast and saturation, and when the temple lights are switched on this adds a third color. The three of them balance at some point before dark. There are arguments in favor of several of these moments, except for those with lens flare, which adds nothing to the shot. If pressed to choose just one, I usually go for the late-evening rich-color version. ■

URGENCY PRECISION SPEED

Rating

More urgency than you might expect, because out of a two-hour wait, the key shooting moments were very short—one minute for the sun partly blocked by the clouds, less than one minute when it was just above the horizon but not flaring the lens, and ten minutes when the dusk colors were at their richest. Precision was moderately important for the shots that included the sun, but speed was not an issue.

COLOR MOMENT Mount Popa (continued)

A two-hour sequence

The timespan is long, but the best moments are short, and not entirely predictable. There are several candidates for the final choice.

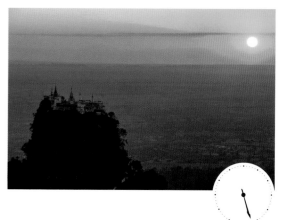

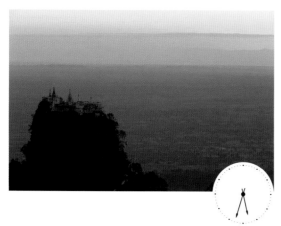

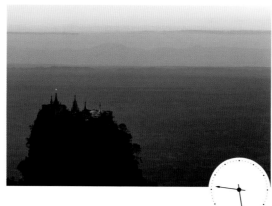

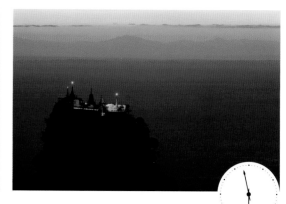

WEATHER MOMENT Gate Tower

It's time to mention here that by no means every photographer is obsessed by moment (though I am, unashamedly). Within the last, say, twenty years, an attitude of rejecting the convention of moment has taken hold, particularly within fine art photography. You can see this at its most definite in typologies—series of images that document in a firmly deadpan, uninflected manner, scenes and subjects that are linked by content. The Dusseldorf school initiated by Bernhard and Hilla Becher is the classic example, and is strongly architectural. It began with photographic lists of old industrial structures such as gas towers, and clearly a "list" of photographs of one type of subject really doesn't need spectacular lighting. That would, in fact, destroy the point of an inventory.

Why am I going off at a tangent at this point in the book? Because non-moment-based photography has a role to play, and even if I'm not particularly interested in it myself, it still adds value and thought to the whole world of photography. More to the point, this lovely gate tower in the center of a real and living Chinese town is perfect material for such a treatment. A typology of such ancient towers is valuable (and it has already been done, by Chinese photographers), and argues for similarity in visual treatment. That in turn argues for black and white and for ordinary lighting. This is not what I was trying to do here. Instead, I wanted a rich view on one gate tower rather than a typical view that would co-ordinate with many others. That's not, of course, to say that this is in any way a superior way of tackling the shot. You could even say that it's a conventional way, looking for the visually strong and impressive,

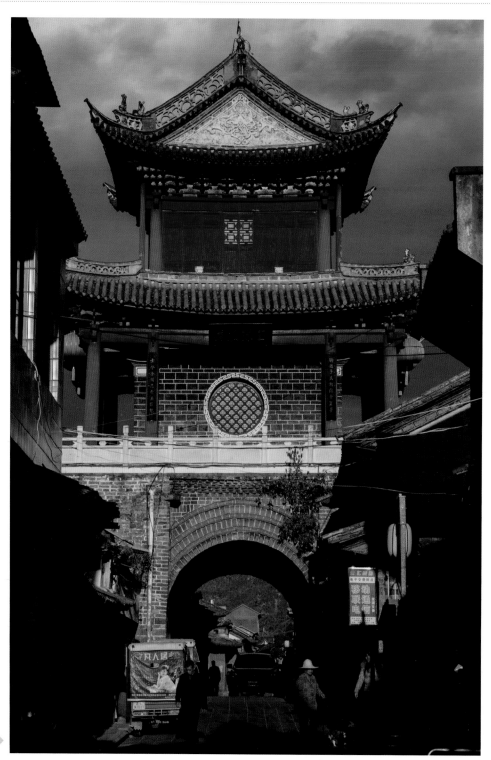

Asian Gate House, Okinawa, Japan

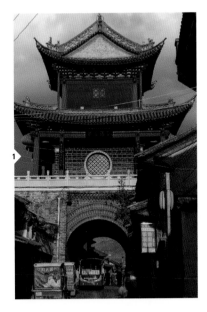

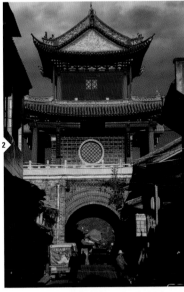

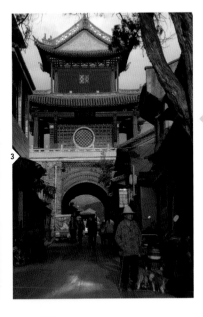

The rise & fall of sunlight

Because it involves two variables—clear low sun and dark clouds on the opposite side of the sky—the effect can change rapidly. In particular, the sun close to the horizon is really vulnerable to being cut off by clouds, so an intense contrast can be fleeting if it happens at all. Here, the effect went like this, with the clouds behind the tower not quite so dark at the beginning, and the sunlight quickly fading at the end.

Rating

In the context of moments that are slow moving anyway, the urgency here was high, because with all this cloud around, the sun could disappear in seconds. The shot depended on strong, clear sunlight at full strength. Precision: moderate, as any reasonable framing that balanced tower against sky would work. Speed: fairly unimportant.

URGENCY PRECISION SPEED

Stormlight

Thunderclouds approaching from the east combine with a setting sun in the west to create a classic lighting combination that adds drama to almost any scene.

the crowd-pleasing approach. Never mind, this is what this little project is about, finding a rich view and using moment to do it. Moment that relies on changing weather.

One guaranteed crowd-pleaser, if you like, is a scene lit by a low sun against a stormy, dark sky. Audiences have always liked this, going way back to classical landscape painting. This is a Chinese town so far thankfully neglected by the tourist industry, and I was fascinated by this central gate tower, shooting it from different angles at different times of the day, over the course of two days. I was hoping for some interesting weather, and finally it arrived late on the second day. There were views from all four sides, and with this choice the classic treatment was from the west, with the sun almost behind the camera (meaning virtually shadowless and rich) and the rainclouds building behind, to the east. If you look forward to pages 196–197 in Shadow Moment—Delicate Arch, you'll spot the similarity of changing light that you can't quite predict. Every minute might be the best and last minute, so you need to keep shooting. I wanted color richness and contrast between gate tower and sky, and so my perfect moment hinged on this. ∎

189

SUNLIGHT MOMENT On the Middle Yangtse

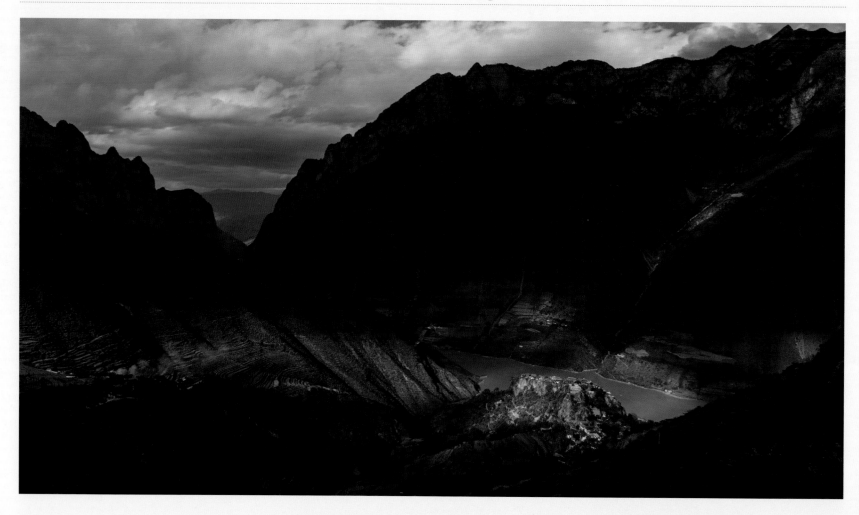

Landscapes never move as fast as street life, but some situations operate by the minute, and that's fast enough. Light, and the weather that controls it, is the main variable, as here on the banks of a remote stretch of the Yangtse River in China. The viewpoint, which often clinches a landscape shot, in this case involved no effort. The winding track on which we were driving simply revealed this view on a bend, and it got no better. What mattered for the shot was the light, and the possibilities were good right at this time—late in the afternoon, with the uncertainty of shifting breaks in a fairly full cover of cloud that was moving quickly in strong high winds. The illustration is the reverse view, looking back toward the camera position and the sun, which, from where I was shooting, was behind and to the left. Cloud cover was about six-eighths, which made small gaps that traveled across the landscape, camera left to camera right. This kind of lighting is fluid, and just partly predictable. The point of the shot was the ancient village perched on a rocky outcrop right on the river. This is an old part of China, no roads other than the unmade track we were on, and the little settlement is the natural focal point of the scene. It was obvious, perhaps, to want it spotlit, but that moment, captured in the main shot, makes the idea of an isolated village crystal clear. Compare

Baoshan and Yangtse River, Yunnan, China

this with the alternatives, as the gaps between clouds moved left to right across the landscape. Full cloud is really flat and disappointing, but a large amount of sunlight also fails to pull the attention. It was a matter of waiting, no complete certainty but a reasonable expectation. It took no more than quarter of an hour from our arrival for the right moment, and then we moved on to find another viewpoint, which was quite good but not as good. ■

Rating

After an initial concern about the lighting, which luckily proved groundless, urgency stayed low, and I shot for five and a half minutes. Precision was definitely important, even though I tried out various positions for the patches of sunlight. Speed was unimportant.

The range of light

The two extremes of the lighting at this time were completely cloudy to half sunlit, the first disappointing as a landscape view, the second quite pleasant but without the impact of the more concentrated pool of light in the main shot.

The weather conditions

This is a reverse view from across the river, looking back toward the camera position and the sky behind the camera. The cloud cover is drifting south (left in this reverse view), so that the gaps cause pools of light that rise and fall with the contours as they too move southward. The dark promontory on the river is the village of Baoshan.

The setting

This was the view as we came across it, on a bend in the track that revealed this sweep of the Yangtse River for the first time. The patches of sunlight are moving from left to right and slightly away from us.

LIGHTING MOMENT Maple Tree

Villa Esterio, Yamanashi Prefecture, Japan

Good architects know all about light. Their buildings depend on it for their presence and effect, and when they're really good, like Atsushi Kitagawara in this courtyard of a larger complex in Kobu, Japan, they think about the details of how the light falls at certain times. The narrow shaft, a pencil-thin arrow of sunlight crossing a floor of white pebbles, is no accident. It's entirely planned, but then handed over to the chance of weather and light. The combination of precise control and unpredictable nature. There are, frankly, not too many cultures that think like this (well, all right then, Song Dynasty China for another, earlier, example). This is where photography, or at least architectural photography, simply follows the code. The designer/architect/artist created it, and the photographer's best strategy is to simply understand what was intended, and capture it. Minimalism has roots here in this simple arrangement of tree (autumn maple, loved in Japan) and white structure, from walls to pebbled floor. What brings it to life is the totally outside agency of light. ■

Rating

Urgency is quite high, as the view of the sun was blocked by the walls, and there was no certainty about whether clouds would obscure the sun at any moment. Precision: high also, particularly about viewpoint and framing, as the narrow shaft of sunlight could make a strong diagonal in the composition. Speed: not important, as this was a shot with the camera on a tripod, and the time being measured in minutes rather than fractions of a second.

Key Points

Lighting precision
Minimalist
Geometry

An architectural tree

The single maple was sited with an architectural role, punctuating the white structures in stone and concrete.

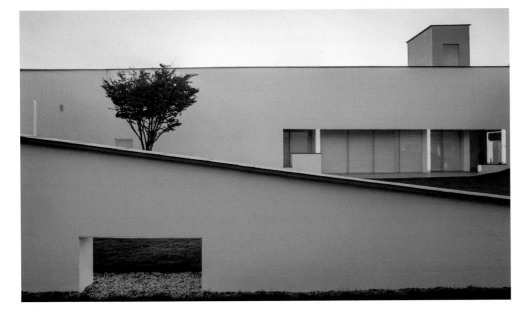

A brief shaft of light

A gap between freestanding walls (part of the architectural style here) allows a pencil-thin line of sunlight to fall across the pebble-strewn courtyard near sunset. The angle changes with the setting sun—as it moves northward, the strip of sunlight moves slightly clockwise.

Fading light

Behind the camera, a deliberately sited gap in a wall allows a thin pencil of sunlight to cross the courtyard at sunset. In a very Japanese aesthetic, the moment of diagonal sunlight becomes all the more poignant with its inevitable fading away.

SUNSET MOMENT Village in the Hills

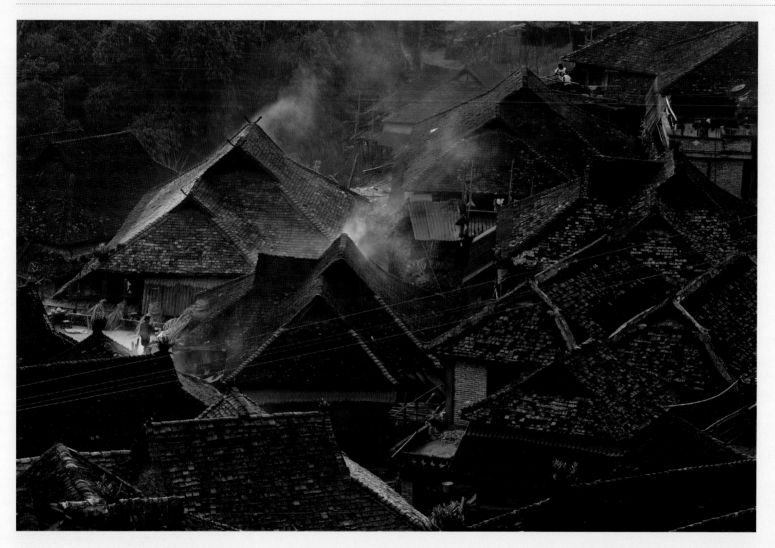

The last three situations have all involved a lot of waiting, and this one too. This is something I explored in another book, *Capturing Light*, mainly because it might seem that there's not much to say about hanging around for the sun to sink. In fact, you can make use of this time. To capture your best moment (there are clearly several to choose from, each with its own appeal), you do need to make use of this time, to anticipate how sunlight will fall across a scene that you've never seen before. There is, naturally, no going back a moment just because you missed it, and this justifies over-shooting, for safety.

The setting here is a mountain in the deep south of Yunnan, China, close to the Burmese border. This is a village of the local Bulang ethnic minority, sited in a bowl surrounded by forested hills, photographed from the upper part looking down. And also looking into the sun, increasingly so as it sets, as you can see from the flare that creeps into the shots partway through the late afternoon. Shooting into a setting sun like this has the possibility of rewarding contrast and atmosphere, with lit surfaces contrasting with shadows. It also, however, runs the risk of flare, even when the sun itself is way out of frame, as it is

Zhanglang village, Xishuangbanna, Yunnan, China

here—the lens is 200mm and focused tightly on a small section of the traditionally built village.

As with all the photographs I'm showing here, they stand as examples for a kind of situation. Every scene is unique, so deserves a description of the details, but if it went no further than that, it would just be a series of anecdotes. Instead, the account of a situation like this is supposed to help prepare you for something similar. As you can see from the first

A half hour of changing light

Over a little more than 30 minutes, the changes in light striking roofs (and flaring the lens) were significant.

Shifting planes of sunlight

The key to the lighting of this sequence is the pattern of sunlit roofs, which changes quite sharply as the sun sets. As the illustration shows, this works like an overlay of bright shards on the darker, bluer and less contrasty shaded parts of the village, with its crowded, multi-angled buildings. A matter of taste, naturally, but the roofs from which the last sunlight is just disappearing add a sense of time passing to the main shot.

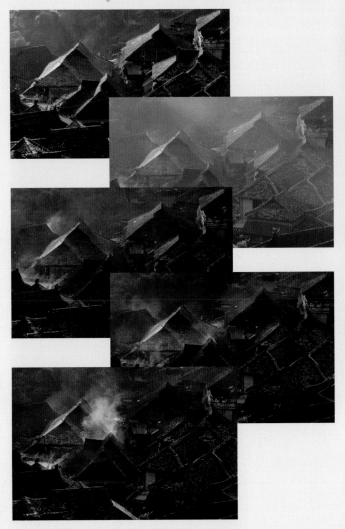

shot in the sequence, late afternoon but well before the sun is nearing the horizon, the possibilities are there. The viewpoint is good, and gives a frame-filling view of hill-tribe thatched roofs and a cluster of dwellings, surprisingly without the trappings of contemporary technology (solar heaters, satellite dishes, etc.). This makes it suspiciously an idealized view, I admit, but it's real. And will not last for too many years. So, good basics, deserves the best moment, which will be mainly about light but will hopefully have someone in view and some other unpredictable things, like smoke from a cooking fire.

Already, as you see, there's a kind of wish list that gradually builds up, and if you keep it reasonable it can help. The main ingredient is the lighting, and ideally it's going to be some kind of raking light, warm and orange, contrasting with the shadow blue. Inevitably, close to this moment, lens flare will set in, as the sun lowers to the point when it shines on the glass under the lens hood. Holding a hand or a piece of card as far in front of the lens as possible and lowering it until it just cuts the sunlight is the standard solution, but it still may not be enough. In that case, just before the flare may be the best possible moment, and then there will probably be a very short moment after, when the sun is too weak to cause noticeable flare. The latter is what happened here. So, the idea of moment in this case has to do with last highlights striking rooftops, and also, fortunately, with a woman walking in view and the smoke from a wood fire. ◾

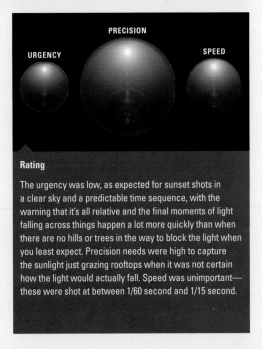

Rating

The urgency was low, as expected for sunset shots in a clear sky and a predictable time sequence, with the warning that it's all relative and the final moments of light falling across things happen a lot more quickly than when there are no hills or trees in the way to block the light when you least expect. Precision needs were high to capture the sunlight just grazing rooftops when it was not certain how the light would actually fall. Speed was unimportant— these were shot at between 1/60 second and 1/15 second.

SHADOW MOMENT Delicate Arch

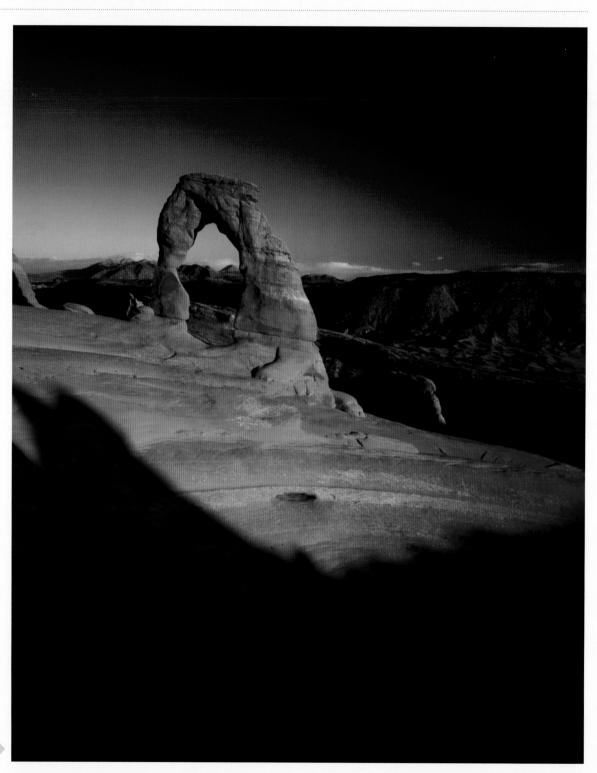

Alongside the uncertainty about how exactly the colors will change around sunset, which we saw with Mount Popa, is the way that shadows will progress. Whatever breaks the horizon to the west, whether trees, hills, buildings, or a cliff-face, there are potential shadows, and not always easy to predict. At least, not when it comes to the precise fall of shadow shapes across the scene in front of you. Sunlight (when the sky is clear) and shadow progress hand in hand, but which one calls the shots when you're composing and timing varies. In the shot of the old stone village perched on the banks of the Yangtse River a little earlier, the cloud cover meant that inevitably the pools of sunlight dominated as they crossed the landscape. Shadow was simply the background for them. Here in eastern Utah, under crystal clear autumn skies, the moment for shooting was called by two things—the gradually deepening color of the sandstone in late afternoon sunlight, from yellow through orange to red, and the march of shadows from foreground toward the arch. The color change was the more obvious from the start, and so the less interesting.

This is one of the most famous, and definitely one of the most elegant, sandstone arches in the American West, and takes something over an hour to climb to from the road. One obvious issue with such a well-known site is other people in frame, but on this occasion everyone took the commonsense view that the best place to photograph was from here, on the other side of the sandstone bowl from the arch. As usual, if it's your first time in a location, you can have only an approximate idea of how the shadows will move, so it's essential to keep shooting until the end; you never know quite when the best

Delicate Arch, Utah

Key Points

Predicting shadows
Rapid color shift
Color richness

The earlier shadow

About 20 minutes before the main shot (this was on film, so no EXIF data for accuracy), the main shadow from the rock wall out of sight right and behind the camera is beginning to creep forward. At this point there is no indication that it will break into two.

The onset of color

About half an hour after the main shot, the shadow has crossed into the bowl and is rising toward the arch. Actually, at this point it has stopped being an interesting component of the picture, and the rich red color has taken over. This is the moment of maximum red, after which, the color weakens.

Last sunlight, less color

In the final minute of sunlight, as the sun goes down behind the horizon, the color weakens. This does not mean a poorer image, just a different feeling to the scene.

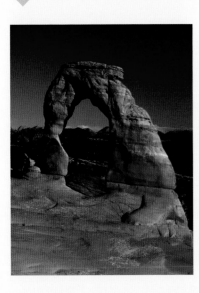

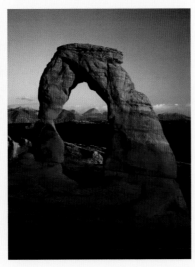

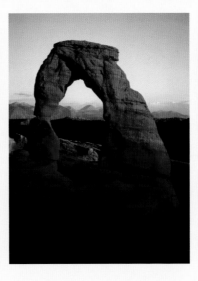

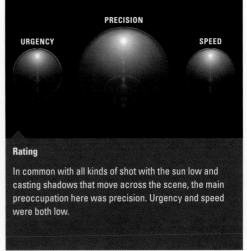

Rating

In common with all kinds of shot with the sun low and casting shadows that move across the scene, the main preoccupation here was precision. Urgency and speed were both low.

shadow moment will be. As you can see from this sequence of images, color is something that affects the arch more than its surroundings, while the shadow that finally creeps up the arch has no special visual interest. For the wide-angle view of the main shot here, however, shadow shapes dominate, and simply by carefully monitoring the way they developed and moved, it was quite straightforward to spot the moment of this split shadow at the nearer edge of the sandstone bowl.

After the split shadow of the main shot, the shadow moment has essentially passed. It becomes less interesting as it crosses the bowl, and we pass on to another kind of moment, that of rich color. This is more predictable, and with desert sandstone almost everywhere in the world, there's a convention of aiming for the richest red. It's just a convention, of course, not compulsory. ∎

The wider setting

Approximately two hours before sunset, this was the wide-angle view (20mm) from the camera position I'd chosen, looking across the basin-like rock depression in front of the arch, which stands on the lip.

Rolling shadow

The configuration of the sandstone bowl, and the rocks out of sight to the west, cause the shadow to move in the direction of the arrow, falling and rising with the contours.

BLUE-EVENING MOMENT Tea Plantation

After the sun has set, there begins a different but often very rewarding sequence of light and color, heading toward the famous few minutes of blue evening light beloved by location photographers who are after rich color contrast that can even overcome the flat feeling from slightly boring scenes. Hence its commercial usefulness, and why it is used so much in, for example, resort photographs. I go into the light-balancing issues in more detail in the book *Capturing Light*, but here I want to concentrate on the matter of moment, which is shorter than many people might imagine, and seems even more so after the long, slow setting of the sun if you're waiting from late in the afternoon. That, incidentally, is normal if you have to guarantee the shot, as in a commercial assignment, as this was, of a spa resort set in a tea plantation owned by the client, Brilliant Group in Yunnan, China.

Spa resort & tea plantation, Jingmaishan, Yunnan, China

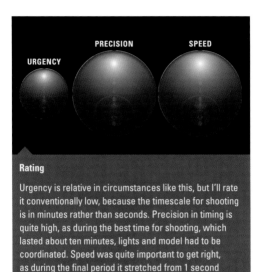

Rating

Urgency is relative in circumstances like this, but I'll rate it conventionally low, because the timescale for shooting is in minutes rather than seconds. Precision in timing is quite high, as during the best time for shooting, which lasted about ten minutes, lights and model had to be coordinated. Speed was quite important to get right, as during the final period it stretched from 1 second to 30 seconds.

Much depends on the weather, and especially on how clear the sky is, so it's impossible to predict the exact changes, but in a case like this, with partially overcast sky and looking west toward the setting sun, what happens is an increase in color. Immediately after sunset, colors generally fade, sometimes delicately but sometimes in a rather dull way, and dull was the case here. Gradually, though, the sky color becomes blue, and as long as you don't try and neutralize this in the color settings, it acquires a richness that contrasts attractively with 3200K tungsten lighting.

In fact, the secret to this kind of light scenario is managing the crossover point between the two kinds of light: falling daylight with its increasing blueness after sunset, and the orange tungsten artificial light inside the spa buildings and from discreetly placed photographic spotlights aimed at trees and at the model walking down the pathway. Bluish violet and yellow-orange are of course complementary colors, so it always looks good. The key is the crossover point in brightness, when they both more or less match. That happens for usually around ten minutes only, and that was when the main shot was taken. ■

From sunset to early night

The entire sequence of shots takes place over nearly three-quarters of an hour, with the early shots taken just for reference and to check on the camera screen how the lighting balance was going. In all except the first shot the artificial lights were on, but hardly visible until the ambient light darkened at nearly eight o'clock (the times are artificially later because the whole of China is on Beijing time, and here in southwest Yunnan we're about one and a half time zones westward).

Balancing the crossover of daylight & artificial

The diagram goes from just after sunset at left to night at right. The upper band represents the sky, and the main band below the green tea plantation with trees and the thatched spa buildings. The tungsten lights, switched off at the start (black rectangle), rise in brightness simply in relation to the falling daylight. The point at which both balance, and at which the tea plantation still registers, is a narrow band outlined at right, lasting about ten minutes.

SLO-MO MOMENT Shinto Shrine

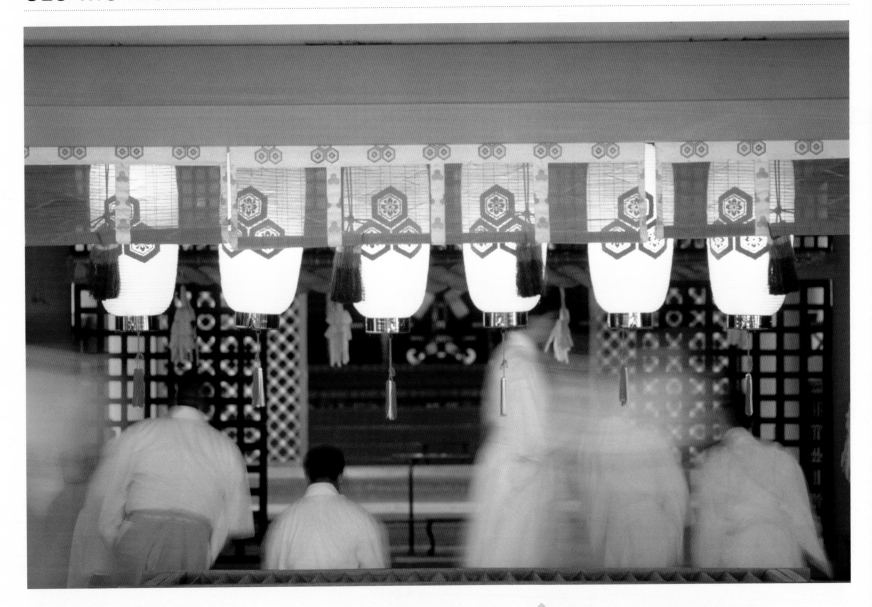

Shinto priests, Itsukushima Jinga, Myajima, Japan

Photography has some very specific, and entirely unreal, ways of stretching and extending moments, slowing them down in ways that we can never actually see or experience. The most obvious is the slow shutter speed, aka time exposure, and the result is completely familiar. At a large fraction of a second, like a half, or longer, the moving subject becomes vague, streaks into motion blur. None of this seems at all strange—now. We've all grown so used to seeing this kind of streaking that we simply accept it as a part of the photographic language of slowness. But it doesn't have any equivalent in normal life. It's just a camera construct, and one that at the beginning was purely a mistake, and an all-too-common one at that. Early photography had a regular problem with shutter speed, because film emulsions were usually too slow for the job. Keeping thing sharp was natural because that's the way we see, so it took some time before motion blur came to be accepted as a visual effect that could be useful and attractive—at times. If you like, it has become an accepted part of the photographic vocabulary, and I see it used more and more, maybe even too much.

An ephemeral blur

The one-second exposure allowed time for the moving figures of the priests, as they left the ceremony, to translate into blurred but still-recognizable shapes. White against a dark background always leaves the strongest trace in motion blur (dark against light tends to wipe itself out).

Frame one

An attempt at a formal pattern, marred by the part-figure at left and the unoccupied area at the bottom of the frame

There was a reason for it here, at the main Shinto shrine of Itsukushima JInga, on Myajima Island near Hiroshima. This is the location of the famous and much-photographed "floating" Torii gate that stands in the sea a little way offshore. The shoot was for a book, *Sacred Places* (see also pages 170–171 for the Bodhi Tree in Bidh Gaya), and I was mainly interested in activity rather than monuments. This was the morning prayer for the priests, and this was the only viewpoint. The moment was practically static, so in the absence of action, I chose to go for formal graphics, and used a 300mm telephoto from further back to compress things into rows. From the first shot, I wasn't happy with the emptiness of the lower part of the frame, nor with the half-cut figure at left, and I re-framed. In the second shot, the orange lintel is an improvement (orange pervades the shrine's buildings), and I tried to match in shape and size the upper backs of the white-clad priests with the paper lanterns, but the lack of anything happening still bothered me. I decided that my best chance of a definite moment would be when they stood up at the end of prayers and left, but there would be time for only one or two frames. More to the point, I thought it might look more interesting and ephemeral (with a nod to a tenet of Shintoism) if I let them ghost across the frame. That they were white against a darker background meant that this would work. I set the shutter speed to one second (I think—this was on film and so with no EXIF data), and it did indeed work. ■

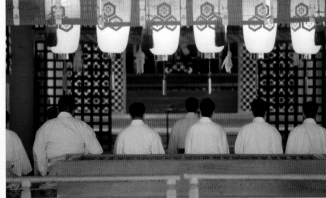

Rating

While the scene was static for most of the time, the final moments became urgent, particularly because of the time exposure, which allowed only two shots. The precision was fairly low. The speed, obviously very slow, was nevertheless extremely important for success.

Frame two

Revised framing for a more formal pattern, but still static.

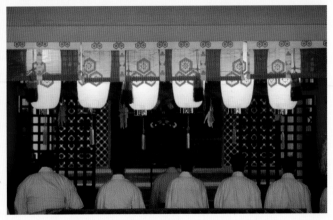

EXTENDED MOMENT Borrowed Seascape

For the final two picture moments of the book, I'm returning to the always-risky technique of digital intervention, as in Sequential Moment: Tea Factory in the last section. Why risky? Because once you begin manipulating photographs in Photoshop—oh so easy and superficially satisfying to play at—you're on the slippery road to perdition. There's an increasing class of images that don't really know what they are, photograph or illustration. They are actually photo-illustration, and there's nothing at all wrong with that, but when the computer starts to take over imagery, then in a way anything goes. What I'm trying to do here is limit myself to presentation, meaning a sequence of photographs already shot, no real alteration of meaning, just combining them in an open way that enhances the reasons for the sequence. Open in this sense means not trying to fool an audience that the final image was in any sense a single real shot. See if you agree.

This view out from a seaside house, called the Asia Gate House, designed by architect Tesuo Goto and the client Amon Miyamoto, was taken for a book on contemporary Japanese architecture and design, and the house is perched on a cliff in Okinawa. This is not generally considered a good idea because of the high risk of typhoons here. The locals build farther back. The reason for siting this property right on the sea was to make a modern version of an ancient idea that comes from China: borrowed landscape. In Japanese this is called shakkei, and here it's more borrowed seascape. That idea is to frame your own view, usually from your garden, in such a way that you draw into it features that are much further away. You borrow the distant, public landscape and make it visually your own. Fascinating idea, also very appealing to photographers, who are often up to such tricks by juxtaposing things in the viewfinder. One problem

Asia Gate House, Okinawa, Japan

is that you can't control the landscape beyond, and before you know it there might be a wind farm in front of you. The view out to sea is generally safer, and here on Okinawa, there's a wide flat shelf of rock that is exposed at low tide but otherwise submerged, so the view really does change.

I shot the identical view at different times over three days. The problem then was, how best to show them next to each other to show how much the view changes. Stacked one on top of another, or side by side, is not very interesting, so I changed tactics when it came to actually showing the result, and looked for a way that kept it all in the same picture. Digitally there's nothing complicated about this, a straightforward Photoshop job of stacking three pictures as layers

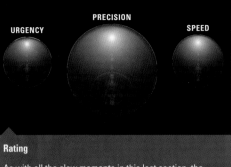

Rating

As with all the slow moments in this last section, the time frame means little urgency. This is balanced by the need for precision, in this case of a special kind, sitting the camera in exactly the same position for each shot. Speed needs are very low.

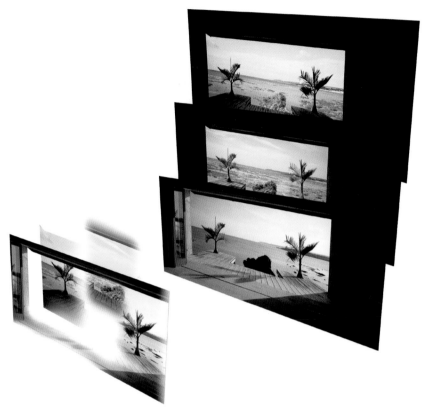

and then manually erasing parts of them with a large, soft-edged brush.

I called this scene an extended rather than a combined moment (it is image combination, after all), because the result is stretching out the time as the sun moves and the tides turn. I justify it because the entire idea of this piece of architecture is to provide the people in the house with an unrolling and unfolding scene, a landscape that changes over many days. The passage of the sun and the tides don't coincide, so it is different hour after hour and day after day. The only problem with this way of presenting it is that three different times and tides were the maximum that would look different. More than three across the width of the opening would have meant slices too thin to show the range. ■

Assembling & merging

Putting the three images together into one meant assembling in aligned layers, and erasing softly from one to the next using a grad filter in a Photoshop mask.

Time of day multiplied by the tides

The tidal flow, with its wide range over the flat seashore, is not synchronized with the passage of the sun, so the permutations of the scene are endless.

AGGREGATED MOMENT Average Expression

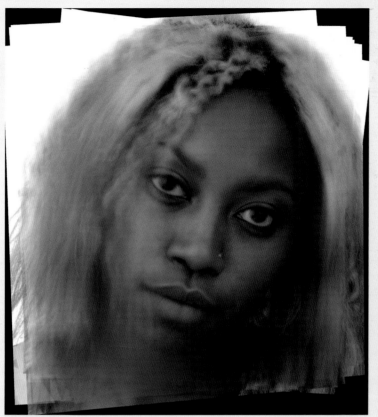 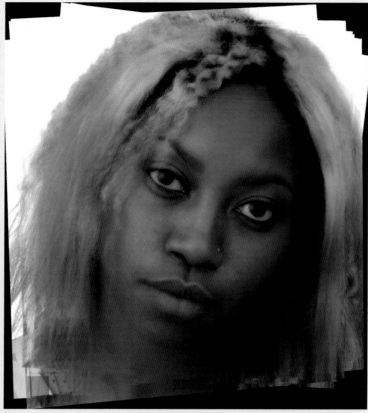

With some apologies to purists who think, probably quite rightly, that moment is about a single action, what happens if we combine a short range of moment in a way that averages it out? Would it show something new, different, useful? Or just blur the meaning? The digital techniques are certainly easily available. I'm not here talking about the ways of showing a flow of action, as happens in, say, sport or dance, but something that remains in place, in this case a face in a portrait session.

Think about ways of making moments slow, and this becomes is a very digital photographic technique for extending time. The starting point is a large number of similarly framed images, in this case an easy and common source—a studio-portrait session. The variable here is the expression, which boils down mainly to permutations of eyes and mouth, with some subtle changes in the facial

muscles. The model's skin is particularly fine and smooth, so changes hardly at all. Taking 18 frames, Photoshop has been used to do two essential things. The first is to match the images so that the main features (eyes, mouth, nose) are all aligned. The second is to combine them in a stack so that they merge. This is a simple software exercise that involves loading them all into a stack, aligning them, and then choosing one of several different Stack Modes. The two that work best and are the most appropriate for this are Mean and Median, which are the two most common ways of averaging. Mean is what most people think of as averaging—adding all together without changing the brightness, and tends to bring a slight ghosting where things don't align exactly. Median selects the most common value, which in this case means eliminating occasionally different positions of the mouth and eyes (it's also the

Sylvie Koanda, 13 minutes

technique used to remove passersby from scenes and crowds from views of monuments)

Both work in a kind of way, and they each show an expression that is different, subtly, from any of the individual 18 shots. The Mean version (left) has a slight softness to it, but this recalls the softening effect of a portrait filter, and so has a curious acceptability to it. But in the end, is it useful? There's a kind of evening out of expression that comes down to taste. I see a slight difference between the two expressions, the Median (right) being a little cooler than the Mean. You could dismiss it as bland and even lacking in expression, or you could take the more conceptual view that it shows the sum of the expression over the 13 minutes of the shoot. ■

URGENCY PRECISION SPEED

Rating

As the combining of all these images happened later, in the computer, all three qualities of urgency, precision, and speed were low. Attention did have to be paid to precision so that the images would align.

Maximum mode

The subject's dark skin makes Maximum Stack Mode a possibility, except that the eyes become peculiar, and so these were kept as in the Median version

The procedures:

In Photoshop, the first job was to assemble the 18 images in a single stack, and make them a Smart Object, as:

File > Scripts > Load Files into Stack & check both Attempt to Automatically Align Source Images & Create Smart Object after Loading Layers

Next, choose the Stack Mode, as:

Layer > Smart Objects > Stack Mode > Mean (or Median)

INDEX

INDEX

Picture Credits:

The publisher would like to thank

p10: © Henri Cartier-Bresson/Magnum Photos;
p13: © Bruno Barbey/Magnum Photos